W9-BVP-097

The Roswell
Artist-in-Residence
Program

The Roswell
Artist-in-Residence
Program

An Anecdotal History

Ann McGarrell

with *Sally Anderson*

Foreword by Jonathan Williams

UNIVERSITY OF NEW MEXICO PRESS

ALBUQUERQUE

©2007 by the University of New Mexico Press
All rights reserved. Published 2007
Printed in the United States of America
Book design and composition by Diane Gleba Hall

11 10 09 08 07 1 2 3 4 5

Library of Congress Cataloging-in-Publication Data

McGarrell, Ann.
The Roswell Artist-in-Residence Program : an anecdotal history /
Ann McGarrell with Sally Anderson.
 p. cm.
Includes bibliographical references and index.

ISBN-13: 978-0-8263-4166-2 (cloth : alk. paper)

1. Roswell Artist-in-Residence Program—History. 2. Art patronage—New Mexico—Roswell.
I. Anderson, Sally. II. Title.

N5207.5.R67M44 2007
700.79'78943—dc22

 2006030566

*This book is dedicated to Luis Jiménez (1940–2006):
friend, mentor, extraordinary artist,
whose energy continues to influence
the Rowell Artist-in-Residence Program*

Contents

Color plates follow page 78

List of Illustrations

Color Plates

Foreword

The Poet is the Guy Who Puts Things Together

Jonathan Williams

> We are the two greatest painters of this era: I in the Egyptian style
> and you in the Modern style.
> —le Douanier Rousseau speaking to Picasso

> Every time I walk I do a dance, it's called here and there.
> —Aaron Siskind

In Roswell, New Mexico, the locals say it hasn't rained in three months. Out at the artists' compound, Milton Resnick is saying to no one in particular, "I love talk. The world is too large without talk." And Lorna Ritz is saying over the phone, "The colors find the forms." Across the street I see the Schooleys (Skinny and Gussie) moving about on their porch.

It is impossible to write about the Roswell Artist-in-Residence Program without a sharp focus on Don Anderson, whom I like to call the Polymathic, Panoramic Proteus of the Pecos Valley. Sally Midgette Anderson wrote a lovely piece for *DBA at 70*, a Festscrift we published as Jargon 103, April 6, 1989.

The Navajos have a saying that seems to apply:

> *Hózhǫ́jí naaghá.*

Literally this means "he walks around in harmony with the natural world and within himself," or "he lives right, according to the natural order of things," or "he lives in a way that is beautiful." The first word, "*hózhǫ́jí*" is also the name of the great chant (called "Blessingway"), which is the most important ceremony of all. Closely related to the second word are the expressions of the Navajo equivalent for religion or deepest values: "*nahaghá*" ("things move around"). "*Bik'i nahaghá*" means that a ceremony is being sung over him or her. "*Shinahaghá*" means my profession, my religion, that for which I live and move.

Thinking about these things for several years, it has often struck me, Don, that your life expressed them: always moving; and through motion and action, finding a harmony, a beauty, a peacefulness in the order of things.

Introduction

Sally Midgette Anderson, 2006

This book resembles a personal memoir, except that the memories have been collected from eighty-one of the more than 170 former artists-in-residence who have experienced "the gift of time," which is what the Roswell Artist-in-Residence grant has come to be called. It is not at all inclusive; slightly fewer than half the artists responded to the request for reminiscences. Of the seventy-three who did, most submitted a written account, while Ann McGarrell interviewed the rest. A few others chose only to submit images. For most of these, we have provided a brief biography and description of their work. But the narrative of the history of the program takes second place to the artists' reminiscences and accounts of their year spent in this remote outpost. What is presented is the raw material of the history of this program told through personal stories, rather than any sort of historical or art-historical formulation. The book is also intended to represent the uniqueness of this program, both in its provisions and in its lack of restrictions, and thereby in its long-term effects on the residents themselves.

New Mexico is one of the largest states in the United States and one of the least populated, with only one large city in its center: Albuquerque, with a population of around a million people. Unless you live in the central-northern portion of the state, where the scenic Sangre de Cristo Mountains and other tourist attractions are located, as well as most of the population, the distance between destinations tends to run to hundreds of miles, areas which are often nothing but empty grassland. Several of the artists whose stories are told here describe this vividly:

"I liked driving out into the middle of nowhere, stepping out into the vast empty landscape, where I felt like the connecting dot between earth and sky." (BEVERLY MAGENNIS, former resident)

"I found myself driving through a landscape devoid of any signs of life whatsoever. No houses, no other cars, no animals out in the fields. The clouds parted, and before me was, as far as the eye could see in every direction, a seemingly unpopulated expanse of vast grasslands. I was reminded of an old episode of *The Twilight Zone*. The sensation was awful, as in 'full of awe:' a species of fear, a kind of long-distance loneliness that leaves an impression, and in my case, has persisted ever since." (STEPHEN FLEMING, former resident)

The spectacular mountains and canyons of northern New Mexico form a stark contrast with the rolling flatlands of the southern half of the state, which is usually characterized as "high plains desert." The "desert" designation comes from the fact that the average rainfall is around ten inches a year, so that the "plains," while covered with grass, provide only sparse grazing for the herds of antelope that can be glimpsed from time to time during the long drive south. And it has its own kind of picturesque beauty, especially when the sun rises abruptly and pushes the night away to the west in a giant moving shadow; or when the clouds seem to touch the earth; or when a distant rainstorm moves along the land.[1]

Roswell (population forty-eight thousand) is the largest town in southeastern New Mexico; it sits roughly in the center of the high plains area and serves as a hub for several much smaller towns in the vicinity. It is about two hundred miles from the nearest city: Las Cruces and El Paso to the south and west; Albuquerque and Santa Fe to the north and Lubbock, Texas, to the east. It is a rather compact town, with a few far-flung

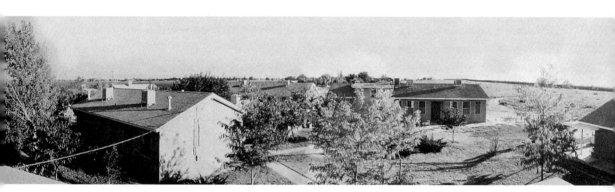

The compound (from roof of director's house looking South), from residency application, ca. 1980. *Courtesy Roswell Artist-in-Residence Program archives.*

CHAPTER ONE

Roswell, NM, corner of Second and Main Streets, ca. 1992. *Courtesy Roswell Artist-in-Residence Program archives.*

ranches; the main industries have historically been agriculture, ranching, and oil and gas.

During World War II the town was booming because at the beginning of the war the military had created a large air force base immediately to the south of the town. At its height, it employed more than sixteen thousand personnel, which created a large economic boom in the area, and also opened the possibility of air service to other cities. This good fortune only lasted about twenty years: in 1964, President Lyndon Johnson closed it for good, resulting in a corresponding bust for the town's economy that was felt for many years. Since that time, community leaders have valiantly tried to bring in businesses from the outside, renaming it "the Roswell Industrial Air Center," but they have had only limited success. It is still known as "the base" around town.

A number of Roswell's inhabitants have grown up somewhere else: a large proportion came from Mexico or points south, and the others from everywhere. There is a small black population, and very few Native Americans, though, remarkably, hardly any from the Mescalero tribe, whose reservation is up in the nearby mountains. Basically, there is the cowboy culture, and the Latino culture, with varying degrees of interaction; there are numerous "cowboy bars" as well as excellent Mexican restaurants. Over the past thirty years, more and more retirees have settled in Roswell, attracted by the generally mild winters and inexpensive housing.

Front yard of House "E" at the compound. *Courtesy Roswell Artist-in-Residence Program archives.*

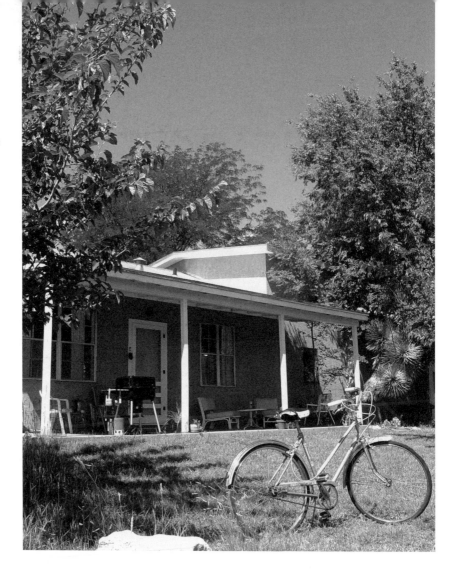

"The compound," where this story begins, is the name given to the cluster of eight low stucco buildings situated on an eight-acre plot on the northwest outskirts of Roswell; it serves as the main facility for the Roswell Artist-in-Residence Program. The name originated with Jane Kozuszek, the wife of Larry Kozuszek, the second program director. She wanted to replace its original nickname, "Hippie Corners," bestowed in the late '60s when local people (and probably a large part of the country) suspected that *all* artists were hippies. "The compound" is located at the western edge of the city, and originally it was completely surrounded by open fields of golden grass, almost as far as you could see.

For nearly forty years, this modest community has been home to small groups of visual artists from four continents, chosen by juries of selected artists and curators, and brought here on a residency grant for a year in order to have the freedom to work and to develop their creative

ideas. The neighbors attest that it is a quiet community, often almost invisible to them, because the artists are eager to take advantage of every minute of their "gift of time," and tend to spend most of it in the studio. Each house is complete in itself, fully furnished, with several bedrooms, suitable for housing a whole family. The studios are spacious, with large windows letting in the north light. A printmaking shop and a wood shop complete the facility. Since the residencies are staggered, not everyone arrives at the same time, so that the effect is of a group that is constantly changing—some are "party" groups, some are only interested in discussing major artistic questions; and some simply choose to remain separate. Most of the residents over the years have been either single or couples without children; however, at times the facility is alive with the sound of young people playing. What seems to remain constant in almost all cases is the profound impact the experience has on the lives of those who come as residents for a year: their love of the New Mexico light and the "big sky" views, and their abiding loyalty to that time of their lives and to those who shared it with them. In a sense, the story of the compound and of the program is simply a narrative of the experiences of the individuals who come here, and what it means to each of them to be allowed, finally, to devote all their time to doing what they love so deeply. The story also includes the ever-developing relationships between the artists themselves: the deep loyalties, the artistic influences, and the inevitable disagreements as well. The book is drawn from the words of the artists themselves.

The compound, and the program itself, began in 1967, with Don Anderson's purchase of the property at Berrendo Road and Montana Avenue. At that time there was a single farmhouse on it. Subsequently two other houses were moved in from the base, and a studio was added to each. One house was for the program director (initially also serving as the assistant director of the Roswell Museum), and two were for resident artists. At first, another house to the west also served as one of the residency houses (referred to as "the house on Mescalero Road"). In 1969–70, in response to specific applications from artists, Don added three more houses (some with two studios) to the three that were there, bringing the

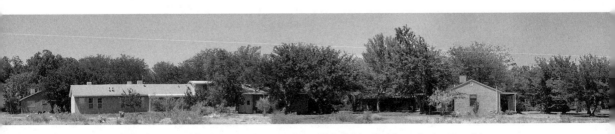

The compound (looking north), ca. 2000. *Courtesy Roswell Artist-in-Residence Program archives.*

number of artists on the compound to six (five artists and the program director). In addition, Don sometimes agreed to rent a separate facility for an artist who did not wish to live in a community. He also owned a building downtown, which he eventually converted into apartments and studios for a few artists who wanted to return after their year in Roswell and stay for a while. By the mid-'70s, the number of applications for the five places had increased to the point that a jury process had to be set up to screen them. Finally in the late seventies, a ninth studio was added to the compound, to accommodate families with two working artists.

However, while little has changed on the compound itself since the late seventies, its governing institutions have undergone some radical changes. In 1967 when the grant program started, the Roswell Museum and Art Center was relatively small, with a modest collection of contemporary art, mostly New Mexican artists from Taos and Santa Fe. The residency grant itself was conceived as a way to expand the museum, by showing and purchasing works by the artists who would come here. During the seventies, when the Roswell grant became well known all over the country, and hundreds of artists applied, the Roswell Museum vastly increased its collections of contemporary art, as well as expanded its gallery space to accommodate the increased activity and interest. The Roswell Museum and Art Center Foundation was then created for the purpose of monitoring the Roswell Museum's collections and providing an administrative vehicle for the residency program.

A major turning point occurred in 1980, when the Aston Wing was added to the Roswell Museum, to house the Astons' collection of Native American and Western artifacts. This had the effect of shifting attention and resources away from contemporary art. In the 1990s, under various

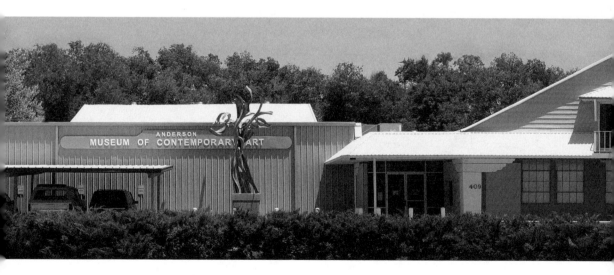

directors, the emphasis continued to shift, until finally it was decided that the Roswell Museum Foundation should no longer be the administrative vehicle for the Roswell Artist-in-Residence Program.

In 1994, a large new factor entered the picture; Don Anderson began to convert a warehouse he owned into a gallery, in order to showcase the works of former artists-in-residence, which he had been accumulating over the years. He intended this to be a permanent collection of as many works as he could gather from former residents (in addition to what he already owned), to demonstrate the diversity and depth of vision manifested by these artists during their time in Roswell. By 1995, the "warehouse" opened its doors to the community, and Don later renamed it the Anderson Museum of Contemporary Art (AMoCA).

With contemporary art now under the sponsorship of the new institution, it made sense for a new foundation to be created to replace the Roswell Museum Foundation, which had been administering the residency program. In 2002, a new non-profit organization, the Roswell Artist-in-Residence Foundation (RAiR), was created. It took responsibility for both the Roswell Artist-in-Residence Program and the Anderson Museum. The latter has become the public face of the program, representing the diversity and vitality of the artists' collective achievements to the community, and to visitors from all over the country. It also serves as a unique public facility for the town and the state, and is used for workshops, meetings, concerts, and parties by many different groups. In short, AMoCA provides an incomparable introduction to contemporary art to all who come.

Since 1967, 176 artists from all over the United States and from eight foreign countries on four continents have spent a year working in Roswell. Twenty-seven of them have asked to return for a second (and for some, a

The Anderson Museum of Contemporary Art. *Courtesy Anderson Museum of Contemporary Art.*

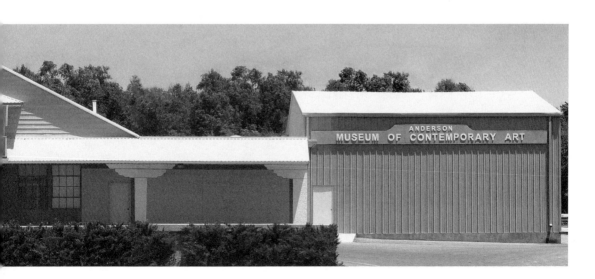

third) residency; another eight later returned to facilities in Roswell that Don Anderson set up especially for that purpose. Nine more former residents have settled in Roswell for a considerable period of time, and even more of them have moved to other parts of the state. Of the 164 of "our" artists still living, more than 80 percent of them are still practicing artists (despite usually having to have a "day job" in order to make a living). This demonstrates perhaps better than anything how powerful the "gift of time" has been in affirming the artists' commitment to their art above all things.

(1967–71)

The Beginning

Oil and Water

Most Americans associate Roswell with the rumored crash of an alien spacecraft more than fifty-five years ago. A happier few have come to know it as a place with two remarkable art museums, both of which contain works by the artists whose stays in Roswell are the subject of this book. The story of the Roswell Artist-in-Residence Program is the story of the artists, their work, and the visionary man who sponsored them.

Roswell rests on a huge aquifer in the desert of southeastern New Mexico. To the south and east, the compacted Permian seas of prehistory have been transmuted into oil over the past 240 million years. Oil and water: they do not mix, but they are crucial elements in survival here.

The oil industry brought Don Anderson to the region and made him a wealthy man. He built (literally, both designing and participating in hands-on construction) a splendid rambling house east of town. He became passionate about reshaping the landscape, in 1962 moving tons of earth with a bulldozer to form rounded masses of sculpted earth from which the giant habitable sculpture called *The Henge*, conceived by Herb Goldman, begins its upward thrust.

"You could say that Herb Goldman was the very first artist-in-residence here, even before there was an artist-in-residence program," says Anderson. "He stayed here in our house all during the time he built *The Henge*."

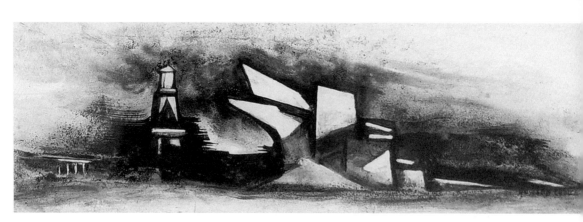

Howard Cook, *The Henge*. 1972. Ink on gesso. 4" x 13". Copyright of the estate of Howard Cook. *Courtesy Anderson Museum of Contemporary Art.*

Herbert Goldman (1963)

Herb Goldman grew up in Detroit, where at the age of twelve he apprenticed himself to a sculptor. He served in the navy during World War II and received his BFA from the University of New Mexico in 1949. He has completed more than ninety commissioned sculptures, large and small, all over the country and abroad.

Goldman was forty years old when he constructed *The Henge*. Anderson had seen his sculptured reliefs at the Albuquerque Zoo and thought he might like to commission a much larger work. He invited Goldman to visit the site on his property. Goldman was eager to make a sculpture that would be literally monumental. He designed a series of soaring intersecting monoliths, reminding Anderson of ancient structures he had seen during his travels in Afghanistan: a site's disintegration into compacted rubble, mounds and middens eroded; overgrown; surviving forms and surfaces set amid sand dunes. Anderson himself built the undulating hills from which *The Henge* emerges. As the scale of the piece (150 feet by 150 feet by 50 feet of Gunite concrete) became apparent, Anderson asked Goldman to provide a series of interior rooms. One enters from the pitiless New Mexican sunlight, past an enigmatic sculptural relief, through a narrow dark passageway, much as we imagine the initiatory path into ancient places of ritual to have been. The viewer emerges into a windowless room, which originally was a simply furnished living area. The rooms beyond are flooded with natural light. Metal stairs lead to a deck at the top of the tower, evoking the bridge of a great ship. The prospect, however, is not of the sea, but the frequently changing contours of the once-flat Anderson land, now scalloped, mounded, hollowed, studded with sculpture, trees, and a fountain.

The most striking structure in Roswell, *The Henge* remains an object of ardent curiosity. Locals call it "the bomb shelter," "the bunker" (yet it is entirely above ground and has no function beyond that of being itself), and "the Flintstone house." As one looks across the fields from the road to *The Henge*, it appears to be what it is: a giant sculpture. One of the pleasures of *The Henge* is the transformation it works upon the visitor who, having explored the structure's exterior masses, comes inside to participate in the negative volumes of those same forms. He or she is no longer merely a spectator, but—eerily—a participant, drawn upward into bright white space. *The Henge* is both a piece of fantastic visionary architecture and a place for family gatherings. Three generations of Andersons have used it for parties, carrying food and drink to the big table, hurrying through a room inhabited by vivid painted presences. It is thus emblematic of what Don Anderson's relationship to art and artists has come to be: something

Herbert Goldman with *Mother and Child, Polar Bear. Courtesy of the artist.*

that is at once both exceptional and homely, surprising and familiar. An artist himself, he empathizes with the needs and problems of artists. Some of these can be solved by his getting on a John Decre bulldozer to modify the landscape, shift a piece of sculpture, extend studio space.

As a child and young teenager in Chicago in the 1920s, Don Anderson spent many hours at the Art Institute, where, he says, "art began to work on me." He has been a serious and gifted painter ever since, discovering oil paints and brushes in Purdue University's student hobby shop as an undergraduate engineering student. His landscape paintings indicate a particular attention to mountains and water, perhaps unsurprising in a man who lives in the broad emptiness of the New Mexican desert. There is a constant awareness of distance in these works, a suggestion of something lying beyond, outside the picture plane. The eye is always being led toward another possibility. Michael Aakhus (former resident) says:

> [Don] said that he had read a great deal as a young man and in this way had come to know remarkable places around the world. Later, having had the opportunity to visit these places, he took them into his memory; and when he returned to his canvases he painted a representation of both experiences, the literary images overlaid by his having had the opportunity to see the real thing. I asked him if he used photographs, and he said no. He said he felt they might dominate the final outcome of the painting. He wanted the two experiences to come together in his mind's eye.

Roswell at all times imposes an awareness of distance from the next place, or from the last one. If you drive south from Santa Fe or Albuquerque at night, three hours pass before you reach the crest of Twenty-Five Mile Hill and all at once see a pool of lights down below. The long drive is ending. The English painter and sculptor Jane South (former resident 1997–98) describes the experience:

> I drove for three days to get to Roswell with all my stuff in the back of my pickup. I was about two hours away, off the highway, high up somewhere in the pitch black when I stopped the truck and got out to sit on the hood and have what was supposed to be my last cigarette. I counted seven distant and distinct storms below, soundlessly visible in flashes of lightning. Just then I realized how open and vast this place was; it felt like what I imagined outer space to be, deliciously infinite.

Since the formal beginnings of the Artist-in-Residence Program in 1967, more than 170 artists and their families have made that journey,

pulling into "the compound," a scattering of dun-colored buildings at the edge of a pecan grove and a dusty field. There they have unloaded babies, worldly goods, and art supplies, and settled down to a long stretch of uninterrupted working time.

The Roswell program differs from most other artist residencies by its length (a year, sometimes extended), its provision of studio and living facilities, a monthly stipend, and (at some times and in some circumstances) materials. There are no requirements beyond those imposed by one's own work. Of the hundreds of applications received every year, five artists are selected for the residencies.

"Everyone involved with the program, including the founder and the director is an artist," says Stephen Fleming (former resident, and director of the RAiR Program since 1993). Ironic and articulate, Fleming speaks forcefully, leaning across his kitchen table. He adds:

> The program's needs and concerns are for artists. Of course I see this as a virtue, a huge positive quality, but it makes it hard to sell to the outside world: no pretty buildings, not many big names. A year in Roswell is a confrontation with rural America. It's a town people drive *through*, not a place they drive *to*. Part of the rationale of the RAiR Program is to bring exciting artists to a small town for the cultural good of the local residents. In fact, what really happens is that artists, often for the first time, are exposed to the reality of rural America. Since almost no one is making TV shows about real lives in this part of America, this story goes untold, and all anyone hears or sees in the media are the strangest and most unsettling features of our urban culture. Needless to say, a lot of people end up very confused about what's really happening in either place. I'm still trying to sort it out.
>
> Roswell has the most churches per capita of any town in the U.S. Is it Xanadu with a mad merchant prince, or is it a clutch of mud huts in the desert? Neither. Both. The compound was a pioneer settlement in a remote corner of Roswell. The only formal rules are no guns, no dogs, and the Golden Rule. If you bring artists together they will take care of themselves. It's hard to categorize or define the place, but every once in a while you get a glimpse from the outside of the compound. I'll be at the hardware store, somebody asks me where I live and I tell them, the artists' compound on Berrendo Road, and he'll say, "I never knew any of those artists, but one of them had a daughter who was the best basketball player I ever saw."[2]

The town of Roswell itself differs in almost every aspect from New Mexico's official imagery: colorful Native Americana, turquoise and

silver, red chiles garlanded into *ristras*, adobe; the mystique of Taos and Chimayo, or the profusion of galleries along Canyon Road in Santa Fe. Instead, this is the monochrome high desert of southeastern New Mexico, close to the border (the town's southern enclave is informally called Little Chihuahua), and closer to West Texas than to Albuquerque, both in distance and in character. Roswell is flat, tan, and austere, largely barren of vegetation. The principal street is animated by a series of strip malls and the ubiquitous fast food places that make all American towns resemble one another. Some of the shops in the downtown area have cartoon aliens perched atop them. There is a UFO Museum and Research Center with displays of faded newspaper articles, metallic foil, and props from movies about space aliens. It has a world-class gift shop with glow-in-the-dark "alien" lollipops and nightlights in the shape of squat little space vehicles in Matisse colors.

Rising in the western distance is the perfect triangle of Capitan, the illusion of a mountain that is really the end of a mountain range, visible in its perfect pyramidal configuration only from Roswell.

Former resident Richard Thompson muses, "Maybe what takes place in Roswell is a deeper romance because everything is stripped so clean and clear."

Random Strokes

After moving to Roswell in 1946, Don Anderson was troubled by the lack of any local art presence. A dedicated painter himself, his work deeply anchored in remembered landscape, he was lonely for contact with other artists. For him it would be enough to know that other artists were working nearby, that a kind of context for painting existed. For many of the artists who come to Roswell, it has been reassuring to know that the program supporting their work is one founded by a man who is himself a skilled artist. All the program's administrators have been working artists, with a realistic sense of other artists' needs: enough time and materials to accomplish meaningful work; a place to live; a studio; as much privacy as can be borne.

In 1967 Roswell had a small, minimally endowed local museum with important Navajo textiles and pottery, but with few examples of contemporary art. Only a handful of artists worked in the immediate area, and Roswell had no facilities to attract them. The well-known Western painters Peter Hurd, Henriette Wyeth, and their son-in-law Peter Rogers lived nearby, but they were stars in a distant firmament, many miles from Roswell, involved with their own work and somewhat disinclined to participate in the artistic life of a small town. Anderson wanted to do

something meaningful, something that would invigorate Roswell's languishing art community.

Don Anderson recalls:

> I had no idea how to do what I wanted to do. I talked with Gene Smith, director of the Roswell Museum, and Lee Johnson, the assistant director, and they said, "Well, maybe you could invite some artists to come out and stay for a while." I knew that Howard Cook and Barbara Latham [the first residents] needed to get out of Taos and do their work in a warmer place. There was a house available right at the edge of our property, and Howard used my studio. I think they returned each winter for eight years.

Howard Cook and Barbara Latham (winters 1967–76)

Howard Cook was born in Massachusetts in 1901. He studied at the Art Students' League and was much involved with the art colony in Woodstock, New York, in the early 1920s. A highly praised muralist, painter, and printmaker, he met the painter Barbara Latham in the course of his first visit to Taos. They married in 1927 and settled outside Taos, where they lived for nearly forty years as distinguished members of the Taos art scene. Advancing age and its ills made winter in the mountains a painful time for them. They welcomed the possibility of a sojourn in Roswell when Gene Smith conveyed Anderson's offer:

Barbara Latham and Howard Cook. Photograph by Laura Gilpin, ca. mid-1970s, 35 mm negative. *Reprinted with permission from the Amon Carter Museum, Fort Worth, Texas (Latham.1.2).*

Ranchos de Taos, N.M.
August 14, 1967

Dear Gene–

What a very wonderful suggestion you made in your telephone
call, and what a great blessing it is to think that we shall be able
to spend the coming winter in Roswell rather than the uncertainty
of thinking about Tucson, which could not have been possible
anyway, for many reasons . . .

You can well imagine how losing this place, this part of our
lives, affects us. . . .

With all good wishes, Howard

Cook and Latham seem to have had an extremely happy and pro-
ductive time in Roswell. The compound had not yet come into existence
when they first arrived; instead they lived in a small house adjacent to the
Anderson property and a short walk from the studio Cook shared with
Don. In the following years, they purchased a house nearby. A number of
the artists knew them, although they didn't live on the compound, even
after it was completed. Finally, in 1976, because of Howard's failing health,
they moved into a retirement home in Santa Fe full time.

Latham's work is marked by a kind of witty regionalism, attention to
detail, and a fierce affection for Southwestern color and iconography. She
often depicts figures in the New Mexico landscape, overwhelmed by the
uncompromising presence of the Sangre de Cristo Mountains.

Susan Cooper (former resident) describes Barbara Latham with
deep affection:

> Having come from an environment (the University of California at
> Berkeley) where all of the faculty members were men, we were told that
> only 10 percent of us would still be painting in ten years, and that none
> of these would be women. Consequently, one of the most important
> experiences for me in Roswell was meeting Barbara Latham Cook.
>
> She was about seventy-five years old at that time and she was the
> first professional woman artist I'd ever met. She answered millions of
> my questions about being a woman artist. One thing she said was very
> important at the time (and now). I was worrying that my work wasn't
> "fashionable." Barbara said something like, "Don't worry about that.
> Just do what you do and do it the best you possibly can and better than
> anyone else. If you're lucky it may become fashionable. But probably
> not." She would come to my studio spontaneously and peer into the
> window yelling "Yoo hoo!" It was startling!

The pattern of informal mentoring between older and younger artists would recur all through the history of the residency.

John Wallace (1968)

At the beginning there was no formal application process. For the first few years, it consisted of artists who had heard of the grant being screened by an ad hoc committee at the Roswell Museum. At Lee Johnson's suggestion, Don Anderson contacted the Skowhegan School of Painting and Sculpture in Maine to spread the word. Could Skowhegan's director suggest artists who might benefit from a year of studio time and a place to live in the Southwest? He could. Several distinguished artists were invited, but declined to leave New York. The director then proposed John Wallace, an enormously talented young painter who had recently been at Skowhegan. Johnson invited him to come for a year. Wallace, married and with two small children, resigned from his teaching job at a junior college in St. Louis and looked forward to a year of painting in Roswell. Toward the end of his stay, Wallace described the conditions in a letter to Skowhegan director Jack Eastman:

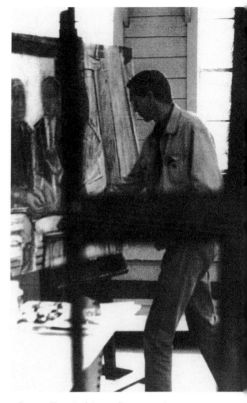

John Wallace in his studio, 1967. *Courtesy of the artist.*

> The facilities here were not anywhere near ready to have brought someone to Roswell. The house was not ready to be occupied; the studio was not built. We are living on what amounts to a construction site. There have been carpenters, plumbers, electricians, roofers, painters, dump trucks, front loaders, plasterers, masons, etc. working on the house and studios for the whole length of time I have been here.

The old farmhouse, the compound's original structure, was heated only by space heaters, and sporadically at that. The babies got sick. It was months before the rooftop "swamp cooler" systems functioned properly. With no window screens, the studio and house were either suffocatingly hot or full of scary insect life. Amid cacophonic construction noise, Wallace painted behind closed windows while his young wife was convinced that people were watching her through the uncurtained windows of the farmhouse.

Margaret Grimes Wallace, an accomplished painter in her own right, was twenty-four that year in Roswell.

"She *looked* about fifteen," says Brian Leo (fellow resident) admiringly. "She thought I was a hippie because I had a beard," says Jerry Kirwin (fellow resident). "I guess that reassured her. The time in Roswell was hard for those two; they'd expected something different, less primitive."

Margaret listened in growing alarm to the local AM radio station with its casual reports of knifings and shootings at the edge of town. The air base south of town had just closed. It had constituted the core of Roswell's middle class, and its removal left a void in the social structures of the town. Suddenly the town's population was skewed toward Hispanics, Native Americans, Anglo cowboys, and a few invisible oil millionaires. Later Jerry Kirwin and other artist-activists would be important in encouraging transition and inclusiveness. On Margaret's twenty-fifth birthday Robert Kennedy was shot. She remembers lines of Hispanic men standing in the dusty street, listening to transistor radios, weeping, in the blazing June sunlight.

Each night, just before sunset, flights of swallows would land outside John Wallace's studio, forming a circle perhaps eight feet across. When a young bird was introduced, all the other birds would approach, one at a time, and chirp at it, welcoming it to the circle. "The birds were friendlier than the humans," he now says ruefully.

At night, John and Margaret would watch lights moving across the night sky: UFOs? Was something ominous going on at White Sands, the distant missile range? There were strange nocturnal sounds: Coyotes? Prowlers? Walking out in an early morning fog, Wallace saw barns and cows emerge with eerie suddenness out of the mist. Across the road were a produce farm and a working ranch with its noises and effluvia. This was a West much wilder than they had expected, a lonely and alien world far from academe.

The compound was not yet a community. At that time it consisted of the original farmhouse and two additional houses that had been moved in from the abandoned air base to the south, and were in the process of being made habitable. During the Wallaces' stay, Jerry Kirwin lived in a house on Mescalero Road, just to the south, and Brian Leo eventually moved in next door to them when the work on the next house was completed. Living and working conditions remained overwhelmingly difficult for the Wallaces. They decided that they had to leave. Out of work, broke, with none of his enigmatic large paintings completed, they returned to Margaret's family in St. Louis.

"[Wallace] was not a New Mexican, if you know what I mean," was Brian Leo's explanation, "more of a flatlander or a prairie person," the implication being that it took a desert rat to live through the chaos of the compound's birth pangs.

Skowhegan was miffed at the residency's administrators for not living up to their artist's expectations; the Roswell people were offended at being reproved. It was not an auspicious beginning. Maybe the whole program was wrongheaded, a bad idea.

The two New Mexico artists who were involved in the program's early days, however, were eloquent proselytes. Brian Leo had initially suggested setting up a small bronze foundry for artists. After a two-hour meeting with Don Anderson, the project had instead become a full-scale lithography shop; as resident master printer he editioned lithographs for Howard Cook, Peter Rogers, and Lee Johnson, among others.

Brian Leo (1967–68)

Brian Leo came to the grant from Albuquerque where he had just received his Master of Fine Arts (MFA) in sculpture from the University of New Mexico; he was also trained in printmaking. Originally from Minnesota, he was and remains deeply attracted to the Southwest. Leo speaks of his involvement with the program:

> The first shop was downtown in a rented building next to the old library, in a front room, and I went there all the time and just worked and did some printing on the quiet. Garo Antreasian, the printmaker up at the University of New Mexico, was very positive about the project; he helped me find litho stones and generally gave me advice. Things got going pretty well. Soon the shop was moved to a back room at the Roswell Museum and I worked there, printing and graining stones, listening to the night sounds out behind the building. Sometimes a vinegarroon[3] would wander in. Jeez! They're scary!

Leo continued to work on his own sculptures and paintings in the compound's little garage building.

> It was a fine studio, maybe unrecognizable now. I made a lot of artwork there, primarily sculptures and some painting, and watered the bloody salt cedars they'd planted all over hell, watched the sheep across Montana Avenue. It was pretty peaceful. Jerry Kirwin lived just across the field—he became a good friend.
>
> My time in Roswell was serious and important for my development and my career. I know I grew artistically while I was there. I made some pieces whose quality I still respect, even though some of them have fallen apart. Life is a sort of battle between the making of artworks that are full of your most burning intent, even if you know that someday those same works may fall apart in some way or all ways.

It's really the same experience I had on the night of our party out on Pine Lodge Road where we went to welcome the aliens. My date was a fine Vista girl. Naturally I was wearing my space suit, a pressure suit. At the stroke of midnight, back at her place, my particular and immediate burning intent was frustrated because, given my state of excitement, there was no way I could get out of my pressure suit. Talk about life and art—sometimes you can't go as far as you'd like. Another girlfriend, a welderette sculptor, threw me over for a poet, if you can believe that. You could say I craved companionship. What a droll understatement that would be.

Leo explored the countryside, driving up to the mountains and to the little village of Arabela; he attempted to climb El Capitan, and hung out in such fabled venues as Dana's Lounge, the Green Lantern, the Valdez Café, and Scotty's. Leo continues:

I was seen there, but not nearly enough. I bought my first pair of cowboy boots on Main Street that spring, and paid thirty-seven bucks for them. Still have them.

In those days Don and his wife Pat really made themselves available to us; they were lots of fun. This is a time to say how great a person Pat Anderson was: gracious, jolly, and a good cook, too. They gave a dinner party—Paul Horgan was there. He suggested that George McGovern really might actually win the presidency. I was busy eating, but I remembered this statement.

After I'd been in Roswell for a few months I went back up to Albuquerque, spreading the news that this business down south was actually real and generous, and the UNM folks and faculty took notice. Remember that in those days there was a sort of chasm that opened out around Cline's Corners, about a hundred miles from Roswell; the UNM folks didn't think Roswell actually existed. The first time I drove through there I saw all those cadets from New Mexico Military Institute strutting around town in their uniforms and I thought, "Hoooleee shit, I don't think I'd like it here." I couldn't have imagined the other sides to Roswell.

By the time I was a grant recipient in December of '67, New Mexico had already entered my soul in ways, and in places, and with energies, and with results that have conditioned and aided and in a real sense rescued my life. Don Anderson was the catalyst for that process; let's call it a process. He is in a quite special realm of advocate or helper to my continued artistic life, even though it's years past. You want me to be honest, correct? Or I can just sit here and bullshit you and make

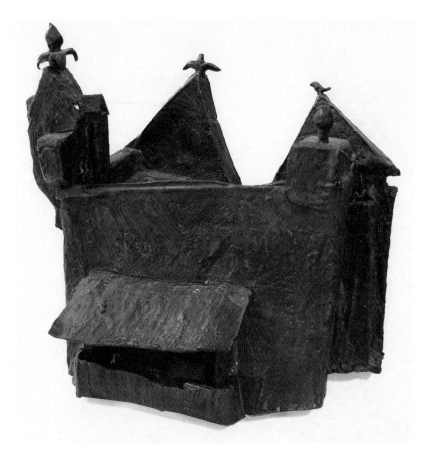

it sound good. There are a few folks who have the highest place in my development. There are teachers and others in my long schooling who've been vital influences. Judith, my wife, is the most important person. I had my wild period before we married, and it will be thirty years this summer. Then there are other folks who have helped me in employment, in art, or just working in various ways, and Don is right there in the front row.

Leo continues to make and exhibit sculptures in cast steel and wood. A series of wood sculptures representing a fictional New Mexico village was first shown in 2005, along with a set of new works he refers to as "Poetry Stuff." When asked what "Poetry Stuff" represents, Leo replied, "I'm not quite sure."

Jerry "Geraldo" Kirwin (1967–68)
Jerry Kirwin was born in the East but soon moved West and became a committed westerner. In the 1960s, he worked on impressive, massive wood icons that verged on abstraction. Later he created everyday scenes with small bronze figures of men working, to express the depth of meaning in ordinary work. "I was a guinea pig," Jerry Kirwin boasts:

Jerry Kirwin,
Totem. 1968.
48 ¾" x 40" x 11".
Oil on plywood.
Courtesy Anderson Museum of Contemporary Art.

CHAPTER ONE

There was this idea for a grant, an artists' residency. Nobody had figured out what an artist would need to live on for a year—yeah, a studio, a place to live, supplies, a little bit of money. I had a wife and four kids; I had to be sure I could take care of them, too. Don and the museum had to estimate all this.

Gene Smith and Lee Johnson from the Roswell Museum came out to see me in San Patricio. I fed them *quelites*—in English that's lamb's quarters; they used to grow on my land down toward the river. Those two were horrified. Later I heard they thought they'd better give me a grant and save me from eating weeds. I didn't have the heart to tell them it was a delicacy.

The art community then was so small that everybody within fifty miles who had anything to do with art knew what everybody else was doing, what everybody's work was like. Peter Rogers knew my stuff. Anyway, they asked me, and I came to Roswell.

You have to understand there was no compound then; there was just one house, the original farmhouse where the Wallaces lived, and the little outbuilding where the laundry is now. Fields all around—it was the edge of the desert. They put me in the house across the alfalfa field and turned the tractor shed or garage or whatever it was into a studio for me. Don sent his crew over and they sheet rocked and wired it up, insulated the garage door. I helped, because it didn't occur to me not to.

My daughter Maria turned on the kitchen faucet and let the water run so it would be cold—and it started steaming! It scared her to death, because we hadn't had hot water in the kitchen at the ranch. She hollered "Mommy, mommy! The water's burning!"

For some people the grant is almost a burden. Suddenly you have everything you need, and you have to get that monkey off your back so you can work.

When I got off the grant I stayed in Roswell for a while. Title III money was starting up, so the museum got some federal money for cultural enrichment programs. Gene Smith put ads in the paper offering free art classes, and the same kids from wealthy families showed up, the people who use museums and libraries anyway. Gene wanted to know how to get poor people in. I told him, "You come with me to the NAACP." I took him down to the *barrio*,[4] *La Chihuahuita*, Little Chihuahua. We pitched the program to the priest, to the ministers in the black churches. They listened. I remember Reverend Jameson saying, "I think that's a good thing for children." Suddenly we had huge classes at a neighborhood center down in the barrio, then a big show of children's art at the museum, and the parents came. They were

so proud! It was the first time any black or brown people had come to the Roswell Museum. The planetarium, a new educational building adjunct to the Roswell Museum, opened about that time, too.

I'm not very good at being a full-time artist. I always needed something else. I moved to Chihuahuita, got drafted to work for the Community Action Program. You have to understand this was a time when Head Start was a Communist plot in the eyes of a lot of people. The Roswell Meals on Wheels program consisted of one woman, Norma Gómez, who cooked all the food, packed it up, and delivered it in her car. All these ideas were brand new and kind of suspect; the Cold War mentality was something mean and real: us or them.

The air base had closed, and all those people had moved away, leaving hundreds of empty houses. The Federal Housing Administration had all these guaranteed mortgages they were going to have to

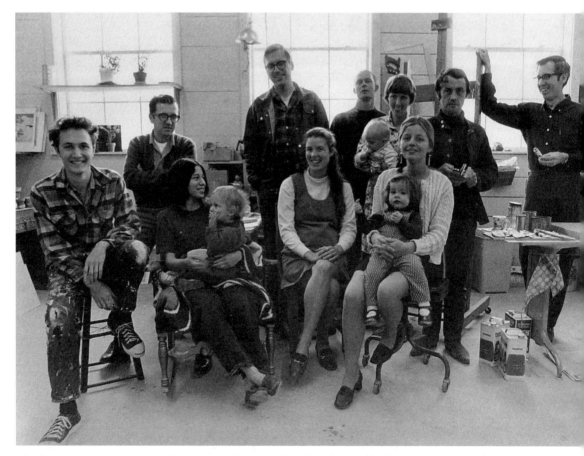

The first group. 1970. Front Row: (L to R) David Reed, Judy Rifka holding John, Sally Midgette, Margaret Goodman holding Jessica. Back Row: (L to R) Gene Smith, Bill Midgette, Tom Stokes, Jane Kozuszek holding Walter, William Goodman, Larry Kozuszek. *Courtesy Roswell Artist-in-Residence Program archives.*

CHAPTER ONE

eat. I helped convince them not to start building new housing projects but to set up a program to help people qualify for the houses that were already there.

Then I was recruited to work for the regional Community Action Program guys in Austin. I was a tactician; I would figure out how to make contacts and use them. Have lunch with bureaucrats, talk to them, learn about their programs, then design a new one that covered different needs.

Over the years the artist-in-residence program has undergone a kind of metamorphosis. It was fun to see the buildings—old barracks from the base—come in and get reconfigured. "Hey, let's try cutting it in half, okay? Maybe turn it sideways?" In the early days, I think artists were chosen because what they were doing was so odd they needed support because they weren't ever going to sell what they made. But now I think the choices have gotten more predictable, more "what's hot in New York." It's all juried and respectable now. I don't know. I hope it stays cranky and special.

William Goodman (1969–70)

William Goodman, a painter and sculptor who was born in England but is now an American citizen, became an artist-in-residence in April of 1969, a few months after the first three left (although Leo and Kirwin were still in town off and on, and were friendly with him). Although particularly known now for his large abstract steel sculptures, he is also an excellent painter, and his giant antic painting *Oddy Knocky* remains one of the favorites in the Roswell Museum's collection. Will says:

My recollections of how I got "on the grant" are scattered, like animals that resist being herded together at one spot. I do know that my former teaching assistant at the University of New Mexico, Brian Leo, wrote to me about the grant, saying that Roswell was a good place and that Mr. Anderson had set up an unbelievably generous program. If there was a catch in it somewhere, he hadn't found it. My contract at UNM came to an end and was not renewed. My sculpture was going very well at that time, but I was suffering from a severe "teaching ulcer." My family and I moved to Roswell after Don bought a sculpture from me. He showed us around Roswell in his International station wagon with a Mickey Mouse decal on its door. He took me to likely sites for setting up a studio, including the old municipal airport, an abandoned Minuteman missile silo, and, notably, Building 73 at what had recently changed from Walker Air Force Base to the Roswell Industrial Air Center—still referred to as the base.

We rented a house on Alden Place at the base and moved our things from Albuquerque. The artist-in-residence program was not taking any new artists at that time. There was even a rumor that Don was in the process of weighing up whether it was such a good idea after all. My chronology of this time is fuzzy. I was working on some welded steel sculptures, and at some point I did become one of the artists in residence, although we continued to live at the base rather than at the compound (or "Hippie Corners" as it was then called by the locals) at the opposite end of Roswell. I started a series of paintings, a series of shaped canvases I called *Metagrams*. Most of them were abstractions whose illusion of form was created both by the shape of the canvas itself, and by the cast shadow realistically depicted on the canvas. I remember being pleased with them, but except for one in the Roswell Museum collection I have no idea where they are now.

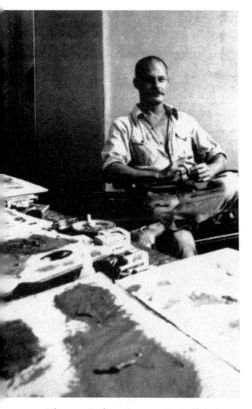

Thomas Stokes. *Courtesy Roswell Artist-in-Residence Program archives.*

During this time, the late President Kennedy's pledge to land a man on the moon and bring him back was approaching fulfillment. There was much discussion in the press about what the first man to land on the moon should say when he opened the hatch and stepped onto the lunar surface. We subscribed to the *El Paso Times*. Most of the letters from readers urged something along the lines of "Praise the Lord and stick it to the Russkies." I felt compelled to point out, in a letter to the paper, that the astronauts were intelligent people and capable of making up their own minds—they should be able to do a Coca-Cola commercial if they wanted to. This outraged a local physician, a member of the John Birch Society. Besides, he sneered, there was no Alden Place—the writer of my letter was a coward, hiding behind a fictitious address! When it was pointed out to him that there was, indeed, an Alden Place (at the base), he stormed down there and confronted my terrified wife. She brought him to my studio in Building 73. The paintings puzzled him.

He demanded to know if I believed in God. I was not really in the mood for theological disputation. I just wanted the man to leave. The proverb, "A soft answer turneth away wrath" came into my mind, and turned out to be true. Yes, I said, I believe in a Supreme Being. Wrath turned away, he departed. Incidents like this made an artist's residency in Roswell unpredictable.

The environment provided by the residency encourages an artist to concentrate on his work without having to confront some of the distractions that might normally sap his creative energies, and without having to go into hock. It is perfect for those who find stimulation in the climate and space of the Southwest—not everyone does. Being alone with one's work, and perhaps with family members chafing at the experience, can induce feelings of desperation. When my time on the grant ended, my marriage ended, too. My wife had been used to living in large cities, which had provided her with a much greater variety of food, entertainment, and educational stimulation. I liked Roswell and continued to live there a few more years.

Most people on the grant arrive in Roswell, get set up, put in their year working hard, enjoying each other's company and the peculiar ambience of southeastern New Mexico. They have their show at the Roswell Museum, and then leave. My own experience is slightly different, though nonetheless rich, for having been around the area for the best part of thirty-five years, within which period for one year I was one of the artists-in-residence.

Goodman currently lives near Tinnie, New Mexico, surrounded by a litany of evocative place names: Ancho, Arabela, Baca, Coyote, Lone Mountain, High Lonesome, Broken Back Crater, Luna, Oscura, Spindle. He continues to make and exhibit his large sculptures of Cor-Ten steel.

Thomas Stokes (1969–70)

After Goodman was given a grant—perhaps about the time he moved into "the house on Mescalero" from Alden Place—another artist, Tom Stokes, came to live on the compound itself. He arrived in September from New York City, having had a very successful show of his luminous color-field abstractions, at the renowned Betty Parsons Gallery. It was hard for him to make the transition to Roswell's relative isolation. There was almost no one in Roswell who could share his pleasure in his New York triumph: really only Don and Pat Anderson, with whom he was already close friends. In addition, although he had ordered his paint materials in advance, it took several weeks for them to arrive, so he felt very much at a loss until he could get back to work. He struck up a close friendship with Will Goodman but did not particularly get along with the only other family living on the compound at the time, the Midgettes. After his brief stay in Roswell (September 1969 to May 1970), Tom moved around, living in England, the West Coast of the U.S., and Santa Fe. He had a number of shows of his work, and continued to work on his subtly colored, almost minimal canvases, until his death in early 1993.

Bruce Lowney (1970–71)

Bruce Lowney's first residency began in May of 1970; he came into the house that Tom Stokes had vacated. Bruce came to the grant as a print-maker, having been trained at the Tamarind Lithography Workshop in Los Angeles,[5] and having served as a graduate assistant to the distinguished printmaker Garo Antresian at the University of New Mexico. In addition, he is an accomplished painter. Bruce recounts:

> Perhaps my experience at Roswell was a bit different from others. When I was first there in 1970–71, I was invited to set up and expand a lithography studio at the museum. They wanted a Tamarind-trained person to run the shop. I stayed briefly at the compound, but then it seemed that the house there was needed for a couple. I prefer living alone, and so another house further east was found.

Lowney had little contact with the other artists, but thrived on the grant. He specializes in quiet paintings and lithographs featuring otherworldly cliffs, trees, and rock shapes that radiate mystery and a particular luminosity.

Making Something Happen

The Pressure Cooker

[1] A displaced New York Abstract Expressionist painter and his wife, also an abstract painter.
[2] A young figurative painter from Brooklyn.
[3] An even younger visionary abstract painter, former student of both 1. and 2.
[4] A California painter trying to exceed boundaries of materials.
[5] Other wives (including another painter) and children.
[6] A peripatetic poet.
Mix and stir.

"Poetry makes nothing happen," wrote W. H. Auden in his great elegy for William Butler Yeats. He was wrong.

In 1962, Jonathan Williams was poet-in-residence at the Aspen Institute. There he met Don Anderson, who was an executive participant in the Aspen program. Two years earlier, Williams had met the figurative painter Bill Midgette in Indiana, at the home of Midgette's teacher, James McGarrell. During those years he had driven back and forth across the country countless times in a series of fading cars, reading his own poems,

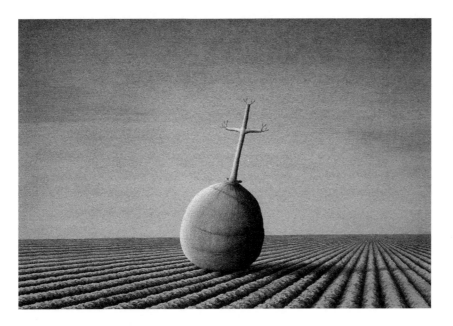

Bruce Lowney, *The Symbol of Dominion*. 1977. 12" x 15". Lithograph. *Courtesy Anderson Museum of Contemporary Art.*

and promoting the work of other poets in the beautiful books he published at Jargon Press. He also photographed a great many living artists and writers. Williams was and is a man moved by particularity and greatness, a poet, essayist, and photographer who has unrivalled powers of looking and listening. He and Don Anderson recognized their uncommon shared enthusiasm for the excellent and the new. Anderson became for many years a major backer of Jargon Press.

Williams returned to Aspen in 1966 and visited the Andersons in Roswell. *The Henge* had been completed, and its blank interior invited decoration. By this time Williams had seen Midgette's first large canvases, which attempted to reach out into their surroundings by becoming part of the rooms they were in. "I think I know somebody who'd like to paint on your walls," he told Anderson.

Willard Midgette (1969–71 and 1970–71 as grantee)
Sally Midgette Anderson relates:

> It's a wonderful story. Anne, our daughter, was a baby. We were in Taos; we had to get away from Reed College and the Portland rain. Bill needed the New Mexico light, and he also needed to get away from campus politics.

This was 1968, a time of intense political turbulence on American campuses. Memories of the Free Speech movement at Berkeley were vivid

among the younger Reed faculty. Older faculty members had already lived through painful incursions by the Velde committee[6] in the 1950s. Figurative painting was actually considered suspect in certain earnest avant-garde circles. Did reverence for the art of the past imply a lack of present political commitment? Was art necessary in a responsible society? Things were that stupid.

As a young faculty member, Midgette was trapped in endless academic committee meetings. His time for painting was being eroded; he was quietly furious and miserable.

Sally continues:

> Jonathan visited us in the summer of 1968. Bill was chafing, because he wanted to have an entire room to paint, instead of just the ever-larger two-panel corner pieces he was doing. And Jonathan said, "I know a man who has a room." Bill sent off a proposal to Don for a mural which would cover the walls of an entire room. A few weeks later, I remember answering the phone, hearing such a kind voice, asking to speak to Bill.
>
> It was Don, of course. He was very interested in the proposal and asked Bill to come down to Roswell and stay for a few days, to talk about it all. Jonathan had described *The Henge* to us, but we couldn't really comprehend what it was like. What's a henge? Standing stones? When Bill came back he was so happy, so excited.

During this initial visit to the site, Midgette made preliminary photographs of *The Henge* interior. He began to have a feel for what should go where.

The interior of *The Henge* is partly below ground level. At times damp intrudes, despite the proximity of the desert. The walls are gritty concrete, an inhospitable surface for direct painting. Midgette would need to affix canvas in some permanent way. He became acquainted with a mural technician from the Work Project Administration's (WPA) artists' project years, who reassured him that it would be perfectly feasible and desirable to cover the cement walls with canvas and work directly on that. Midgette did research into archival adhesives and sealants to satisfy himself that once he had accomplished the painting, it would endure.

A work of this size would be a major project for any artist. Midgette was thirty-two years old and had done only a few large-scale paintings. Nonetheless, he estimated the materials he would need, and took a year's leave of absence from teaching, although he would continue to commute to Portland for a few more agonizing committee meetings. "The more I see of general college life, the better Roswell looks," he wrote the Andersons.

Bill Midgette came to Roswell in December of 1968 to execute *The Henge* commission. He and his family arrived ill and exhausted from their long move from Oregon. Sally was frantic; Bill and baby Anne were both burning with fever; they detoured into the Roswell hospital's emergency room for diagnosis (pneumonia) and treatment (antibiotics). The farmhouse on the compound had been readied for them. They collapsed into it. The next morning Pat Anderson knocked at the door; she had brought them a loaf of homemade bread, still warm and fragrant from the oven. "Pat made us feel instantly welcome. We knew that we had come to a good place," Sally remembers. "This was our first real home."

Does any other American space speak of the artist's journey as movingly as *The Henge*? Emerging from the bright outside into the windowless room, one flicks a light switch, illuminating the room and its nearly life-size figures, whose presence provokes an epiphanic shock. On the left wall, Don Anderson's back is to the viewer as he simultaneously looks mildly into the room from what is either a mirror or a framed portrait of himself. The painter's ambiguity is deliberate, but, given Anderson's penchant for using large mirrors to further expand the interior of his already huge house, I read it as a mirror, as the artist's deliberate homage to Anderson's taste.

Patricia Anderson wears a pale turquoise A-line dress with lime-colored embroidery. Fine-featured, blonde, calm, she steps toward her husband in the elegant low-heeled pumps of the 1960s. At the corner of the wall, moving to the right, the painter Bill Midgette glances over his left shoulder as he works on a full-length self-portrait.

A grisaille portrait of the poet Jonathan Williams dominates the far wall, a tutelary presence. Models, the three Anderson children, and a handsome Siamese cat variously appear. Despite its overall reference to classical painted interiors (Annibale Carracci's Farnese ceiling, Paolo Veronese's decorations for Villa Maser), Midgette's painted room at one level of interpretation limpidly illustrates the daylight reality of a family's life. At the same time, glimpses of the painter's concerns with figuration (the instances of posed nude models) and illusion (mirrors) suggest another, even more private, narrative that evokes the great theme of art and reality, the transformative process of creating and peopling an imagined world.

So Williams, the "peripatetic poet," brought together the "young figurative painter from Brooklyn" and Don, his major patron, initiating a series of events that changed Midgette's life, and eventually that of the Roswell community as well.

Midgette had been committed to painting from childhood, one of a very few prodigies whose gifts and passion persisted into adulthood. He had spent every summer between 1953 and 1956 as a scholarship student

at Skowhegan, returning there in 1959, studying with doctrinaire realists like Ben Shahn, Henry Varnum Poor, and Jack Levine (whose sour Boston humor he admired), and the lyrical sculptor Kenneth Callahan. He might equally have cited Chardin or Luca Signorelli as mentors. "Skowhegan was my summer camp," Midgette mused.

In 1953, when he was sixteen, he had met James McGarrell at Skowhegan. McGarrell was twenty-two, and on his way to graduate school at UCLA. Seven years later, Midgette would be among McGarrell's first graduate students at Indiana University. After his marriage to Sally Driver and his MFA from Indiana, the young Midgettes sold a print by German Expressionist Lyonel Feininger that they had received as a wedding gift. It brought them enough money to live in desperate frugality for a year just outside of Florence, where Midgette could see the originals of paintings he had loved since childhood.

Over the next few years his pictures ranged from tiny still life paintings to vast painted environments. Later in his career he would take on impossible subjects: a Native American powwow (in the permanent collection of the Roswell Museum and Art Center), a Navajo *pietà*, a New York subway, all saved from schlockiness by Midgette's command of painterly techniques. Through his very love of the act of painting, he continued to pay homage to the old masters he revered. A few years later Luis Jiménez (former resident) would address similar subjects in his stunning resin

Bill Midgette, 1969. Photograph by Bill Midgette. *Courtesy Roswell Artist-in-Residence Program archives.*

CHAPTER ONE

sculptures. "People told me that serious artists don't make art about cowboys and Indians and buffaloes," says Jiménez. "Well, some of us do."

Beyond the accomplishment of the remarkable *The Henge* painting itself, Midgette's time in Roswell was notable for incarnating a version of the RAiR Program's best self.

Don Anderson comments: "Bill helped a lot in organizing the Roswell program; he got us going professionally, and made contacts with artists."

Sally Midgette Anderson recalls:

When Bill and I came, there were only three houses on the compound —the original farmhouse, another that had been moved in for resident artists, and one for the program director. By the time we left, three more had been added, some with two studios.

Larry Kozuszek had been hired to replace Lee Johnson as assistant director of the Roswell Museum and as program director of the residency; he and his family became friendly with the Midgettes. For the first nine months of 1969, the Midgettes and the Kozuszeks were alone on the compound, although intermittently artist visitors would stop by. This was the year that Bill was working on *The Henge* mural.

Midgette's notes on the "artists' talks" between himself, Resnick, Passlof, the Reeds, and Richard Mock remain a palimpsest of that time and place.

Musing on his own work after a night of intense conversation, Midgette wrote:

(Resnick) is so solidly in the modern tradition deriving from a fantastic artist's appreciation of the artist's problem, making the picture work; he so clearly feels the triumph of each stage of the evolution— especially Cézanne's. It all just underlined my own separation from the tradition. I want to get a new way for pictures to work—the old way doesn't have enough emotional energy left for me. I can't close my studio off like that—I would rather dare for my other kind of content, challenge all the bad assumptions of "figure-painting" and all the great handlers of it, for the sake of construction, a painting that has its openness to include as many different sorts of content as painting can.

David Reed (1969–70)

David Reed was born in southern California in 1946. His studies with Bill Midgette at Reed College had been interspersed with travel and painting in Europe. Reed spent the summer of 1966 at Skowhegan, and

The Reed family and Anne Midgette (center) inside *The Henge. Courtesy Roswell Artist-in-Residence Program archives.*

the winter term at the New York Studio School where he had first met Milton Resnick.

"He showed me it was possible to live a life in which one's love for art exceeded one's love for the world," wrote Reed in a memorial for Resnick in 2004.[7] David Reed continues:

My memories of the time that I spent in Roswell are entwined with memories of Bill Midgette. He was my teacher in drawing and painting classes at Reed College in Portland, Oregon. I was an obnoxious, opinionated art student. Refusing to do the exercises he assigned, I told Bill that I couldn't see gradations of value and "didn't believe in modeling." He let me draw my own way, even encouraging my preferences.

I took a class at the Portland Museum School, as part of the existing exchange program, and was thrown out for behaving in the same way. Bill arranged for me to graduate with a major in art from Reed College, a first. As part of an "anti-art" festival, I once organized a prank with friends that nearly got me thrown out of Reed College. Overnight, we painted the facets of Buckminster Fuller's historic geodesic dome with varied bright pop colors—quite a surprise for students and teachers arriving for art classes in the morning. Later I found that it was only Bill's advocacy that kept me from being expelled. In Roswell, Bill was my next-door neighbor. He talked to the FBI after they surrounded and raided my house. We had a visitor whom the agents took to jail. Our phone had been tapped and the FBI thought that we were part of an underground railway smuggling anti-war activists to Mexico. Another time, a group of carpenters, needing to make a repair, came into my studio to find me asleep on a cot in the middle of the afternoon. I'm still embarrassed to remember that I pretended to remain asleep while they banged around. Did Bill convince them that I wasn't just lazy, that after taking a nap I could wake up and see the paintings in a fresh way?

Bill Midgette's inspiration and attitude about art allowed me seriously to consider becoming an artist. Upon graduation from Reed, I went to New York. In 1969 my wife Judy, also a painter, and I had our son, John. Soon after, we moved to Abiquiu in northern New Mexico. We lived and painted there for a long summer. I painted the mountains, skies, and trees that I could see from the house, and abstractions based on the landscape. At the end of the summer, Bill invited me to visit Roswell where he was living and working. He arranged for me to show my paintings to Don Anderson, recommending that I receive a grant. He knew how helpful it would be for me to paint away from commercial and life pressures, and to focus on my work in a place where I could interact with other artists.

Living next door to each other, and working in adjoining studios, Bill and I saw each other often—at least several times a day. The year that I spent in Roswell became an extended lesson in art, and, more importantly, I saw an example of someone being an artist in a fully human sense.

Bill, unlike other artists I had known, had a full life. He was a father and family man. He was involved with the wider current culture, fully engaged. He photographed the local landscape and environment. He especially loved the big spaces and the light of the plains and mountains around Roswell. We would sometimes drive to the local bird sanctuary in the early evening to watch the open spaces in the

changing light. That summer he also became obsessed with the local Connie Mack League baseball team—high school students who played on a semiprofessional level. He went to most of the games and we sat many afternoons and evenings in the bleachers, while he talked with fellow fans, often the families of the players. He was on a first name basis with almost everyone, greeting them as he came in—"How's the big left-hander?"—talking over with them the controversies of previous games. Because of him, my long hair was tolerated and I also received a welcoming nod. Once someone a few rows ahead of us yelled at a passerby to ask why the usual third baseman was not on the field. Bill called down that the player and his family were visiting relatives in Oklahoma. The Roswell team did very well that year, making the playoffs and nearly winning a national title. I'm still learning from those lessons about how an artist can be part of the world.

In Roswell, Bill organized what he called "slide evenings" for talking about art that interested us. We projected slides of old master paintings, as well as more current art on a home movie screen set up in his living room. There were some especially memorable evenings with other artists who had been invited to Roswell: Pat Passlof, Milton Resnick, and Richard Mock. Bill pushed Milton, asking questions until Milton articulated the point of his stories and enigmatic phrases. Bill kept a journal of these discussions. He wrote, "I suppose most artists ultimately support the pursuit of their profession with a sense of ability or gift, of their faith in their ability at some gut level to do good work—my only support is my intelligence." It was this intelligence that prodded us and stimulated our discussions. We talked about Rembrandt, Rubens, Titian, whether Cézanne's crudity was intentional or not, Milton's meeting with Soutine's family, de Kooning's return to the figure, the "eye" in Gorky's paintings, the ground in relation to the mark, transparent paint and transparent studio walls, the problems and possibilities of collage, artists' talks and studio paintings. For me, it's enlightening and upsetting to reread copies of Bill's journals that I kept from September 1970. I'm brought back to those times and reminded that those discussions remain unfinished but still relevant.

Bill and I visited each other's studios often. I especially remember one particular visit. We sat and looked at a large, nearly finished painting of several life-sized figures in what seemed to be an illusionistic extension of the studio. Bill was having trouble with the painting and felt that it somehow didn't work. I made suggestions and he made the changes right then on the painting as we spoke—moving a leg, putting a piece of paper on the floor to clarify the floor plane, increasing the light coming in through the window, changing the color of a

shirt, lightening a shadow. Of course, none of my suggestions really solved his problems with the painting. In the end, he painted them all out. But Bill said that my suggestions shook up what he was doing in a way that was helpful and led him toward solutions. We learned that we could tell where the problems were in each other's work, but that we couldn't provide solutions because our ways of working were so different.

Looking back, I'm amazed how much he trusted me, despite our different points of view—the way that he encouraged me to become a peer instead of a student. Much to his consternation, I had continued to call him "Mr. Midgette" after leaving Portland. It was in Roswell that I finally trained myself to say "Bill."

Reed tried to understand the space in his own paintings through looking at and into the landscape with great intensity. While painting at Oljato (on the Navajo reservation near Monument Valley) he found that he was beginning to see the landscape "in a new way."

> There was a lone tree above the spring where I lived. I painted it at sunset. I found that there was a kind of light inside the tree. If I painted in the right way while seeing this light, the tree would release the light to me and it would do me good. I began to feel that Christ was inside the tree and every other object in the desert, waiting to be released.[8]

Reed hoped that his painting would somehow set free this holy light, revealing it to others. He found that the paint itself, rather than any subject, contained the spiritual charge he hoped to convey. He adds, "I liked this— it was so clear and the painting was a vessel in which I could grow."

He found this luminous thrust again in Italian Renaissance painting's attempts to depict the grace of redemption in, say, Mannerist drapery, the robes of levitating angels and Venetian courtesans: a length of taffeta crumples in the air in front of towering clouds, reflecting and emitting radiance. A loop of movie film snaps, curls, floats. These nonfigurative forms that dwell somehow apart from Reed's rich and layered surfaces, the gestures of his brush- or squeegee-stroke, are the marks of reflection in all its senses. To some degree his willingness to follow such forms was shaped during lengthy conversations between himself, Midgette, Richard Mock, Milton Resnick, and Pat Passlof in his year as an artist-in-residence at Roswell.

Reed's later work plays with notions of dimension, narrative, and illusion, suggesting multiple approaches to a single painting. Enigmatic and haunting, Reed's pictures continue to celebrate the spiritual and sensual

nature of paint itself. He has described his work as "a conversation with the artists of the past: we agree or disagree, but carry on a dialogue."[9]

Milton Resnick and Pat Passlof (1970–71)

Milton Resnick (1917–2004) belonged to the heroic generation of New York Abstract Expressionist painters who came to prominence in the 1950s and '60s. Born in the Ukraine in 1917, he emigrated to New York with his family when he was five years old. After his father refused to let him be an artist, Resnick left the family home at age fifteen. He never stopped painting, despite an economically precarious life, producing lyrical, nearly monochromatic paintings that are passionate explorations of light, space, and the voluptuous qualities of the materials at his disposal.

Midgette had presented a show of Milton Resnick's acrylic sketches at Reed College in the late '60s. "Just starts," Resnick would say later, characterizing them as works pushed to the point where something interested him enough to stop painting and keep what he had set down. David Reed spoke eloquently about Resnick's importance both as mentor and artist. The two young painters suggested that Anderson offer a joint residency to Resnick and his wife Pat Passlof.

Pat Passlof replied to the invitation on behalf of Resnick and herself: Resnick would be willing to teach a seminar. They could not afford to come for less than seven thousand dollars. Passlof recalls their initial diffidence:

> Milton at first hesitated to accept the offer from Roswell, then decided to go for only two or three months. We, in fact, stayed for nine months and could have stayed a year, but Milton got restless. When Milton first received the offer, I told him I would not go unless there was a place for me to paint, too. I called Roswell about this and the result was the first house in the compound with two studios. Don had it built especially for us and the grant was expanded from one to two as well.
>
> We drove the nineteen hundred miles from New York to Roswell in our rusty Citroën wagon, more or less from one Citroën service [station] to the next.
>
> We were counting on finding a Citroën mechanic right there in Roswell. We limped in, having lost the leveler somewhere after Fort Worth, six hundred miles back, and drove straight to the Citroën service station, where the manager told us he no longer serviced Citroëns. When the museum called the manager, he said, "I thought they was a couple of hippies—send 'em back." (Milton had a beard.)
>
> At the compound we met the group: Bill Midgette, Sally, and their two children; Dick Mock and his wife Eilene; David Reed and Judy (now Rifka), and their son John. We brought some supplies with us

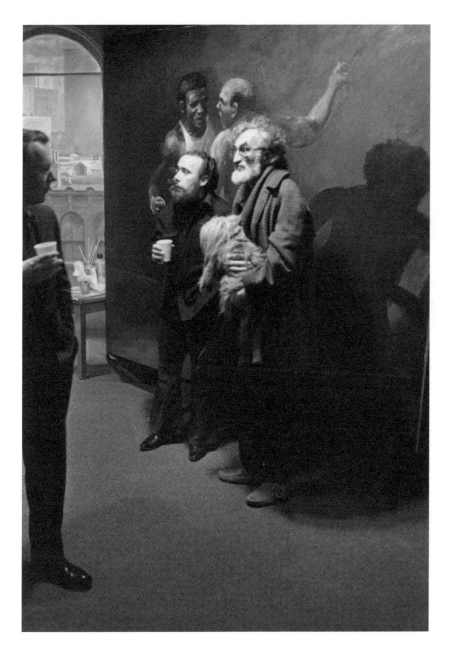

Milton Resnick and Bill Ebie, inside Midgette's environmental painting, *The Loft. Courtesy Roswell Artist-in-Residence Program archives.*

and counted on a large order to be shipped from Rosenthal's in New York. (At that time, the grant also included materials.) We waited and waited for those supplies and scoured the state of New Mexico for oil paint. Eventually, I gave Milton my supplies so one of us would have enough to work with, and I took up ceramics with Eilene. There was an excellent gas kiln and I read up on its requirements and helped Eilene make a gas-fired Raku kiln. We also tried to dig a pit kiln

Pat Passlof. Photograph by Milton Resnick. *Courtesy of the artist.*

in the field adjoining the compound, according to a Native American model. The soil was hard as rock and everything that grew on it was either barbed or poisonous. Luckily, someone was working with a backhoe on the compound. We asked if he would dig for us. In one swipe he accomplished what would have taken us weeks. We did one firing, which was not very satisfactory.

Driving along a back road, I passed a cut exposing what looked to me like a very pure vein of gray stoneware clay. The beds I had seen before were not worth the bother because they had so much sand and gravel in them. I put a few buckets and a shovel in the wagon and went to look, and the first shovelful proved me right. At the same time and from every direction came many large centipedes that moved with uncanny speed and suddenness. The whole place was crawling in a most menacing way. I barely filled one bucket before I turned tail and ran.

We all read the State of New Mexico's pamphlets on the threatening wildlife with which we seemed to be surrounded. As a matter of fact, one morning I opened the door to find a very substantial snake coiled on the doormat. It looked to us like a rattler but turned out to be a large but harmless—or so they say—pig snake. In the studio, a black widow spider made up her mind to spin a web from the back of my painting at exactly the height your hand would naturally go to steady or hold the painting. Heartlessly, I destroyed her web several times and each time she rebuilt at precisely the same spot. I surrendered.

At the compound, the buildings were surrounded with lawns that had to be sprinklered, and the sprinklers were moved every few hours to water evenly. All the grass in Roswell was covered with a white film from the mineral salts in the depleted artesian basin over which Roswell was built. Through these lawns a very attractive fernlike creeper with tiny white flowers threaded itself. This delicate growth flaunted two- to three-inch thorns strong enough to penetrate a shoe. I had to weed it out so that our dog Ping Pong had a safe place to putter.

The two lane road west from Roswell cuts across the northern reaches of the White Sands Missile Range. It is not leveled, as modern roads are; instead it climbs up each of many steep hills where at each summit there is a sign saying "DIP," and dip it does, straight down

CHAPTER ONE

to where another sign warns of flash floods and sometimes of dust storms. The one I experienced was not out in the boondocks but about half a mile from the compound, for which I was heading in the car. The wind came up. The sky turned black, blotting out the sun so that, close as I was, I had to pull over—I could not see a thing.

I remember a quiet day when for some reason I was one of the few people at the compound. Don Anderson wandered in. We were by then devouring impressive amounts of paint. Don didn't say anything about that—he was just curious to know why we used such a disproportionate amount of white. I told him we did it to save money—to stretch the expensive colors."[10]

Don describes Milton Resnick's orgiastic pleasure at suddenly having enough good paint to do everything he wanted to do. "He would unscrew the tubes, drop them on the studio floor, and stamp his foot on them. Then he'd scoop up the color with a palette knife or a brush; the whole floor was his palette." (Here Anderson stifles mirth.) "We had to bring in a steam scraper to get the floor cleaned off after he left."

The grant had enabled Resnick to triumph, after many years of struggle, over the terrible irony of being a fine painter who couldn't afford the paints he needed to do his work. Instead of being appalled by Resnick's unrestrained consumption of materials, Anderson found it hilarious and charming.

Pat Passlof:
Rosenthal's had misunderstood our instructions and was holding the whole order until some back-ordered cadmium orange came in, so our supplies finally arrived three months late, allowing me to get back to the studio at last. Milt thought the delay saved his painting *Pink Fire*, for which the orange was originally intended.

We had our Lhasa apso, Ping Pong, with us. Sometimes, when I let her out late at night, I would see a fleeting shadow. At first I thought my eyes were deceiving me but when I compared notes with others, they had seen the same shadow. Not only that, but the shadow had performed feats of food theft. Someone saw her open a screen door and run out carrying a platter with a whole frozen turkey on it. She was a near-feral stray. I began to leave some dog food out for her. She allowed me to come close to her and I saw that she was pregnant. One day she came to me whining. She had porcupine quills in her face, nose, neck, and forelegs. I got a pair of pliers and some alcohol and followed her into the field—a little scared. Much to my astonishment she sat still and let me pull every quill. Someone named her Susie. She

dug herself under one of the houses and had her puppies. As we all watched, Milton squeezed in on his stomach and brought out puppy after puppy until there were ten. I was worried that she might attack Milton since she would be cornered and he would be unable to defend himself in such close quarters—but Susie understood everything. We all worked to fence in an enclosure between two of the houses at a height she could jump but the pups couldn't. I dearly wanted one of Susie's offspring, but Milton wisely said no. We were having a hard enough time supporting ourselves, and we had Ping.

We found an old (1902) boot and saddle store and made friends with the owner. She knew we could not afford the fancy custom boots they were making and told us that somewhere she had a box of old returned or abandoned boots. One day when we stopped by, there was indeed a dusty box full of tiny children's boots. But no, the old lady insisted, these were men's boots. The men of those days, she told us, never walked and prided themselves on their small feet, like the ladies of the Ching dynasty.

The man with the backhoe was in charge of some construction on the compound. Someone told him that Milton was a veteran, so he went to see him, making me anxious, but Milton was fortunately cordial. He took a liking to Milt and dropped in on him whenever he could. The two had several long talks. It turned out that this man was the head of the local Veterans of Foreign Wars (VFW) chapter and important in the town. At Christmas, the doorbell rang. I peeked from the shower, but couldn't come out. Mr. VFW had driven up in a pickup truck, not his usual backhoe. Milton didn't have his glasses on—he thought it was the garbage collector who drives a similar truck—and slipped him a couple of dollars. (In New York City, when a workman wishes you happy holidays, it is often in expectation of a tip.) The man was offended and left. I had one small lump of dough left in the fridge—just enough for a six-inch pie, which I made. I wrote a note, hopelessly trying to explain Milton's gaffe. We drove to the man's house. As we were looking for the mailbox, about twenty people came out in the snow and invited us in. His wife took my pathetic minipie, made a fuss over it ("Pecan pie!") and put it on a groaning board filled with huge succulent fifteen-inch pies of every description. The wife and sisters had been baking all week long.

None of this sounds as if we did much work, but we did, and good work too. Milton painted *Pink Fire*, now in the National Gallery of Australia, and many others. I painted *Keeping Still Mountain* and many others as well.

Kay Liakos, the wife of a local pediatrician, who had come to know several of the artists well, remembers her delight at hearing that Milton had been riding his bicycle around the local roads. At one point, he became so entranced looking at the beauty of the sky that he simply fell off the bike.

Wesley Rusnell (former resident):
I remember visiting the compound when Resnick and Passlof were there. Milton Resnick made us lunch. He had somehow managed to granulate carrots, chopped very fine, then mixed them with currants and beets, the brilliant orange and the deep purple—and he incorporated hard-boiled eggs, all that white and gold. They glittered on the plate. I'll never forget how beautiful it was.

Judy Rifka:
David Reed and I first saw Milton Resnick at the New York Studio School. He came into class looking like a scary street person, all tattered and unkempt, and then he began to talk, and went on for six hours, everyone abandoning their easels to listen to him, hanging on every single word he said.

"I come to you like a snake," Geoffrey Dorfman[11] quotes Resnick as saying during his time at the Studio School. David Reed was struck by Resnick's startling resemblance to the angelic and *maudit* Antonin Artaud,[12] whom Resnick had glimpsed and admired in Paris. Entwined with the potency and vision of his teaching, is the beauty and menace of the "harmless" big snake coiled on his Roswell doormat, an icon of the tempter, the adversary, the fallen angel, the enchanter who had the power to infect young artists with the venom or elixir of a lifelong passion for painting, a wound for which there is no balsam other than the ravishment that comes from making a good painting.

Pat Passlof recalls:
Milton knew David and Judy from the New York Studio School, but everyone was new to me and I liked them all. One day, Bill had to drive up to Santa Fe. Naturally, he wanted company on this eight-hour drive, and I volunteered. Knowing Milton's aversion to sightseeing, I thought it might be my only opportunity to glimpse Santa Fe. Sally tried to warn me that there was nothing to see on the way, but I went anyway. I actually enjoyed the muscular landscape with its brown stubble; it reminded me of a lion's back. I remember counting

the trees: there were fifteen in two hundred miles, every one at a pull-over spot consisting of one tree and an empty fifty-five gallon drum. I guess you could piss behind the tree or bask in its shade. But of course we talked—I, rattling on as I sometimes do when the pump is primed. The end result of that long ride, I believe, was that Bill invited me to teach at St. Ann's School back in New York.

[Some nights] Bill would invite us to watch and discuss selections from his ample slide collection. After everyone left, he would try to write down what was said. Back in New York, he gave me a copy of those notes—they were amazing testimony to his powers of recall and sharp mind.

A short time before the Midgettes left Roswell, I recommended Ken Kilstrom for the grant. It was perfect for him and his wife, Joy Soeda—and sorely needed.

Richard Mock and John Reed. 1970. Photograph by Bill Midgette. *Courtesy Roswell Artist-in-Residence Program archives.*

Richard Mock (1970–71)

Dick Mock came to Roswell in August of 1970 to visit David Reed and Bill Midgette; he had been friendly with them when they were all living in Portland, Oregon. Having just received his MFA from Oklahoma State, Dick was eager to pursue a radically new kind of installation art, using a large variety of materials. As Reed had been, he was amazed by the facility; he immediately applied for a grant and was accepted. At that time, there were four houses for artists, including those that had been moved in (from the air base, or from Midland, Texas) for David Reed and Milton Resnick. Mock moved into the house vacated by Bruce Lowney. Don Anderson then decided that he would like to add a fifth house, to create a slightly larger group (which also, from then on, usually included artists like Goodman and Lowney, who lived off the compound, across the field or downtown).

At the time that Mock arrived on the residency, he was working on large resin-dipped textile structures, far removed from the mordant political graphics for which he is best known today. Dick remembers:

> The art material that I was creating for my installations while on the grant was used to assemble four major exhibitions in Texas during my stay. I continued to use the materials for installations back in New York City from 1972 to 1980. The exhibitions done there from 1972 to 1974 were basically repeats of installations done in Texas while I was on the grant.
>
> Once I had the large vocabulary of shapes and colors, I was able to create for specific spaces with ease. I was looking for a highly manipulable colored material and discovered that the combination of colored pigment, latex rubber, and nylon worked well. It was also highly portable.
>
> With the money that I received for doing the exhibitions in Texas, I bought a 1938 LaSalle hearse, which my wife Eilene Mazur and I drove back to New York City filled with the material created on the grant. The hearse was previously owned by a doctor in Roswell.
>
> I want to say that the art dialogues that went on between Bill Midgette, David Reed, Judy Rifka, Milton Resnick, Pat Passlof, and myself were very illuminating and helped me form a clear view of where I intended to go with my art.

Darkness at the Edge of Town (1970)

Turbulence and paranoia from the outside world briefly penetrated the compound. A neatly dressed young man in a suit and dark glasses showed up, proffering a card imprinted with his name and the word "artist." The compound quickly spotted him as an FBI plant, thus delighting Richard Mock, ever the gadfly, who went to some trouble to provoke him. "Hey, if somebody wants to give me a million dollars, I'll start a revolution," Mock offered, mindful of the prevailing Cold War nuttiness. White Sands Missile Range and the air force base at Alamogordo were not far away, in terms of New Mexico distances. Who were these people on the compound at the edge of town? Druggies? Communists? What did artists do when they weren't making art? Or when they were, for that matter? Roswell then as now was a conservative town. Sally Midgette, Judy Reed, and other wives from the compound had participated in Another Mother for Peace marches, along with many local women who were outraged and devastated by the loss of life in Vietnam they witnessed nightly on television news. The Russian-born Resnick spoke passionately to anyone

within earshot about the life-and-death importance of painting. Finally, reassured or baffled, the FBI "artist" vanished, and life on the compound continued. The compound's first baby, Dameron Midgette, was born on March 10, 1970.

What this group seems mostly to have done is talk.

"I love talk," said Milton Resnick. "The world is too large without talk."

Bill Midgette's notes provide a unique and intimate glimpse of strongly opinionated contemporary artists reacting to the art of the past and, simultaneously, to each other's immediately contemporary work. After Roswell, instead of returning to his teaching job at Reed College, Midgette moved with his family to New York City, where he was scheduled to have his first solo show. His career blossomed over the next few years, before the onset of his illness.

Jonathan Williams writes about Bill Midgette[13]:

> How could this extraordinary man have died of a brain tumor at the age of forty? Extraordinary men, I am told, do it all the time, but we, typically don't want to pay that close attention to our scarifying, common frailties.
>
> A very interesting painter. He didn't smoke, he didn't drink. He was intensely physical. He was brilliant and ebullient. He was nervous as a cat. I don't know what that says.
>
> I met him in 1960 when he was a student of James McGarrell at Indiana University in Bloomington. And I knew him well in Taos and in Portland, Oregon (at Reed College), when he'd married Sally Driver. I knew them both, later again, when he was in the artists' residence program at the Roswell Museum in New Mexico. I loved his young family: daughter Anne and son Dameron. Again—one does not expect to be bereft, just like that, of one's stunning contemporaries.
>
> Bill wasn't a gay man, but he was so sympathetic to me at a time when things were really miserable in my life that it didn't matter what he declared himself to be. He was there. I won't go blithering on that there are no gay men or no straight men either. There are what we call *friends*, i.e., friends in need.
>
> More importantly for you: his paintings are *there*. They are of an order that deserves all your respect and attention. Go to the Roswell Museum for a start. I tell you, if we can't pay attention to art of this quality, why does the poor perishing republic think it has any reason at all to go on?

David Reed continues:

First compound baby, Dameron Midgette, at seven months. *Courtesy Roswell Artist-in-Residence Program archives.*

The mural that Bill painted of Don's family is still in *The Henge*. Along with the life-sized figures of Don's family and the Roswell landscape, Bill painted himself, also life-size, painting the mural. Entering the room, a surprised viewer sees Bill turning, brush in hand, perhaps a little angry to be interrupted while painting. The viewer soon understands that the figure is just a painting, but just for a moment we are surprised—thinking that this painted figure is "real"—that Bill is still there in the room, still painting. The other figures depicted in the mural seem caught in time, figures from the past. The figure of Bill also hasn't aged since 1970, but, still painting, interrupted, he seems also in the present. Bill used *trompe l'oeil* techniques—"tricking the eye"—in the mural to raise the questions about art and reality that we debated. His figure seems still alive in the present.

I'm a little afraid to see Bill's self-portrait when I'm next in Roswell, but I'll get up my courage and go into *The Henge*. Bill certainly is very real to me despite his premature death. I realize now how young he was, and how much we lost by not having him with us. He's often there in some way while I'm working in the studio. He encourages me to ask questions and to be articulate. I just wish that I could invite Bill over to show him my current paintings.

Reed, in an essay dedicated to Midgette, writes, "Tradition need not be thought of as a kind of Oedipal struggle. Making art, like experiencing

Howard Storm, detail of *Kenneth Kilstrom* (fellow resident). 1971. 12" x 16". Acrylic on canvas. *Courtesy Anderson Museum of Contemporary Art.*

art, is a kind of conversation with the past—a conversation that continues despite death, sometimes even seeming to defeat it."[14]

Kenneth Kilstrom (1970–71)

Ken Kilstrom was the last of the group of artists who had applied either because they were personally acquainted with the Andersons or with one of the artists already on the grant. He and his wife, Joy, were friends of Milton Resnick and Pat Passlof in New York City. His paintings were filled with angels and wonderfully strange, naive figures. He also enjoyed the open landscape of the compound and the possible kinds of recreation available. He had a habit of coming into Bill Midgette's studio asking him if he'd like to play a game of badminton. (At the time, Midgette was scrambling to get ready for his first New York show and was not receptive.)

The interactions between those four families—Midgette, Reed, Resnick-Passlof, and Mock—each arriving at a different time, formed friendships that have lasted, not least perhaps because of the quality of the conversations, whether as discussions during Midgette's slide evenings, or casual encounters on the way to the studio. The dialogues seem to have been deeply influential for each artist, which is remarkable considering how different their styles and philosophies were.

The constantly evolving kinds of interaction formed a pattern that has persisted through the years: there is often an ongoing dialogue at the compound, and it may change radically with the addition of each new personality.

After about 1971, artists began to apply because they had heard about the grant by word of mouth, and later, because of ads in the newsletter of the College Art Association. As the number of applicants increased dramatically the role of the screeners (initially the staff of the Roswell Museum and Don Anderson) gradually became important.

CHAPTER TWO
(1971–79)

Rites of Passage

In the earliest years, the Artist-in-Residence Program consisted of families and groups who were either friends of the Andersons or of artists already in Roswell, interacting in various ways. As the families left one by one, and other artists were added to the mix, a characteristic pattern of ever-changing relationships began to establish itself. The group was always evolving, and the social patterns also shifted, depending on the pressure to work and on the personalities of the artists and their families. And there were often loners.

Lee Johnson was the first program director, but he left in 1968, to be replaced briefly by Larry Kozuszek. Larry left to accept a teaching job in 1970, and his replacement was Bill Ebie, who served in that position for sixteen years. Bill lived on the compound with his wife, Gwyn, and their two children, Jason and Alexandra, were born there. The Ebies were tirelessly involved in befriending and helping the artists.

Francie Rich (1971)
Francie Rich came to Roswell at twenty-four, directly from graduate school at the California College of Arts and Crafts. Francie was then working on small etchings, witty and lively, of people interacting and laughing together, which she hand-colored to create extra depth and subtlety. Later she became allergic to the solvents and had to give up printmaking.

There was plenty of interchange between artists at this point. Francie remembers lying on blankets outside, with many of the other artists, watching the stars.[15] Once they even got to watch a full lunar eclipse. She spent much time outdoors, and devised a system of extension cords for

Francie Rich. *A
Special Occasion.*
1989. Gouache on
paper. 11¼" x 15".
*Courtesy Anderson
Museum of Con-
temporary Art.*

her portable electric typewriter, so she could write letters and stories out-
side. She remembers riding her brown three-speed bicycle on the highway
(she didn't have a car), and recording her dreams every day she was in
Roswell. Her memories of *The Henge* are also vivid.

Dick Mock became a mentor to her and taught her to use a camera
and the darkroom, although "the only photos I have are of the sunsets." He
also instructed her in the basics of astrology and the Kabala. She adds:

> While in Roswell, I got a job offer at Nicholls State University in
> Thibodaux, Louisiana. After New Mexico, my dream was to see either
> Russia or Louisiana, and I wasn't offered anything in Russia. Much later
> we discovered that my husband (John Hodge, a potter) had applied
> for the same job but was told it had to go to a woman. I had applied
> for a job as artist-in-residence in the New Orleans public schools that
> my husband got.

She and her husband still live in that area; she, too, is now a ceramist.
They fortunately survived the 2005 hurricane Katrina with relatively
little damage.

Bruce Lowney (1974–75)

Bruce Lowney was invited to return to the grant in the mid-'70s. Bruce recalls:

> I was so grateful (to return), to be there on the grant, out of an unhappy marriage, out of coastal California's fog, able to concentrate on prints, and to start painting. In gratitude to Don, I presented him with a print from each of the early editions I did there.
>
> In 1974 the lithography shop (by then installed at the compound) was unused, so I was invited back a second time. Understanding my need for solitude, they housed me in an old ranch house in the middle of an alfalfa field just south and west of the compound. I worked on prints as before, and did more paintings.
>
> When I left at the end of my time there I moved directly onto land I had bought in west-central New Mexico. There I lived in a tent while I built my house/studio. Except for a few stints as guest artist at universities, and a tour with the Peace Corps, I have been there for these past twenty-seven years. I am still building structures, still making editions, and still working on paintings.

Frank Ettenberg (1971–72)

Two months after Francie Rich departed, the painter Frank Ettenberg arrived from Santa Fe. He had recently completed a Master of Arts in painting at the University of New Mexico, and also worked producing lithographs and monotypes. Frank says:

> I prepared myself for the time in Roswell as if I were a soldier, about to embark on an important campaign. The "general" had chosen me; now I had to be worthy of that trust. Or maybe just be the fine boy my mother always said I was.
>
> I got my grant as a runner-up. The director let me know this. So I hadn't been chosen straightaway. This gave me a sense of having won the lottery, instead of really having had my work appreciated. And this sensation gave rise to a bit of paranoia.
>
> I didn't feel too close to anyone I met on the compound. I was the only single one there; the other artists were all married. Maybe that's why I felt so alien to the others. I was also younger and probably not so well adjusted as the other families. So I worked days and sometimes nights. I felt grateful for the chance to break through my work and color-slump. I was so entirely fixated on my work and being drawn steadily deeper into my solitary condition that I didn't even travel to Albuquerque to go to the old haunts I'd left behind.

When I found around halfway through my time there that I could talk to my father, who'd died six years before, I was opened up and in some way healed, able to grieve. I hadn't been able to let go of my anger at him around the time he passed, and no one in my family could come forward to console me, any more than I could feel free enough to go to them for understanding. The experience with him was this: his ghost was friendly and accepting, both of his fate and of me, so I was reached by his gentle and tender spirit. This was entirely unexpected, but I was melted by it. I also wrote about it, needing to hold on to this experience.

I loved seeing Capitan, the mountain ridge, in the distance; it was easy to see why Howard Storm painted it so often. It looked to me as if the road we were on, Berrendo Road, was built heading west, and should have gone straight to the mountain, like the rainbow curving down to the pot of gold. I was disappointed to hear that the road curved away from the mountain and didn't really travel any great distance.

I felt jealous of the artists who kept regular company with Don, who seemed to be his friends. I wondered how I could captivate or cultivate him. But in truth I was too intimidated by him, put off by my own fear of being beholden to a strong man. Just shows how little confidence I was capable of feeling, at the time when I might have been able to visit with him. I lived only a ten-minute drive away from him, but I never invited him to my studio. Once I did have a visit from him,

Frank Ettenberg in his studio. 1973. *Courtesy Roswell Museum and Art Center.*

and that happened spontaneously, not as a result of a prearranged appointment.

I met another artist on the grant who was bent out of shape when he thought about Don offering money to artists to come to work in Roswell. I was aware that this artist had very strong negative feelings, and that they didn't get expressed too clearly. I thought the man was clearly neurotic. How could he be so ungrateful? But I was twenty-seven or so when I got to Roswell and still hadn't gone through too many of the usual things (i.e. love and marriage, having kids, needing to be a breadwinner, etc.) that mess up artists' lives. I also could not understand what was bugging me in my life; I was feeling bad and didn't know what to do about it.

It's my judgment that Roswell is not an easy place to come to if your life has not been going well on an emotional level, especially if you've come from a city. It really is like going to a desert island. Things must come out and they come forth so intensely, that all the stuff may not be heard, or if it is heard, it may not be properly understood. But it's also my judgment that the work, and this relief we get from having to waste our time feeding the art habit—the work does take us over when we work at the compound. We can and do come up with great stuff that might not have come out so easily before we landed in this wonderfully nowhere place. That's why I know that so many of us recipients do leave the program with an extraordinary degree of gratitude for having been there.

Frank is presently living and painting in Vienna, with his Austrian wife.

Luis Jiménez (1972–73, plus five more years)
Shortly after Frank left, Luis Jiménez arrived. Growing up in El Paso, he had received his Bachelor of Arts at the University of Texas at Austin in 1964, and went on to New York, where he quickly became successful and showed in several top galleries.

Luis was one of the pivotal figures of the Artist-in-Residence Program. During his residency and in the years after, he ceased to be an artist who displayed and showed his works exclusively in the gallery context, and established himself as a major creator of public works: monumental fiberglass sculptures displayed in public spaces. As he says, his grant lasted (technically) from March of 1972 to March of 1973, but he stayed in Roswell for a total of six years, sometimes living on the compound, sometimes in one of the other buildings that Don Anderson owned. Luis tells the story:

I grew up in my father's sign shop in El Paso from the time I was about six. I got to know the materials, and once I scraped my hands raw on the rough cement when I was helping make a cement polar bear. We would also go to Mexico City, where I saw the murals and the ancient sculptures. I learned to see art there.

In El Paso we lived in the last house next to the mountain; I was a loner kid who was close to animals. I learned to stay still and watch them. My male bonding with my father was through hunting. I still hunt, and I still love animals. Once, on the compound, I had some puppies outside and a bunch of ravens started to dive-bomb them. I grabbed my bow to chase them away, but one of them didn't go. I kept teasing him with the bow-lacings. He was very young, just out of the nest, so I was able to catch him by the feet. He hated that. He screamed, but I held on and got him into the studio. I named him José. He was a smart bird, a talker. I told Ted Kuykendall, my assistant, not to teach him any bad words, because of the children—but of course he did it anyway. Once a bird learns to say something, he'll never stop saying it. When I left Roswell I took him back to El Paso, to my father, and asked him to keep him in the big cage I'd built for him. But my father let him out, and he flew away. Maybe he's still flying around out there someplace.

Growing up on the border, working in the sign shop—that was a good preparation for surviving in New York. There was something familiar there—the hustle! New York is still a community of artists, but the light's not there.

It was about 1971; I'd had a couple of shows in New York, first at the Graham Gallery, and then at the O. K. Harris Gallery. I decided I needed to make some larger-scale works, public pieces that people could see without having to buy them. I had in mind the piece called *End of the Trail: Electric Sunset* (now in the Roswell Museum). Ivan [Karp], my gallery dealer, said he'd send me some money to make it, but it was a hard gallery year, and finally he couldn't do it. I couldn't even afford to buy the clay for it in Juárez. I dug it up, raw clay, in New Mexico.

About the same time, the gallery where I showed in Austin folded and my work was in storage there. I knew I had to retrieve that work or I'd never see it again. Meanwhile, I'd heard rumors of an art foundation in Roswell, so I wrote to the museum, asking about it. No answer, but I came anyway. I borrowed my father's work truck, loaded the sculptures from Austin into it, and headed for Roswell. I'd learned Don Anderson's name. When I was about fifteen miles outside of town, I phoned his house. He answered the phone and said, "I'm not

interested." I came into town anyway and got directions to the compound. Bill Ebie was in California, but I found a guy named Dick Mock there, and he told me how to get to Don's house, three miles to the east. The approach to the house was intimidating, with "No Trespassing" and "Private—Keep Out" signs. Somehow I made a wrong turn and ended up at the caretaker's house. She saw my truck—my dad's truck, with "Neon Signs" and "Electrical Work" painted all over it, and she said, "Oh, you need to talk to Mr. Anderson; I don't know what he wants you to do." "Yes, that's who I want to see," I replied; then she led me around to the front door. Don said, "I didn't call any repairman." "No, I'm the artist; I talked to you on the phone," I said. "I'm not interested," Don replied. I said, "You haven't even seen the work!" He looked at slides, and he saw the pieces I had on the truck. He said, "This is good work." I told him what I wanted to do, that I needed about five thousand dollars to cast the big piece, that I had the promise of a teaching job at New Paltz and I'd be good for it, that he could have any of the work minus the dealer's percentage. He could have anything

Luis Jiménez in his studio, early 1970s. Photograph by Ted Kuykendall. *Courtesy of the artist.*

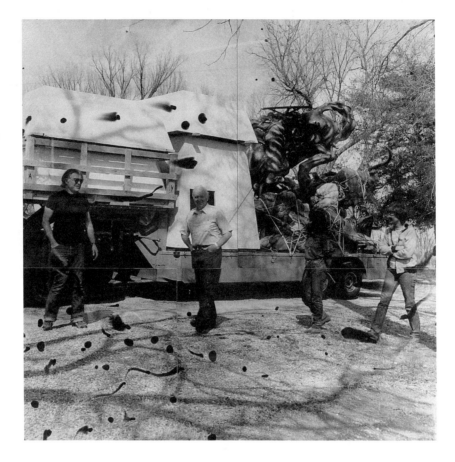

(L to R) Luis Jiménez, Don Anderson, unknown, Sally Anderson. 1989. Photograph by Ted Kuykendall. *Courtesy Anderson Museum of Contemporary Art.*

for 60 percent. He asked me to call back in two weeks, and I did. That was how I was invited into the residency, through the back door.

I'd sold enough from the earlier shows in New York that I felt I could quit my job—a good job, working for the youth board in New York City. One of the pieces I showed Don then was *American Dream*. You might not know that it's based on creation myths, like the Olmec myth of the woman and the jaguar, or classical myths about bulls and women—Europa, Pasiphae. The car is the god.

I really wanted to do public works; I had the idea for *Progress*, a series of six works. Don asked me what I needed. I needed a nice big shop, one or two assistants to help with the casting, and some money to live on. "How long?" he asked.

I thought I could do six pieces in a year. As it turned out, I lived there six years and did two pieces, *Progress I*, of an Indian killing a buffalo and *Progress II*, of a cowboy roping a cow; both now on permanent display at the Anderson Museum. Ted Kuykendall (former resident) was one of my assistants; later he was on the grant himself.

The house where I lived on the compound had two big studios, and for a while I lived at the house on Mescalero; then after some years I used Don's building downtown at 121 East Third Street. He told me I could change anything I needed to change—take out walls, cut through the floors, anything. He'd talked about my maybe getting a hangar at the old air base. That sounded good, but it didn't work out. At one point he talked about moving boxcars in, stacking them around the compound to make studios and houses. I think the neighbors stopped that before it started.

On the compound, sometimes I covered my studio windows with paper. People thought it was because I used nude models, but it was really because I had a dead deer hanging in there, or because I was butchering a deer, dressing it out. Ben Goo (former resident) hunted birds back then and always hung them outside for a couple of days. Some people—vegetarians—were upset.

Don's patronage was extremely important—almost incomprehensible. He's truly interested in artists and their development, maybe more interested in the artists than in the art. Yes, he's a collector, he has a collection, but it's almost as though that, too, is for the artists rather than for himself.

After Pat Anderson died (in September 1978), I went to see Don a couple of weeks afterwards, to tell him how sorry I was, and how sorry I was to have waited two weeks before telling him so. "You don't have to be sorry," he said. "Nobody else has said a word." I thought that was the saddest thing I'd ever heard. But, kind and generous as he always is, I think people were intimidated by him—literally afraid of intruding on his privacy or his sorrow.

When I went back to El Paso after meeting Don that first time, the letter from the Roswell Museum had finally arrived. It said there wasn't any place for me. It's a good thing I didn't get it before I went to Roswell. I'd never have come.

In June of 2006 the community of artists was plunged into shock and grief by the news of Luis Jiménez's death from injuries sustained in an accident at his studio at Hondo, New Mexico. A few days later, the funeral procession would set out from that same studio.

Sally Anderson: "There were fifty cars in the cortège. Every one of us was weeping."

Stephen Fleming:
They carried Luis out to his old truck, the one he used to lift and move his sculptures. With the pallbearers sitting in the back with the coffin,

their legs dangling over the side of the flatbed, and a state trooper in the lead, we made our way down to the highway and across the little river, back into the hills where Luis loved to hunt.

The burial was in a hand-dug grave out in a little canyon a few miles from the studio. Two guitar players provided the saddest Mexican folk songs you ever heard. Millionaires and illegal immigrants, cowboys and artists, and local 'Spanish' folks from the Hondo Valley composed a group portrait set among the rolling, rocky hills that Sam Peckinpah or John Ford would have killed to capture on film. I haven't felt so bad since my mom died.

Like the rough and simple place he lived, Luis Jiménez already seems as legendary as the West itself.

Controversial, vivid, passionately loyal to his roots and to his vision, Jiménez's legacy resides not only in the multitude of potent images he created out of memory and yearning, but also in his incarnation of what an artist's life can be, with its multiple human struggles, triumphs, and losses. He perished in the act of making one last monumental sculpture. There are no good deaths. He was sixty-five years old, rich in energy and ambition, and with works planned for years to come.

Susan Cooper (1972–73)

The word of mouth continued to go out from artists who had loved their experience in Roswell. Shortly after Luis Jiménez arrived, Susan Cooper applied for the grant and was accepted.

Susan Cooper, from Berkeley, California, is a realist painter whose work subsequently evolved into three-dimensional works, and, more recently, into full installations in public spaces. Susan:

> My experience in Roswell changed my life in every way, irrevocably. At twenty-five in 1972, I was one of the first women artists-in-residence. Had I been older, I might have used the time to achieve a direct goal. Yet, because I was so young, the experience had the consequence of molding my life thereafter. The biggest gift was to be able to work as an artist full time. I learned that I could spend all available time in a studio, productively and happily. That is important to know, rather than to imagine. And it is helpful to learn that early in one's career.
>
> Only one painting, completed toward the end of the residency, became a more involved focus for me; this was *Twenty-Fifth Session*, which was bought by the Roswell Museum. Still, I had to go through all that painting eventually and without the grant it would have taken years. In undergraduate and graduate school at Berkeley, we were

taught only the most current avant-garde techniques. I knew how to vacuum-form plastic, but I didn't know how to use paint. After I got my Master's, I wanted to use oil paint. So the time in Roswell was largely spent learning to do that. I continued my lifelong interest in still life and perspective, which persists to this day. In subsequent years the still life became large paintings; then they became high relief, followed by illusionist sculpture. This eventually became public art; that then began another evolution.

Susan Cooper. 1971. *Courtesy Roswell Museum and Art Center archives.*

Gwyn Ebie was a ceramist. She made her materials and equipment available. In the nighttime I would do ceramics. I truly worked around the clock.

I had never been able to use cadmium colors because of the expense. Finally I could use the best materials that facilitated better painting.

I liked going to cowboy places and watching the dances, both the cowboy waltz and square dances. This was an exotic new culture for someone from Los Angeles. The clothes, dancing, speech were so different.

Another new discovery was birding. Some of the compound artists would occasionally go to Bitter Lake, the nearby wildlife refuge, to see the sandhill cranes and snow geese come through. It was spectacular to see and hear these huge birds whose sounds, flight patterns, and shapes were uniquely beautiful. We also took a trip to Carlsbad Caverns. El Paso was another destination. It had a real delicatessen. Across the border was the very colorful Juárez. White Sands was a good trip as well.

The landscape was a profound change. I loved being on a vast plain because the horizon was in sight, just as it was at the ocean [in California]. Only, the desert horizon was more colorful and had more variety as it receded. Capitan sat in the distance, never appearing the same way twice. It appeared to be a single mountain although it is actually the end of a range. The sunsets were evening entertainment. The wind was also spectacular. Once I had to give up walking across the compound with a large painting, in fear of becoming airborne.

After a few weeks, Elliott, my Siberian Husky, was shot to death for killing sheep. After the shock, I stayed in for a few days; [then] I went up to Santa Fe and got Apple, a Husky mix puppy who I had for nearly fourteen years. Apple grew up at the compound. When he was around six months old he fell into a pool of lime mud, used to drill water wells. This scratched his corneas and he had to have antibiotic

drops every hour through the night. Another time he ran off and returned unrecognizable. His face was covered in porcupine quills that had been aimed at him when he got too friendly (or hungry).

The most impressive personality in Roswell was Don Anderson. To meet someone who would actually help artists without a reward was totally unique. My own parents highly disapproved of my career choice. Here was a man who would encourage it. Don was so generous in a quiet, helpful way. He was so intelligent and could talk about anything. His eyes still contain electricity. Pat was his poetic and warm counterpart. I loved seeing them at openings with Donald and Joseph, their sons. When I first saw Joseph he was nineteen, the same age as his son is now [in 2003].

When my six months were over I did not want to return to California just yet. I became an artist-in-residence at Yaddo for six weeks. Then I returned to Roswell to house-sit for the Cooks when they returned to their Taos home for the summer. I lived in their house for around three months with vinegarroons, mice, and Apple. Apple's worst habit at that time was car chasing. When he ran after Joseph Anderson's yellow pickup, Joseph stomped on the brakes to tell me that he would not kill my dog. That began long conversations, walks, and a strong friendship between us.

I eventually went back to Berkeley, but I missed New Mexico, so I left for Santa Fe in the spring of 1974. Through Don I got a commission from the School of American Research. I had other jobs as well. During that time, Joseph and I fell in love and moved together to Denver, where we married in 1976 and had two children: Martha Cooper Anderson Strieby, born in 1979, and David Gaylord Anderson, born in 1984. The marriage lasted until 1990. After the pain of divorce subsided, we remained very close, especially regarding the children. His illness and death in 2001 was the saddest experience of my life.

Now Don is grandfather to my children. And he enjoys them very much. They have many of his characteristics: keen intelligence, creativity, sense of humor, love of travel, sensitivity to nature.

Susan has remarried and lives in Denver, where she is pursuing a variety of projects in the domain of public art and continues to have a successful career.

Wesley Rusnell (1973–74)
Wesley Rusnell arrived as Susan Cooper was leaving, in March of 1973. He had been living and painting for a long time in Taos, an even more isolated environment than Roswell. A realist painter and outstanding colorist, he

had been showing his work widely in New Mexico and neighboring states. He came with his wife Beth and two young children. Wesley reflects:

I'd been living in the country outside Taos. When I came to Roswell I was unused to living in a neighborhood or community, unique as this one is. I had to get used to the contrast, and also to the interpersonal dynamics. There's such an intensity of focus on the compound—it's almost incestuous. A part of the intensity may come from people's being unprepared to be plunked down in a small town in the middle of nowhere. But when it flows, there's such a spontaneous grace. The residency is so much a matter of chemistry, good or bad chemistry. The paintings I did at the compound—and doesn't that name, "the compound," tell you something about the isolation, the austerity, the feeling that you're huddled together against hostile forces from out-side?[16]—paintings from that time have a strictness and coldness that they never had before or since.

In the spring of 1973 Luis Jiménez and (his then wife) Cynthia were there; it was a prolongation of Luis's grant, his "visiting" period. He had a lot of independence about being on the grant, and this was a source of tension between him and Bill Ebie. Unspoken, but present. And there were other dynamics, infidelities, everything going on in the small space of the compound—an intense little community.

One New York couple had an exquisite medium-sized male poodle, another resident had a big Siberian husky, and they had hor-rible fights; you can't imagine the snarls and yelps. It might have been amusing from a distance.

Another subtle dynamic involved things like taste and style—pref-erences and identities. At times on the compound you could feel an absurd social division between East Coast artists and those from the West—not much mixing or exchange of ideas, only a few stimulating discussions as artists.

My own work began to become more strict. The exhibition that we all have at the end of our grant period means that each artist is faced with what he has done. In my case, it was eighteen paintings, big color-ful nudes. I could sense a kind of rigidity in the figures. I kept painting nudes over the next several years, more nudes. They came to have a flow and supple rhythm. After my grant was over, I had the use of a studio downtown, with comparative privacy and quiet. There's a porosity to the privacy on the compound—sounds, radio, tools all flow from one studio to another. A psychological dynamic, perhaps. That layout around a central ground—now it's lusciously shaded, of course, less open. We used to play volleyball to the east of the woodshop. There was

Wesley Rusnell. Photograph by Ted Kuykendall. *Courtesy of the artist.*

a clear demarcation: east side, west side. It induced a kind of spatial distinction. I always felt that if one stepped outside the back door it was like going onstage. There is loneliness and isolation, while being able to see visitors. It intensifies the need for feedback. If I knew visitors were coming, I dreaded it; it almost frightened me. The "desert island village" analogy is felt most deeply by residents from big sophisticated cities—the deracination, the disorientation. You know the locals used to call it "Hippie Corners"? Well.

Another thing: There were brief fleeting occasional moments, as when Stephen Lorber and Jillian Denby (the couple from New York) each came up to me at the opening and expressed their admiration for what I'd done. This is a community that spans the coasts, with the smallness and intimacy of East-West art communities. I met the poets Jonathan Williams and Robert Creeley in Taos. Serendipity. Taos was a crossroads; so is Roswell, but in an entirely different way. San Francisco and Taos as communities are *at* you, after you. Roswell leaves you alone, no matter what you might do on Sunday. Meeting collectors in Taos, I was reminded of lampreys, wanting to snap you up and devour you—actually saying "I want to have one of you." I had a total lack of familiarity with how to deal with the assholes of the art world.

We decided to stay in Roswell after the grant, found a house in town. We survived on food stamps and sales of work at five galleries. Eventually I began working part time at the museum—grunt work, carpentry, adjunct teaching. The people at the food stamp office had never confronted someone whose livelihood came from being an artist. My caseworker was a retired B-52 bomber pilot who'd gone deaf in one ear. I became something like his therapist. After eight months of no income from art, I was told to report to the employment office. The museum had okayed funding for a registrar, and a little voice in my head said, "Take that job!" It changed our lives. Many slight miracles, meeting interesting people. Considering where we are on the map, I've had the advantage of enjoying much of what I do at the museum. Beth became a teacher again, got her accreditation updated, and was on the faculty at New Mexico Military Institute, where she taught English for seventeen years. She retired in 2002.

I don't have a big ego. I felt alienated for thirty years, but I have more insight now. I've come to see Roswell as an anthropological object, an artifact.

Lorna Ritz (1975)

Lorna Ritz arrived in May of 1975, long after the Rusnells had left the compound, although they still lived in town. She has lived mostly in Massachusetts though she received her MFA from Cranbrook Academy of Art in 1971. Her lyrical abstract paintings have been exhibited widely in the U.S. and abroad.

She is rare among artists in her passion for documenting her work and her thoughts about it. Descending into her basement in Amherst, Massachusetts, she reaches up to a high shelf, pulls down heavy storage boxes. They are filled with notebooks, some bound in Chinese silk. She checks them quickly.

"No, no—these aren't Roswell." She heaves down another carton, peers inside. "These are the right ones." She goes on:

Roswell is where I really became a serious artist—all those quiet spacious months to paint! It had taken me five days to drive from Providence, Rhode Island, to Roswell, pulling a U-Haul trailer. I remember stopping for the night at a motel in Amarillo, wanting something to eat, but there was nothing open but bars, bars full of cowboys. At about the third one, I walked in like I owned the place, made dinner out of bar snacks, sashayed on out, pretending I wasn't scared.

Next morning it was worse. Outside in the daylight, I felt physically squashed between immeasurable layers of earth and sky.

The first week I was in my studio I wanted to hide under the sheets. I had never seen such a wide-open landscape, and I didn't know how to begin to paint, or what to paint. There was all this crisp, flat blue sky without even a cloud in it, and flat land without the sensuous curves of New England where I come from. I was given all this delicious paint, canvas—everything I needed. On the fifth day I had to give myself a talking to, scolding myself, saying, "You came all this way for what? Get to work!" Once I began, I never stopped. There were not enough hours in the day to keep up with the new ideas that were coming to me from this landscape I had never previously experienced, and for the first time in my life I had nothing to do but paint.

One night at sunset I walked so far that I was lost in the desert across the road. I actually found a little red glass heart in the middle of nowhere, which I still have. Color stayed alive in the sky until very late,

but I could not see well enough to find my way home. I didn't know that I had walked in a circle and was already home.

When I needed people, I'd go into town for breakfast, where, after many months, men with tall cowboy hats would tease me that I had more paint on my clothes than probably on my painting. All the hats would turn in the same direction when I walked in.

I remember Luis [Jiménez] so well. He was this large presence back then, and I knew, young as I was, that his presence would enlarge over time. He used to have me over to his studio where a new sculpture would be bigger than the space it was in.

Ritz bends over the small red notebook, reading aloud:

May 25, 1975: A full moon eclipse, and my first night of peaceful sleep. I went to Bottomless Lakes: everything new to me, so flat and hot, the sudden sharp rays of cliffs, strange birds with horns. The water looked so cool and tempting, but they've told me there are hidden whirlpools. I didn't go in.

May 30: The landscape west of here is sharp mountains rising out of the flatness—how beautiful. Sunset colors open up the sky. Today changed everything for me.

June 3: My finest day yet. Eight hours in the studio, then two hours horseback riding.

Lots of greens and a flat sky blue, no yellows. The spirit within it carries it. Mountains a hundred miles away describing the flatness where I stand. You have to let it permeate completely. Surrounded by the sunset. Not enough time in the day to express what I feel.

I visited a little house with a waterfall in the Hondo Valley. My visual vocabulary is changing. Isolation turns me inward when I want to be reaching out. Isolation also means no feedback.

I've worked for weeks and the painting hasn't released me. I live in the tensions between forms and colors. In painting as in real life, sometimes I make poor decisions.

June 30: The mountain lit up the other day, cloud shadows making darkness all around it. Everywhere the slow curves of earthly structure. The sky secures the space.

I've started to grow herbs and hang them in the house. I can't explain, but it's wonderful. My constant is the rhythm of the sun rising and setting.

Completely happy. The more I learn the more I open up, the more inspiration comes. First I work on a painting for a week, then I work out the formal elements—they are separate.

July 22: Full moon before the storm. I want to push down a wall!

Crashing thunder, lightning circling over the compound scared me enough to make me come out of myself, smelling the green earth—so sweet. Sand moves like the sea—waves, dunes. So quiet you can hear the earth turn. Heat like breathing in flowers.

Night painting: the windows closed against biting insects, the yellow incandescent light falsifying everything. I feel life all around me, my eyes are windows and my skin vulnerable to hot and cold. No more set molds or patterns, and no more apathy.

Lorna Ritz, *Untitled.* 1980. 66" x 74". Oil on canvas. *Courtesy Anderson Museum of Contemporary Art.*

Ben Goo (1975–76 and 2003–04)

Ben Goo, the sculptor from Hawaii, arrived just after Lorna, although one gathers from their accounts that there was not a great deal of interaction between the hunter/carnivore sculptor and the exquisitely lyrical young painter. At that time, he was working in marble, creating smooth

elegant abstract forms, monumental in size. He had an MFA from Cranbrook Academy of Art, and had also studied sculpture in Brera, Italy. Ben also taught at Arizona State University for several decades. Ben begins the story:

> I originally came to Roswell to visit a former student of mine. It was she who suggested that I apply for the residency, since my work was already known to the museum. I worked in marble then. They had huge blocks of Vermont marble, black, white, shipped to me. What it must have cost!
>
> I learned the highly disciplined craft of carving wood in Hawaii. My teacher was German, a carver from Oberammergau, the famous wood-carving center in Germany; he taught me to carve reliefs of leaves, flowers, people. Later in Iowa I began to carve the full round, and for a time I worked as a studio assistant in a design workshop.
>
> [I remember] the farmer across the way who would let us pick our own vegetables. My wife got very interested in canning, and so she put up many beautiful jars of vegetables. Everything you can

Ben Goo at his exhibition at the Roswell Museum and Art Center. 1976. *Courtesy of the artist.*

imagine. Someone came to visit and told her she should enter her vege-
tables in the state fair. Canned vegetables! Well, she did, and they won
blue ribbons.

Luis Jiménez was on the compound then, in 1975. My wife was a
champion trap shooter, and she also loves to hunt and fish. The three
of us would go hunting at Bitter Lakes—it wasn't illegal then. I would
hang all our birds outside for a few days, up under the porch roof. That
upset some people. But of course we ate everything we killed; it wasn't
some pointless exercise.

Later our two families rented a house together at Rocky Point in
Baja California; we would fish in the early morning—fish for break-
fast! We would catch octopus, and you know, their nervous system
goes on for quite a while even when they're dead, and so one would
see the octopus marinating itself in a big bowl, turning itself around
in the marinade. Artists seem to think a lot about food.

Richard Shaffer was also there. He covered the walls of his studio
with huge canvases, twelve feet high. He gave himself a reason for
painting—or the grant did, and he had to live up to that.

Richard Shaffer (1975–76)

The painter Richard Shaffer studied at the San Francisco Art Institute and
at Stanford University, where he received an MFA in 1975. His main inter-
ests at that time were realist painting and philosophy. Richard submitted
a poetic meditation on what his experience at the compound meant to
him in general, in anticipation of returning to the compound in a year.
He begins:

Internal Storms

Just an idea, but of course it has already begun, the downpour of
thoughts about this project, the desire, longing to get drowned by the
avalanche of paintings inside me. The restlessness and the commit-
ment to get out there in the elements and work has always remained
inside; I want the storm to brew—let it rip! ! ! ! ! The painting that has
plagued my mind's eye for over twenty years: Martin Johnson Heade's
Thunderstorm Over Narragansett Bay is a model of a vision that I am
going to realize out there in the rain and electric storms of the south-
western mesas.

The New Mexico sky is the most broad and colorful and surpris-
ing; it is mostly empty, barren, and dry with heat, but the moment
comes when it "opens" and the waterfall of lightning and thunder and
hail and flooding begins. The beauty of it is that you can see it coming
at you, just like the Heade painting. It is at a distance from you, so you

feel safe for a while, but suddenly it is upon you, and it is so violent and relentless that it demands that you give it full attention. That is what I am going after, that moment and the turmoil and effort to actually "get out there" and do it is filled with risk, doubt, and misgivings. It was easier when I was young and stupid. Now it is even difficult to conceive of that moment, let alone actually accomplish it in fact, but I shall. I know this because it started today, the downpour of energy and desire to have it happen. It is clear, like love and the need to live and paint.

We all return "home" by that road that we freely choose. The return is easy and exciting, and all roads lead us back to that place that we love: familiar, not strange; calm, not anguished; real, not fictional; known, not mysterious.

The real home is a place inside and outside. Roswell is like that to me. I have a "beginning" of travel from that place, and now—years later—it still remains a home to me, a place that is remote yet near. I can understand it and I can remember it even if I am outside it and miles away.

> It's love, like the nurturing of any home.
> What comes from dark is the light.
> What was once confined, freed.
> What once closed tightly will open.
> No more shallow barriers, only deeper space;
> Once populated, now emptied.
> Fill me.

These are images about color and shape and texture and line and thought about natural forms, the atmospherics of turbulence, violent changes, the twisting of the shapes. The Chinese have five elements, not just four: Earth, Air, Wind, Water, and Fire. The new aspect is the wind, and the paintings are like the wind, swept and moved by the energy of natural force, slipping and sliding into existent and real convergences, torn by rifts of warm and cool, light and dark, heavy and light. The language of the image is the same language of the weather itself. Go out and work under the lightning bolt; see what happens. Look up not down, into the air and the heavens, no longer downwards into the facts of the word, the stillness of still life, rather the tremendous soaring of the hurricane, avalanche and tornado. The southwestern sky empties the thinking; emotion rules with the frightening sounds of the storm, crackling bolts and streams overflowing. The paint follows the form that is amorphous; no logic except for the paradox of being caught

under the umbrella of confusion, fleeting moments, and immediate response, only the air is surface and depth at the same time.

It is happening all over again, right from the first drizzle, the internal storm of pushing out the barriers of safety and moving into the pleasures of risk.

Since leaving the compound, Richard Shaffer has had a major career, with many prestigious awards and shows all over the country. He works both abstractly and figuratively. His focus recently has been on performance art.

Beverly Magennis (1975–76)

Beverly Magennis's stay overlapped with Lorna Ritz, Ben Goo, and Richard Shaffer. She was born and raised in Toronto. When she applied to the residency, she was teaching at the University of North Carolina. Outgoing and personable, she works in ceramics, creating witty pieces, both small and large. Beverly starts out:

> Of all the opportunities and commissions and sales and support of my work, nothing has meant more to me than the Roswell artist-in-residence grant. Here are some memories:
>
> A young raven sat perched on the cedar fence outside my house. It was midday. From inside I watched Luis Jiménez approach the bird, flashing a shiny object. The bird, captivated by the light, allowed himself to be captured.

Richard Shaffer and Beverly Magennis. 1976. Photograph by Ted Kuykendall. *Courtesy of the artist.*

José the Raven. Photograph by Ted Kuykendall. *Courtesy of the artist.*

The bird was taken to Luis' studio and lived there, tethered to a ladder. Luis named him José. [This was perhaps the second of the Josés that Luis had.] José was a young raven, a talker, mimicking everything he heard. Approaching the studio, I would hear Luis call to his assistant, "Ted, bring me that can of resin on the bottom shelf." The studio would be empty, except for the bird talking in Luis's voice. He would imitate the radio. "The time is eleven fifteen. Here's *On the Road Again* by Willie Nelson." He would clear his throat and swear.

Once Luis tethered José to a branch in a tree in the compound, where he perched all day. In the afternoon, a group of ravens flew overhead, cawing. José raised his head and called back to them, screaming, "José! José!"

The bird lived a long time. Luis took him to El Paso. Ted Kuykendall, the assistant, went to visit. He lay in bed in his room next to the studio and listened to José talking. He heard José say, "Ted, bring me that can of resin on the bottom shelf." Hoping the bird had recognized him, Ted went into the studio and approached him. The bird attacked him.

Many years later I bumped into Luis at the Albuquerque airport, and of course I asked him about José. It was sad, Luis said. He'd left the bird alone and somehow his two German Shepherd dogs attacked him. When Luis found him, he was a mangled mess, but he carried him to the vet in case anything could be done to save him. As he walked into the office, a lady was leaving with her poodle on a leash. José, whose head was dangling over Luis's arm, looked down on the dog and said, "Damn dogs."

Roswell blew my mind. I had never been out west. From the minute I set foot in New Mexico I knew I'd never leave. There seemed to be the right amount of space, the right amount of sun. Mostly I recall the country around Roswell, the miles and miles of pecan orchards; the rolling, upholstered-looking hills of the Hondo Valley, the smell of the alfalfa fields south of town toward Artesia; the tumbleweeds flying in the spring winds, catching in the fences; the horizontal lightning and thunder storms cracking open the sky; the Bottomless Lakes, the wildlife refuge.

Magennis, another transplanted Canadian/Easterner, has lived in New Mexico ever since. Her home in Albuquerque, decorated profusely with

her ceramic art, has been declared a historic site. She now lives in the remote tiny town of Reserve, in western New Mexico.

Rebecca Davis (1976)

Rebecca Davis came a few months before Beverly Magennis and Richard Shaffer left. She is a sculptor who works with natural materials (wood, sand, rock, etc.), in collaboration with her husband, the sculptor Roger Asay. Her interests are wide-ranging; her Bachelor of Arts degree, from the University of New Mexico in 1974, was in anthropology, although she also studied art and nursing. She has continued her studies in botany and ecology, which have greatly affected her work. One critic writes of the work of the couple: "Using materials taken from their environ with the greatest sensitivity...the hands and minds of these skilled artist-environmentalists lend their finds new life. In so doing, they create provocative art indeed."[17] She is another outgoing person, to whom the interrelations between the artists were clearly important. Rebecca says:

> The journey from Albuquerque (where I then lived) to Roswell was not as long as most of the artists would have to take, but even so, it was over the mountains and into another world. The Roswell area was like no place I had ever lived before. Roswell was a small town set amid vast open spaces, geographically and culturally tied to Texas.
>
> Bill Ebie showed me my home and introduced me to my new community: Beverly Magennis, Richard Shaffer, and Sue Hettmansperger, (a painter from Iowa, and former resident) and others connected in like William Goodman and Luis Jiménez. Bill Ebie and his family remained a wonderful presence on the compound throughout my stay.
>
> What a blessing to have a good studio and the unhindered time in which to work! If there was a town, I wasn't too much aware of it. I guess there were trips to get groceries, go to the library or the museum, and an occasional taco or enchilada at the tiny Mexican café a few miles south of town. Over the course of time I met some wonderful people from the community, but for the most part my focus was on the compound and in my studio.
>
> One of the first experiences I had was a day trip with William Goodman in his beautiful old beat-up truck. We headed to the mountains for a drive and lunch with the Hurd family. William talked about liking to catch tarantulas to let loose inside his truck; he liked to watch people's reactions. Being a child of the West I was not as impressed as I think he had hoped (although it impressed me enough so that I still remember it after twenty-eight years). I felt so pleased to be

included in this dinner with the Hurds. The beautiful adobe home, courtyard walls, and peacocks in the yard were all part of this wonderful memory.

My family joined me a couple of weeks after my arrival: Roger Asay and his son Joaquín, who was then seven. Roger, also a sculptor, was given a storage area to turn into a studio during our stay and he was able to produce quite a bit of significant work using shaped rawhide. Roger and Joaquín both became an important part of the compound.

I remember watching the lush green alfalfa field across the street. Giant water sprayers would ever so slowly circle the field; the plants would grow, be mowed, baled, and then the cycle would start again. I also have vivid memories of the lantana that grew beside my steps and how the petals would change in rings of color from outside to in, and oh! the beautiful nasturtiums!

We had occasional dinners together on the compound, but most of my contact with the other artists seemed to happen in casual meetings. It meant a lot to me to see everyone work. Our styles were all quite distinct but the quality was high. It was invigorating to be around other artists who took their work seriously. Richard, Sue, and I were all fairly quiet: not without humor, but reserved. We were lucky to have Beverly in our midst to keep our social life stepped up a notch. Like her work, she was playful and exuberant, and that was a pleasant addition to all that happened there.

Having Luis Jiménez working in his studio was also an important part of the experience. I didn't get to know Luis well, but his presence was potent. His studio, the way he structured it, the scale at which he was able to work: these were all memorable impressions. His foulmouthed pet raven, José, was unforgettable. We shared an interest in roadkill. Luis would freeze his finds to study for shape and structure. Roger and I had collected ours for feathers and to boil for bones.

We had a grand Halloween party with homemade costumes. One guy showed up as an exhibitionist with a mammoth sausage dangling under his coat.

While working in Roswell I concentrated on a series of woven, vaguely figurelike forms. Each of these pieces took hours of time to construct. I was able to break up that time by also doing some small gouache paintings and some stick constructions. I loved singing as I worked. The room was open enough to let the sound resonate. Taking breaks just to get outside was also important.

Roger loved to fish in nearby lakes. I think he caught catfish, and Joaquín and I would poke around the water's edge watching for turtles. We would also hike in the mountains or canyons outside of

town. During one canyon visit a large, pure white owl perched on a cliff and then glided slowly and silently next to us. The image and feel of this bird has always remained with me.

I remember another excursion, this time with a young man named Don who had grown up in the Roswell area. He had spent years exploring the hills and looking for caves. Roger and I had been through Carlsbad Caverns, which is impressive, but this was something different. After several miles of driving, Don took us to a hill with a barrel-sized hole at its base. We sat a while, eating sandwiches and watching the desert around us. We found fossils in the rocks and masses of bullet shells on the ground (which Joaquín and I collected for the jingling sound). A huge centipede appeared and curled up into a beautiful spiral when it was alarmed.

Then we crawled into the hole: no ropes, no hardhats, no first aid—just four curious souls. It was dark and the air was instantly cool. With flashlights we saw that the walls were whitish or amber crystallized stone. We crawled through one room and into a second. We turned out the lights and sat silent a moment in absolute darkness. This was an experience like no other and seemed to challenge my internal sense of vision and space. We explored a bit further and came to another narrow passage. A sudden sense of claustrophobia (or something about imagining the weight of the mountain on top of me) made me decide I had gone far enough. Roger stayed with me but our fearless seven-year-old, Joaquín, and Don continued on down the passage and around a corner until their voices vanished. Eventually even Joaquín got scared and they came back before reaching the end—caverns that even Don had not explored.

Everywhere I have lived, I remember more about the land than the people. Roswell rewarded me with a sense of awe about the mysteries that can be found in the shape of the land.

After the residency, Roger, Joaquín, and I traveled throughout the West and finally settled down in Durango, Colorado. Roger and I were married in 1977 and added three more children to our family. After moving to Prescott, Arizona, we developed a collaborative body of work based on natural materials, which has continued to the present. We have been blessed at every step. Joaquín, now in his thirties, is a cinematographer married to a fine artist. Was Roswell part of the roots of his choices as well?

Rebecca Davis and Roger Asay, *Wedded Aspen*. 1984. 126" x 18" x 18". Aspen tree. *Courtesy Anderson Museum of Contemporary Art.*

The overall experience of the Artist-in-Residence Program was very rich and meaningful. I met and worked with some great artists. I had the gift of a studio and the time to work diligently and freely in it. I had the chance to explore and learn from an amazing landscape. The icing on the top was my exhibition and the museum's purchase of my work. The whole program was so well thought-out. It made a difference in the success and direction of my career both in having had the time to develop artistic ideas, and then also the acceptance into shows and galleries in the years immediately following the residency. I look back on those months with pride and many good memories.

Wook-Kyung Choi (1976–77)

Wook-Kyung Choi and her friend Michael Aakhus both arrived after the previous group had all left. She grew up in South Korea but came to the United States to study art. Receiving her MFA from the Cranbrook Academy of Art in Detroit in 1965, she subsequently taught in a small college in New Hampshire for three years, before moving to the Atlanta College of Art in Georgia, where she taught for several years. Of her large expressive realist paintings, she says, "I'm not simply telling stories, but am trying to express visually my experience of the moment lived."[18] Michael Aakhus tells her story:

> It was Wook-Kyung who became my closest friend on the compound. I traded works with her and have some of her calligraphy and one of her paintings on paper. Her work was remarkable, using abstracted forms of birds in vivid colors that would dance across her canvases. She was a small woman but made the largest paintings I had ever seen. She also kept, in a rather elegant silk-covered box, a three-and-a-half foot calligraphy brush, lacquered black and inlaid with mother of pearl and other semiprecious stones. She told me that she was practicing to write some poems with this brush, but that they were not ready to be shown.
>
> Wook-Kyung had come from Korea to study painting at Cranbrook Academy of Art in Detroit. She had completed a residency at Yaddo, in New York State, and had shown her paintings widely in Asia, Europe, and the United States. She taught at several universities in this country but was unable to get a permanent position. She finally returned to Korea and taught at the Woman's University in Seoul until her death.
>
> She came to our country as a young woman and grew up between two worlds, unable to feel comfortable in the States or in her own country. I often spoke with her about this over the years and she would

joke that she was a woman with a bad temper who spoke her mind, and that this was totally inappropriate in her own country. She said in Korea women were quiet and always said yes to their husbands. She had a hard time saying yes, debating all the points, and I expect that her indomitable will was a bit much for the old men of American departments of art as well.

While in Roswell, Wook-Kyung took the classes and tests to become an American citizen. We drove her to El Paso to be sworn in, which was a moving occasion.

I recall one morning going out to Bitter Lakes with her. As we walked into one of the fields, thousands of sandhill cranes lifted off the field in perfect unison. The flock seemed to move in slow motion, turned 180 degrees, and landed at the other end of the field. It was absolutely breathtaking to see so many birds take flight as if they were governed by one brain. There was not one wasted or out-of-sync action by these extraordinary gray birds. Wook-Kyung and I just looked at each other and said nothing.

It was Wook-Kyung's sister who told me of her death. She had become quite famous in Korea, where she has been called the Vincent van Gogh of East Asia, presumably not because of her painting, which was much different from van Gogh's, but perhaps because of the tragic nature of her life and her death by suicide.

Michael Aakhus (1976–77)

Michael Aakhus had just received his MFA from the University of Southern Illinois when he arrived. In his application statement, he says that his "concerns of Oriental art and philosophy in juxtaposition with my Norwegian heritage has served as a source for many of my drawings and prints."[19] Michael recounts:

Roswell, for me, was a transforming experience. I was just out of graduate school in the spring of 1976 and possibly one of the youngest artists to have been invited to the residency. I was offered a job to teach and run the gallery at the University of Missouri at Kansas City, but I held onto my contract until I heard from Roswell. When I got the news that I had been awarded a fellowship in printmaking, I called Kansas City and told them that I was sorry but I would not be coming, packed my old blue Volvo, mostly with my plants, and moved to the compound.

Possibly it's the people that I remember best. It was the sense of community that developed among the artists that made Roswell special. In particular, the director, Bill Ebie and his wife and their two

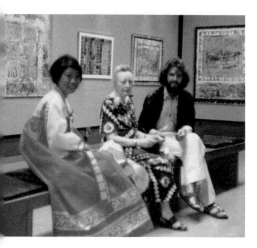

Wook-Kyung Choi, Dr. Jackson, and Michael Aakhus at Aakhus's opening at the Roswell Museum and Art Center. 1977. *Courtesy Michael Aakhus.*

children were wonderful. Gwyn was a ceramist and worked when she could, while trying to take care of the children. I still have a piece that I traded with her, a large pot that stands by our parlor door. Bill was Lebanese, so it was my first chance to sample Lebanese cooking in a series of many shared meals. Wook-Kyung taught me to make sushi, and I taught her to make my grandmother's potato salad.

I remember visiting Don's home to see his impressive collection, and the conversations that we had. He told me how *The Henge* was built, and the mountain of stone and earth that he moved with his equipment to create its remarkable setting.

I remember two stores in the city of Roswell. The first was one Gwyn Ebie took me to, a children's clothing store. Their inventory appeared to go back to the 1920s. Gwyn went there to get shoes for her two children—the place was open by appointment. They had beautiful party frocks for young girls, leather car coats, lace hankies, gloves, and wonderful hats. I bought some of the hats for Jennifer, my sister's daughter. The second store was a liquor store that had a sign that informed customers using the drive-up window that they were limited to two shots of hard liquor while waiting for their package. I had just arrived from a state where a double shot and a drive could land you in jail. I liked to imagine that this was somehow a holdover from the Wild West.

There was one other shop that I visited. It was a clock repair place where I had taken a clock that I'd picked up in an antique store in Norman, Oklahoma, on my way to Roswell. It was one of those shops that import antiques from Europe; the clock I got was from England. It was made from orange and green marble and flanked by a pair of pewter wolfhounds. When I brought the clock in, the fellow who ran the repair shop looked at the works of the clock. He told me that the iron parts were all rusted and that it was unlikely that it could ever run. Leave it, though, he said, and he'd see what he could do. He took the clock apart, sanded, polished, and shellacked all the iron parts in the clock. He leveled it up and it ran fine. He put in about seventy-five hours on the clock and charged me less than twenty dollars. It had to have been a labor of love, or possibly the awareness that a student just out of graduate school would not be able to pay any more. I am grateful to this day for that man's generosity of time and skill. The clock still sits on the mantel in my front parlor.

CHAPTER TWO

I came to Roswell, lived there for ten months, and not until years afterwards did I discover what Roswell was really famous for, the so-called spacecraft that had crashed there and put Roswell on the map. It was interesting that no one in Roswell had ever mentioned this while I lived there.

Since I wasn't watching the skies for spacecraft, one of my favorite Roswell outings was to go on Sundays to the Mexican restaurant. I was informed that it was not a *Mexican* restaurant, but one that catered to people of Hispanic descent and that they had been living here since before there was anything called the United States. Sundays were when all the families would come to hear live Mexican music and dance. I went there with Sharyn Finnegan, an artist from New York City, and Wook-Kyung. The music had a beat that was similar to the polkas I had danced with my grandmother as a kid. The New York artist was crazy to polka. The men were very formal and if they wanted to dance with one of the women at my table they would come and ask my permission. I was told not to go to this place on other nights because it was on the rough side, but Sundays were for families and would be okay.

The town had lost its air base some years before, but pilots for Air France and Lufthansa still trained there. Their huge planes often seemed to float over the city, moving so slowly it was hard to believe they could stay up in the air. One morning on my way to the airport I went past a local motel. It was a cold morning in late winter, and it had gotten cold enough to freeze. The motel had a beautiful green lawn and the finest ice sculptures I had ever seen. They had left their sprinklers on the evening before, and the ice fountains looked to be about nine to twelve feet tall.

In the spring we had a dust storm. The winds came down off the mountains and hit speeds of around a hundred miles per hour. I was out in it for a time but finally had enough sense to get indoors. I had been told to put rugs over the bottoms of the doors to keep the dirt and sand from blowing into the house. When it was over there was some damage in the town, the sign at a motel had come down and a number of roofs had been blown away. The trick of putting a rug at the bottom of the door didn't do much good, but it might have kept actual sand dunes from forming inside the house. It took me a full day of cleaning to get rid of the grit that was in and on everything in the place.

Having the opportunity to order whatever I would need to do my year's work was unbelievable. I ordered my favorite papers, copper plates for etching, and materials for painting. The printmaking studio

had not yet been set up to do etching, but I improvised a hot plate out of a slab of steel and a couple of electric burners. The space worked out fine and the etchings came along over the course of the year. The images were based on map forms, calligraphy, and one was a design for a Korean game board. I still have these plates and from time to time I will pull them out to print with my students. I've never been one to print large editions, so they are in good shape. I've always been too interested in the next idea to pull large editions.

The other work that I did that year was in the area of painting. There happened to be an extra studio that was not in use and Bill let me have it to paint on the high-impact styrene[20] sheets I had discovered in graduate school. They were using them to do vacuforming at Southern Illinois University, Edwardsville, but I found that with a little help from a bottle of lacquer thinner and some printing ink I could make paintings. I finally got pretty ambitious and started working on sheets that were four feet by eight feet and would put them together to make triptychs, the final works being eight by twelve feet. The best of these works on plastic, though, were done in my final weeks on the compound. There is nothing like the pressure of knowing your fellowship is coming to an end to stimulate the creative juices.

The real luxury of the residency was the gift of time. I developed a working routine that allowed me to spend time in the morning keeping a journal, drawing, and if there was time, taking a hike; in the afternoon I would work in the print studio, etching and printing, and in the evening after dinner I would paint late into the night. As a teacher (now full professor) immersed in the life of my university, I look back on those days with envy. Roswell has provided all of us with a necessary reserve of creative energy. There is hardly a day that passes that I do not think back on that year, for it set a standard for commitment to my art that I have held on to through the years. The landscape of New Mexico has continued to resonate in my mind and work.

Gussie DuJardin and Elmer Schooley at their Roswell home, ca. 1979. *Courtesy Rudy Pozzatti.*

Gussie DuJardin and Elmer Schooley (1977–78)

Gussie DuJardin and her husband, Elmer Schooley, known as "Skinny," arrived in Roswell from northern New Mexico, where he had been teaching at New Mexico Highlands University. Their arrival marked a pivotal change in the compound. They were in their sixties when they came, and have remained across the street ever since, bringing a wealth

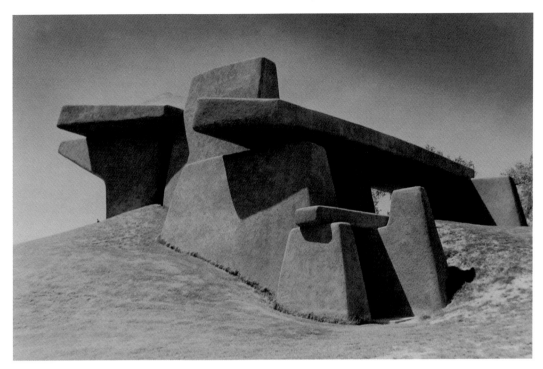

[1] Photograph of *The Henge* by J. Frederick Laval. *Courtesy J. Frederick Laval.*
Herb Goldman, *The Henge.* 1963. Gunite concrete. 150' x 150' x 50'.

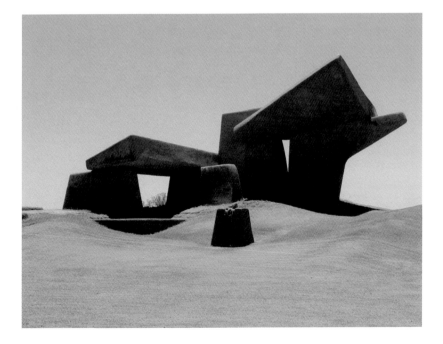

[2] Photograph of *The Henge* by Pattie Anderson. *Courtesy Anderson Museum of Contemporary Art.*

[3] Howard Cook, *New Mexico #3*. 1960. Oil on canvas. 23½" x 60". *Courtesy Anderson Museum of Contemporary Art.*

[4] Howard Storm, *Don's Place*. 1971. Oil on canvas. 26" x 30". *Courtesy Anderson Museum of Contemporary Art.*

[5] Donald B. Anderson, *Fjord.* 1986. Acrylic on canvas. 84" x 60". *Courtesy Anderson Museum of Contemporary Art.*

[6] Robert Jessup, *Night Incantation*. 1985. Oil on canvas. 60" x 60". *Courtesy Anderson Museum of Contemporary Art.*

[7] William Goodman, *Xanadu*. 1970. Oil on linen. 48" x 54". *Courtesy Anderson Museum of Contemporary Art.*

[8] Elmer Schooley, *Untitled*. 1978. Oil on canvas. 84" x 94". *Courtesy Anderson Museum of Contemporary Art.*

[9] Willard Midgette, *Revolving Door*. 1976. Oil on linen. 96" x 59". *Courtesy Anderson Museum of Contemporary Art.*

[10] Lisa Allen, *Homage to Frank Morgan*. 1999. Oil on canvas. 39½" x 29½". *Courtesy Anderson Museum of Contemporary Art.*

[11] Wesley Rusnell, *Reclining Nude, Violet*. 1968. Oil on linen. 48" x 60". *Courtesy Anderson Museum of Contemporary Art.*

[12] Rudy Pozzatti, *Untitled*. 1991. Lithograph and collage. 37" x 31". *Courtesy Anderson Museum of Contemporary Art.*

[13] Deborah Aschheim, *Boat*. 1993. Wood. 53" x 25" x 13". *Courtesy Anderson Museum of Contemporary Art.*

[14] Michael Aakhus, *Untitled*. 1977. Ink on styrene. 60" x 48". *Courtesy Anderson Museum of Contemporary Art.*

[15] Ted Kuykendall, *Self-portrait*. 1987. Photograph. 43" x 33½". *Courtesy Anderson Museum of Contemporary Art.*

[16] David Reed, *167–2*. 1982. Oil on board. 20" x 40". *Courtesy Anderson Museum of Contemporary Art.*

[17] Scott Greene, *Exhaust*. 1992–1994. Oil on canvas. 128" x 192". *Courtesy Anderson Museum of Contemporary Art.*

[18] Cristina González, *El Jardin de la Memoria*. 2001. Oil on canvas. 66" x 84". *Courtesy Anderson Museum of Contemporary Art.*

[19] Eddie Dominguez, *Gemstones*. 1995. Ceramic. 20" x 36" x 8". *Courtesy Roswell Artist-in-Residence Program archives.*

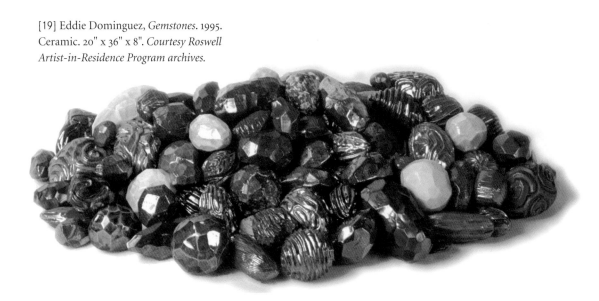

[20] Joshua Rose, *Untitled*. 1988. Oil and wax on canvas. 100" x 80". *Courtesy Anderson Museum of Contemporary Art.*

[21] Luis Jiménez, *Vaquero*. 1973. Colored pencil on paper. 26" x 40". *Courtesy Anderson Museum of Contemporary Art.*

[22] Luis Jiménez, *Cycle*. 1969. Fiberglass. 50" x 80" x 30". *Courtesy Anderson Museum of Contemporary Art.*

[23] Luis Jiménez, *Progress 1*. 1973. Polychrome fiberglass. 126" x 108" x 90". *Courtesy Anderson Museum of Contemporary Art.*

[24] Max Cole, *Juniper*. 1995. Acrylic and ink on linen. 23½" x 31½". *Courtesy Anderson Museum of Contemporary Art.*

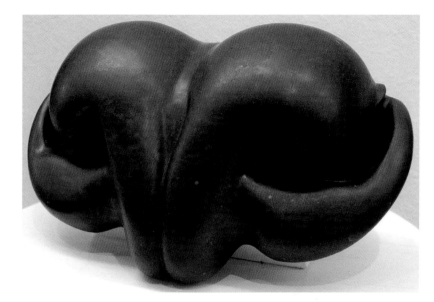

[25] Maria Rucker, *Prosimian Nose*. 2001. Black Champlain marble. 8" x 13½" x 4¾". *Courtesy Anderson Museum of Contemporary Art.*

[26] Michael Beitz, *Crossing*. 2004. Terra cotta. Individual feet from life-size to ½" high. *Courtesy Roswell Artist-in-Residence Program archives.*

[27] Jane Abrams, *Struck*. 1992. Oil on wood relief. 10½" x 12¼" x 1¾". *Courtesy Anderson Museum of Contemporary Art.*

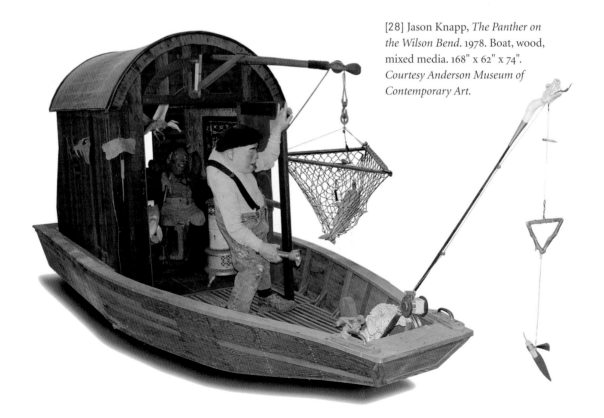

[28] Jason Knapp, *The Panther on the Wilson Bend*. 1978. Boat, wood, mixed media. 168" x 62" x 74". *Courtesy Anderson Museum of Contemporary Art.*

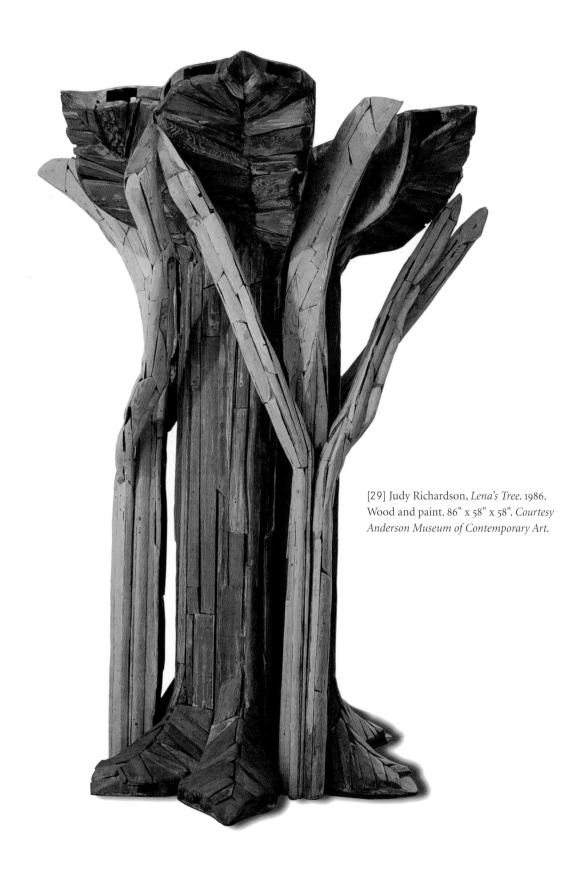

[29] Judy Richardson, *Lena's Tree*. 1986. Wood and paint. 86" x 58" x 58". *Courtesy Anderson Museum of Contemporary Art.*

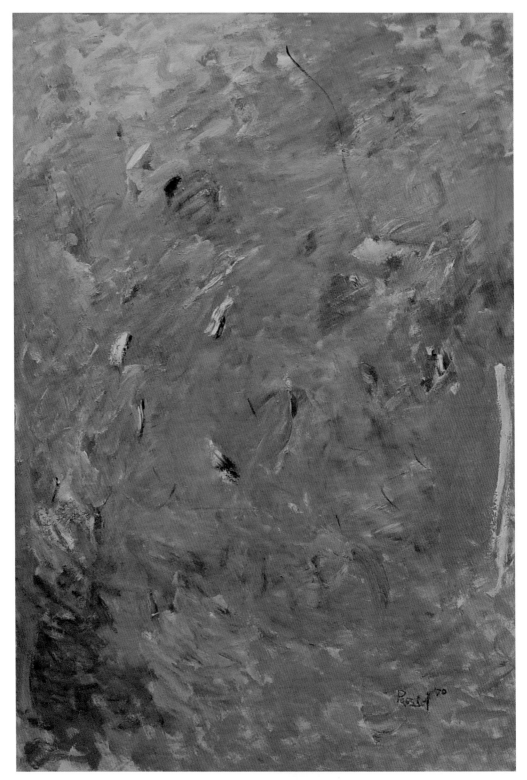

[30] Pat Passlof, *Untitled*. 1971. Oil on linen. 78" x 52". *Courtesy Anderson Museum of Contemporary Art.*

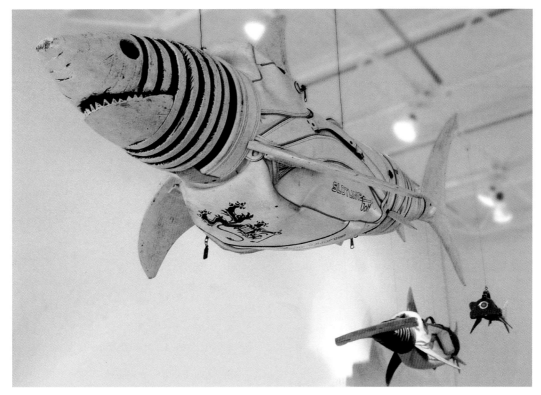

[31] Robbie Barber, (left) *Great White Shark*. 1992. Golf bag, wood and oil. 27" x 94" x 22". (middle) *Hammerhead Shark*. 1992. Golf bag, wood and oil. 27" x 94" x 22". (right) *Baby Hammerhead Shark*. 1992. Vacuum cleaner, wood and oil. 6" x 20" x 5". *Courtesy Anderson Museum of Contemporary Art.*

[32] JoAnn Jones, *Fortitude Amid Perplexity*. 2004. Oil on linen. 9" x 11". *Courtesy Anderson Museum of Contemporary Art.*

[33] Daisy Craddock, *Last Light*. 1983. Oil on canvas. 68" x 62". *Courtesy Anderson Museum of Contemporary Art.*

[34] Milton Resnick, *Untitled*. 1971. Acrylic on paper. 30" x 21½". *Courtesy Anderson Museum of Contemporary Art.*

[35] Steve Levin, *Down in the Willow Garden*. 1998. Oil on copper. 36" x 24". *Courtesy Anderson Museum of Contemporary Art.*

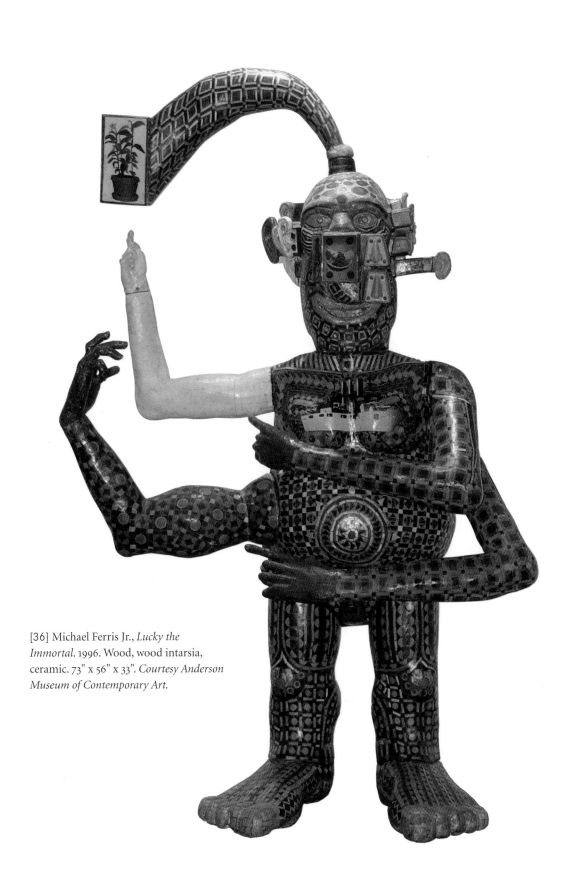

[36] Michael Ferris Jr., *Lucky the Immortal*. 1996. Wood, wood intarsia, ceramic. 73" x 56" x 33". *Courtesy Anderson Museum of Contemporary Art.*

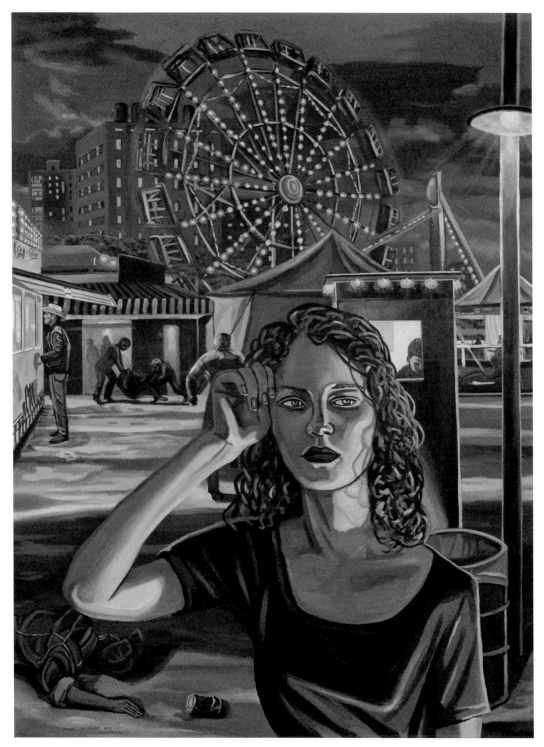

[37] Stewart MacFarlane, *The Fair*. 1992. Oil on canvas. 96" x 72". *Courtesy Anderson Museum of Contemporary Art.*

[38] Julia Couzens, *One*. 1994. Ethyl vinyl acetate on wood. 13" x 13" x 2½". *Courtesy Anderson Museum of Contemporary Art.*

[39] Phillis Ideal, *Photon*. 1994. Oil on canvas. 48" x 59". *Courtesy Anderson Museum of Contemporary Art.*

[40] Adam Curtis, (left) *Boat*. 1993. Steel, concrete base. 52" x 10" x 12". (right) *Untitled*. 1994. Steel, concrete base. 106" x 16" x 16". *Courtesy Anderson Museum of Contemporary Art.*

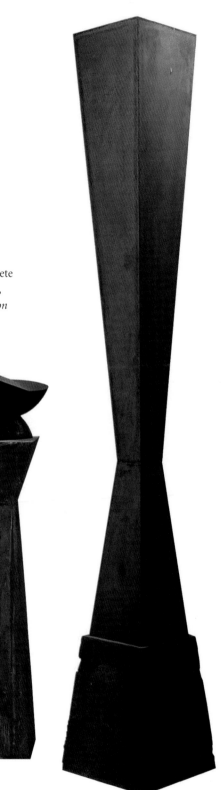

[41] Johnnie Winona Ross, *Chaco, Green Mask*. 1995. Oil on canvas. 72" x 68". *Courtesy Anderson Museum of Contemporary Art.*

[42] Stephen Fleming, *Step*. 1988. Oil on linen. 76½" x 65". *Courtesy Anderson Museum of Contemporary Art.*

[43] Rachel Hayes, *Dots and Loops*. 2003. Silk, vinyl, paint, dye. 64" x 54". *Courtesy Anderson Museum of Contemporary Art.*

[44] James McGarrell, *The Biggest Pantry—Dawn, Noon and Night.* 1999. Oil on canvas. 80" x 180". *Courtesy Anderson Museum of Contemporary Art.*

[45] Astrid Furnival, *Song of Roland*. 1994. Knitted wool. 56" x 108". *Courtesy Anderson Museum of Contemporary Art.*

[46] Jerry Bleem, *Architectural Rendering (Echo)*. 1998. Acrylic, blueprints, plastic, wax, staples. 6½" x 7½" x 6¼". *Courtesy Anderson Museum of Contemporary Art.*

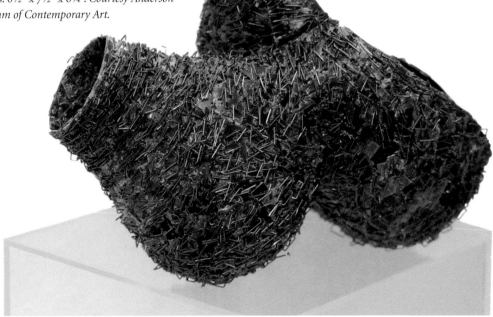

[47] Al Souza, *Ridicule*. 1998. Puzzle parts and glue on wood. 84" x 72". *Courtesy Anderson Museum of Contemporary Art.*

[48] Elen Feinberg, *9338*. 1993. Oil on plywood. 36" in diameter. *Courtesy Anderson Museum of Contemporary Art.*

[49] Stephen Lorber, *The One with Baskets*. 1973. Oil on canvas. 48" x 54". *Courtesy Anderson Museum of Contemporary Art.*

[50] Ju-Yeon Kim, *Untitled.* 2004. Acrylic and pencil on canvas. 54" x 40". *Courtesy Anderson Museum of Contemporary Art.*

[51] Corrie Witt, *The House in Wyoming*. 2004. Chromogenic print. 30" x 40". *Courtesy Anderson Museum of Contemporary Art.*

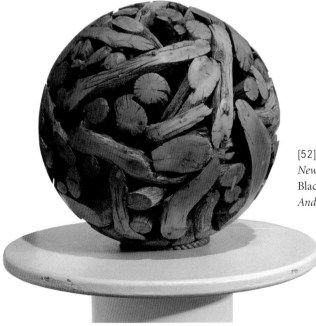

[52] Rebecca Davis and Roger Asay, *New Mexico Black Walnut Sphere*. 1998. Black walnut. 12" in diameter. *Courtesy Anderson Museum of Contemporary Art.*

[53] Yoshiko Kanai, *Doll/Mother/ Love/Eat.* 1991. Air-dried clay, twine, twigs, dolls, cloth, child's chair. 41½" x 16" x 25". *Courtesy Anderson Museum of Contemporary Art.*

[54] Jane South, *Wide World*. 1996. Mixed media on masonite. 72" x 66". *Courtesy Anderson Museum of Contemporary Art.*

[55] Linda Meiko Allen, *Swarm I*. 2001. Acrylic, enamel, photo collage, silkscreen, molding paste, beeswax on panel. 38½" x 38½". *Courtesy Anderson Museum of Contemporary Art.*

[56] Rosemarie Fiore, *Firework Drawing I*. 2002. 9 panels. Firework scorched, India ink on paper. 14" x 11". *Courtesy Anderson Museum of Contemporary Art.*

[57] Diane Marsh, *Three Arches*. 1980. Oil on linen. 76" x 107". *Courtesy Anderson Museum of Contemporary Art.*

[58] Stuart Arends, *Untitled*. 1983. Paint on wood. 24" x 24" x 24". *Courtesy Anderson Museum of Contemporary Art.*

[59] Susan Marie Dopp, *The Fire of the Mind*. 1993. Oil on gesso wood, gold leaf, copper frame. 24" x 20". *Courtesy Anderson Museum of Contemporary Art.*

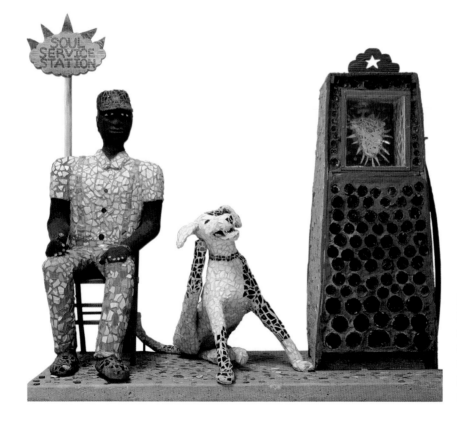

[60] Alison Saar, *Soul Service Station*. 1986. Concrete and tile. 126" x 94" x 48". *Courtesy Anderson Museum of Contemporary Art.*

[61] Brian Myers, *On Borrowed Time*. 1994. Oil on canvas. 57" x 84". *Courtesy Anderson Museum of Contemporary Art.*

[62] William Goodman, *Artesian*. 1996. Welded steel, galvanized. 17' h. *Courtesy Anderson Museum of Contemporary Art.*

[63] Robert ParkeHarrison, *Tower G-95*. 1995. Ink, wax, photo on board. 12½" x 20". *Courtesy Anderson Museum of Contemporary Art.*

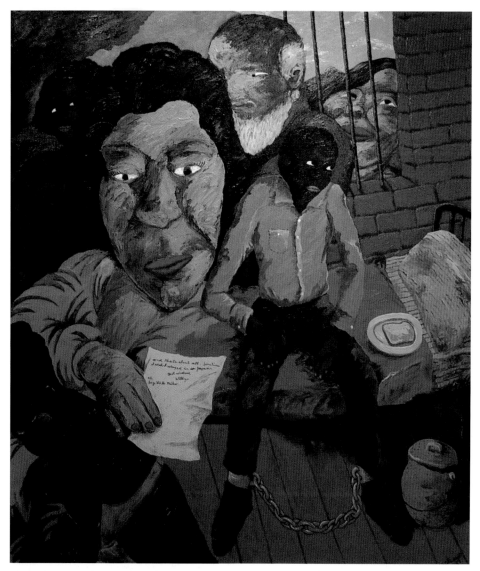

[64] Robert Colescott, *A Letter from Willie*. 1987. Acrylic on canvas. 84" x 72". *Courtesy Roswell Museum and Art Center.*

[65] Ralph J. McIntyre Gallery, Anderson Museum of Contemporary Art. *Courtesy Anderson Museum of Contemporary Art.*

[66] West Gallery, Anderson Museum of Contemporary Art. *Courtesy Anderson Museum of Contemporary Art.*

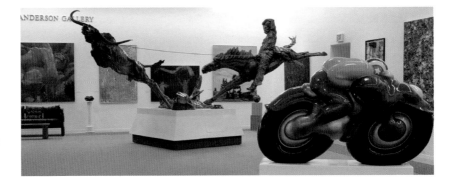

[67] Joseph Carl Anderson Gallery, Anderson Museum of Contemporary Art. *Courtesy Anderson Museum of Contemporary Art.*

of knowledge, humor, and talent from which the artists who come to the compound have continually benefited. Now in their late eighties, their health has been problematic. Gussie is stricken with Alzheimer's and is no longer able to paint. For a while Skinny suffered from severe arthritis, but he continues on.

Ann McGarrell interviewed Gussie in 2004, in the presence of her son's beloved tortoiseshell cat. Gussie recalls:

> I was a young girl in Hawaii when my family said we had to move to Colorado. I said, "Well, I'll come if I can bring my shells." I did bring them; they were important to me. I think I gave them all away, one by one. It was hard for me to get used to the cold in Colorado, but I loved the wildflowers—looking at them, thinking about them, finding out their families. Lupines, mariposas, butterfly weed.
>
> Oh, I could show you things you've never seen—a beautiful ranch house, more than a hundred years old, all stone and adobe. And other places, where the river goes.

Gussie's work often includes evocative and haunting plant forms imbued with mystery. Elmer Schooley's paintings straddle the divide between landscape and abstraction in a wonderful way; his landscapes (or "plant-scapes") are masterpieces of luminosity and painterly skill. He "paints tiny things in a big way—delicate branches, multitudes of leaves, bouquets of buds, flowing grasses, and withering weeds. His close-up perspective magnifies these elements, revealing entire worlds in a speck or dot of paint."[21] Skinny remembers:

> I'd been worried about retiring from teaching: What if I couldn't make it? Was I going to be able to support my family by just painting? I'd had some success—I already had a painting in the Museum of Modern Art in New York—but I was in my fifties, and nothing was certain, nothing at all. I liked teaching, I think I was good at it—good at letting students find out things. But it was time to see what I could do.
>
> We'd been living in Las Vegas, New Mexico. The cold there was very hard on Gussie; she had circulatory problems that immobilized her every winter. In 1977, she applied for the grant. She was awarded it, and with typical generosity they invited me for a joint grant. What the residency gave me was responsibility to my own work. I could paint every day without having to juggle time between chores, students, classes. We had such a good year and Gussie felt so well here we decided to settle [in Roswell] and sell our home at Montezuma [New Mexico].

You need to understand that people from northern New Mexico are worse snobs than New Englanders. They think Roswell might as well be West Texas. They have no idea.

This house has grown. We liked to give parties with the other artists, and the front room used to be three little rooms. Don Anderson sent his crew of workmen over and made it into one big room. He was trained as an engineer and knew what he was doing.

I consider myself to be as much a midwife as a painter. I begin with nature, the specific elements. The painting is there, waiting to be born, stroke by stroke. It doesn't always come easily, no matter how closely you look. You have to coax it out into life. Paint is never going to be a hillside or a field. But you can make something that has something like the intensity that caused you to start painting in the first place.

I still go to the studio. More slowly now, but I go.

Some people have told me that I should have moved to a livelier place, an art center where there is experimentation going on. But I'm a country boy. I've always been able to see the dim traces of a path that leads to painting. What if I'd gone to New York when I got out of the air force? Most likely I would have been another second-rate Abstract Expressionist because that was what was happening at the time. I think it's been good to live in a remote place without having to pay attention to whatever the magazines say is hot, or out, or going to be hot. I have been able to pay attention to a way of painting and make it my own. I've loved the contact with younger artists on the grant, too. There's been a lot of give and take, a lot of ideas, a lot of affection.

After their grants ended in September of 1978, Skinny and Gussie bought a house just across the street from the compound; they hired a contractor to build "his and hers" studios behind the house, and have lived there ever since. Their good friend Sue Ferguson recounts that when Skinny was in his late seventies and had already had two hip replacements, he decided he wanted to learn to ride horseback. He acquired a horse and kept it at Sue's house at the edge of town; he continued to ride it even after it bucked him off several times. Until Skinny and Gussie reached their early eighties, they remained extremely active physically: they swam laps every day at the New Mexico Military Institute pool, and Skinny continued to play golf. In February of 2006, just before his ninetieth birthday, his gallery, Meyer-Munson Gallery in Santa Fe, opened a retrospective of his paintings, including some very recent ones. Hosts of people came from all over the state to celebrate him. Earlier that day, his son Ted had taken him at his request out east of Albuquerque, where he fulfilled a lifelong dream and went up in a glider.

Both Skinny and Gussie and their work are greatly beloved by everyone connected to the compound, and by their many close friends in town. Their contribution to the community can hardly be overestimated, and they are a continuing and much-loved presence in Roswell.

Gwyn and Bill Ebie and Jean Promutico at Jean's opening at the Roswell Museum and Art Center. 1979. *Courtesy Jean Promutico.*

Jean Promutico
(1978–79 and 1990–91)

Jean Promutico has long divided her time between New York City and New Mexico. She received her Master's from the University of New Mexico in 1968, and has won a number of awards for her subtle and shimmering abstractions painted on unstretched canvas. She has shown at several prestigious galleries in Santa Fe and New York City, and has been an important figure in the art scene in Manhattan.

Janell Wicht (1978–79)

Just as Skinny and Gussie were settling into their new home, Janell Wicht arrived. She too would become one of the artists most cherished by the community and by the other residents. Janell came to Roswell just after she received her MFA from Ohio State University in 1978. At the time, she was working on unstretched canvas, creating patterns that evoke Native American designs, richly colored and evocative. Janell tells the story:

> On October 10, 1978, I trekked to the outback of New Mexico in my 1970 red Camaro from Columbus, Ohio, by way of my childhood home in Kearney, Nebraska. Roswell was a foreign land: barren in my view. The high plains were not really my idea of the Southwest. Red purple orange sky behind the pecan grove would have to do until I could visit the desert mountains. Well, here I was at the Roswell Artist-in-Residence Program. Now what?
>
> Adjusting to the studio was easy. Adjusting to the other artists challenged me. Andrea Grassi (fellow resident) was charming and flirtatious, I thought—but I didn't speak Italian and he spoke no English. Jean Promutico (fellow resident) spent hours in a kind of rhythmic trance, making tapestries. She was a fragile mystery to me. Was there a connection with Robin Shores (fellow resident)? I'm just not sure. He

1978 group photograph, as altered by Jean Promutico. (L to R) Friend of Lynda Long, Lynda Long, Bill Ebie, Gwyn Ebie, Jason Ebie (front), Janell Wicht holding Alexandra Ebie, Jean Promutico, Robin Shores, Frank McCulloch. *Courtesy Roswell Artist-in-Residence Program archives.*

made magical carvings of modern day tennis games and highly refined and ritualized coffee breaks. Lynda Long (fellow resident) had taken on a nurturing role with the Schooleys. All this made me feel lost; I missed my cohorts at graduate school. For the first part of my grant, my best artist buddy was Alex Ebie. She was the director's daughter, and she loved to come for studio time on Tuesdays. Only the best materials for this two-year-old. She would paint on paper on the floor, saying "I want to be an artist like you."

The director's wife, Gwyn Ebie, was the official compound den mother. She could weave yarn and coil a pot and tell great stories, all the while watching Alex in the playhouse and Jason, her son, building a rocket. I loved to hear Gwyn theorize about the process of adjusting to the compound—the second-month slump, the eight-month high, the eleventh-month fret. She would recount the "mythology" of the former grantees, and invent future lives for them. It became a game:

"After a number of years in San Francisco, his interest became focused on snails;" or, "Ms. _____'s passion for bamboo is apparent in her recent work."

I wanted to connect with people so that I could understand the very exotic place that Roswell was for me. Gwyn introduced me to local art types who would come to the compound for special occasions. The Unitarians offered other connections. Sometimes people just dropped by because they heard I was originally from Nebraska.

There were special days. On a cool Saturday morning in June of 1979 Don surprised me with a knock on the back door of House C, where I lived. He had guests with him. I'd been on the compound for eight months, and I'd hit my stride: studio, entertaining, pondering. Don never just came to call. He had been by House C for a potluck now and then. He had learned to make deviled eggs for his contribution. A neighbor or perhaps the Schooleys supplied him with huge fresh eggs, and another friend had given him a recipe involving slivered almonds. It was his first attempt at cooking since his wife, Pat, had died. The eggs were a big success. I remember them as golden three-inch boats sailing over a white platter on parsley waves.

"Don't mean to interrupt, but can we come in?" Don asked softly. Sally moved forward before he could explain. "Could we tour?" she asked, wide-eyed. "This was our house when my husband Bill Midgette painted on the grant."

I would do anything for Don, not only because of his generous gift to me, but because I couldn't even imagine the pain he had gone through. A month before I had arrived in October, his wife of thirty-four years had died, leaving him off balance. Not much was ever said about Don's grief, especially to him, but I ached for this man's loss. Unassuming, discreet, he was a giant in my life, and his only expectation for me was that I make art, without any other requirements. Here was a chance to do something besides just invite him for a potluck at the compound.

Don and his houseguests from New York were now my guests. It was a tour to show Sally's son Dameron where his crib had been, where Anne had learned her alphabet. A careful walk through those five rooms and I would forever be bonded to Sally, Anne, and Dameron Midgette. We drank raspberry tea at the big red-topped, chrome-legged table in the best kitchen on the compound. Although it was nine years since it had been their home, we shared stories and became family in "our" house. I was shocked as this newfound sister spoke of the untimely death of her beloved painter husband. Cancer had won out the year before. He was only forty.

We also drank in important life events: death, especially the death of partners; birth (Dameron was the first compound baby); and love, the encircling mystery of love.

As if on cue, the birdsong changed. It was sweeter, less shrill, and I saw a look pass between Don and Sally. This very private man and this electrifying woman were making a connection beyond their grief. Was it at that moment that they fell in love? There was already such compassion and affection between them. We were all part of the compound family. This was a place where we could all be real, even awkward in our emotions. Don and Sally would marry a few months later on the Ides of March, 1980.

The second phase of my grant was different. Frank McCulloch (fellow resident) and the Jason Knapp family (fellow residents) changed the complexion of the compound, and we became a potluck community! I had the biggest kitchen and front porch. We celebrated arrivals and departures, birthdays, Saturday, and new art work. Frank had triumphs in the print studio and with his guitar. His connection to Albuquerque brought many visitors to the compound. Frank taught me about New Mexico artists. We both loved to talk about color and work at night.

My most shameful admission is that I once forced Frank to kill. I was painting a large unstretched canvas on the floor when I felt a fuzzy black hand-sized creature assisting me. Frank was printing late at night in his studio and came to rescue me. He kept saying it was just a harmless tarantula but I wouldn't settle for anything less than death.

I like to puzzle things out, so I tried to learn something about the alleged "Alien Crash" near Roswell. I searched through the public library: nothing, nada, zero. Finally I found a small dusty pamphlet hidden among the books at the museum store. "Some beings from a distant planet may have tried to come here," I told Frank. He was unimpressed. "This *is* a distant planet," he said.

I didn't manage to learn much about the aliens of the crash site (twenty-five years ago, as yet unhyped, this was hardly a big news story), but I did get to know many people during my first year in Roswell. So I hung my show of big unstretched canvases, wrote my statement about them, and hosted a spaghetti feast at my house, spending my last hundred dollars so that it wasn't a potluck. Nearly a hundred guests milled about the compound, and the wine flowed. I had no idea what I was going to do next month when it was over, but for now I was celebrating the body of work I'd done, and the many connections I'd made.

After I'd cleaned up after the party and watched my parents start back to Nebraska, reality hit me. Now what? As it turned out, the grant was only the beginning of my luck. My RAiR show sold out; galleries in both New York City and Los Angeles invited me to show my work. I spent the summer of 1980 in a former artist-in-residence's Santa Fe loft.

In the fall, Don invited me back to Roswell. He offered me a large loft-type space across from the museum. I stayed another four years.

What was the gift of time for me? I had come to a barren land with only the myths of Georgia O'Keeffe in my head. I found a sky I loved, a southwestern artistic heritage to uncover, and connections to the enchanted people. I found many people who would become art supporters and friends. I found a generous family willing to finance a woman artist straight from an MFA at Ohio State. What was the catch? There wasn't one.

I found that Roswell has unique, original benefactors willing to give unique original artists a chance to grow up, to make their own statements.

In a time of *Let's Make a Deal,* this residence program has no deals. It has no fine print. It feels no obligation to play the fame game. It is truly about painting, sculpting, or inventing. For Don and Sally Anderson, it is not about "making it in the art world"; it is in fact about "making the world some art."

Rudy Pozzatti. *Courtesy of the artist.*

CHAPTER THREE

(1980s)

Time and Space

The early '80s could be said to mark the coming of age of the residency, with the artists seeming to settle into patterns of friendship with each other and with the community. One new development was the addition of the large new studio to accommodate those artists having artist spouses who needed a studio as well. That meant there were five family houses for the residents, and a total of seven studios, as well as the printmaking facility. Intermittently, Don Anderson, who loves to build, would refurbish one or another of the houses, taking out a wall here and recarpeting there; his goal was to make them less like ordinary houses and more like artists' lofts.

Rudy Pozzatti (1979–80)
A longtime professor of printmaking at Indiana University in Bloomington, Rudy Pozzatti is one of our most distinguished residents; he has over the years been the recipient of almost all the top awards in the field and has shown his work in numerous venues in the United States, Germany, and Italy, including the Chicago Art Institute, the Walker Art Museum in Minneapolis, and others too numerous to mention. Rudy speaks feelingly about his stay:

> The Roswell artist-in-residence grant is still one of the most satisfying experiences of my professional career. It came at a time when I was deeply entrenched with academic affairs at Indiana University. The

grant gave my family and me the opportunity to move to Roswell, where I was able to occupy myself solely with my own work. The new locale of Roswell and the Southwest reawakened my interest in the landscape and most certainly re-emphasized my sense of color. I met new artists with whom I shared thoughts and ideas. We all had an interest in the figure, so Don approved the hiring of models and we set aside specific times for drawing the figure.

We made important and lasting friendships with Skinny and Gussie Schooley. They are both dedicated artists with unique visions and worlds of experience in regard to the significant aspects of life—feet-on-the-ground philosophy.

Our two daughters who accompanied us, Mia and Illica, really enjoyed the school system in Roswell. They both had excellent teachers, especially in English, composition, spelling—it appears the schools were emphasizing the "basics." They were ahead of their classmates when they returned to their respective schools in Bloomington. This was the exact opposite of what our friends had predicted when we told them we were going to spend the year in Roswell, New Mexico.

Illica is a fine athlete, good enough to have been accepted to play in the boys' basketball league in Roswell. She finished the season as the most valuable player in the league despite the fact that she was the only girl in the league.

I recall with pleasure my talk with Don about the print facilities at Roswell. I told him my concern that we needed a good, clean, air-conditioned space for the storage and handling of paper for me and all the other artists. The very next day Don was at the studio with a surveyor. He suggested that my wife Doti and I and the girls take a car trip to see some of the sights in New Mexico and Arizona, which we did. We visited the Grand Canyon, the Painted Desert, the Petrified Forest, Oak Creek Canyon, and Cañon de Chelly, just to name a few. During our absence Don had his crew construct a very beautiful addition to the studio facilities especially for the storage and handling of paper, which I am sure has been enjoyed by everyone who has been to Roswell on a grant. Believe me, nothing ever happened that swiftly and precisely in the academic world!

There was a lunar eclipse in September or October of 1979. I did at least two works on the event. One, *Night Spectre,* is in the Roswell Museum collection. Natural sights—we marveled at the desert after all the spring rains. The transformation of the vast, lifeless space into a magic carpet of multicolored desert flowers. The Schooleys told us about the Bitter Lakes bird refuge. It was such a magical place. I experienced some extraordinary color sensations in the water and the

reflections of vegetation and cloud formations. The sensation of the light and color of the Southwest inspired a series of works—strip landscapes with usually seven or eight bands moving from the top panel, which was early morning, to the bottom panel, which was dusk. I did ten of these in the series and used the idea in many other works.

I was really struck with the petroglyphs I found at various sites. They were so graphic, incised in the rocks. The stark simplicity of the forms and their abstract quality resulted in a series of works based on petroglyphs.

My closest artist friend was Jason Knapp, an excellent sculptor and draughtsman. [He was a mild-mannered man with a wife and child, who created amazingly spooky figures involved with arcane activities.] We kept in touch for a while after leaving Roswell. Betsy Cain (another resident) was a painter from Atlanta; her housemate, David Kaminsky was a professional photographer. He did a lot of photo and slide work for all the artists.

I can't recall the name of the shop in town, but we used to make visits out there to dig through miles of antiques, things, more things, and perhaps what others would call junk. It was fascinating for artists. Both Doti and I recall wonderful things we wish we had purchased. Doti still thinks of a beautiful cut glass bowl she saw there.

We still have great fondness for the pecan orchards near us, and for the stand where we purchased many pounds of pecans. Doti just received an order from them yesterday—Mountain States Pecans. They said they were closing in two months, which was sad to hear. We ate many wonderful Mexican meals at Rulon's. The Schooleys took us there the first time. We have never found another restaurant that could match their *chiles rellenos*. I salivate just thinking about it.

The Roswell experience was an important one for my family and for me. We spent a wonderful year in a new environment, meeting new people, and experiencing new surroundings. This was invigorating for all of us. I was amazed at how much I was able to do in a year with no other major constraints on my time. After Roswell I became far more protective of my time in the studio, addressing my own creative development. My personal thanks to Don also for making a few of the grants available to older, more established artists. The young ones need the opportunity, but so do those who are further along in this mad pursuit of creativity.

One can never forget the spectacular light shows furnished by the lightning strikes during strong rainstorms. We used to sit on our porches with six-packs of beer, protected by the roof from the rain, to watch these awesome displays of electrical charges—more

entertaining than most movies or TV offerings. Once after a power-ful rainstorm and when the sky had cleared there appeared a series of partial or segmented rainbows—never saw anything like that before or ever again. We saw our share of gophers and roadrunners, as well as scorpions. Two of the scorpions we killed in our house I put into a three-dimensional construction entitled *Pagan Reliquary.*

Roswell had a record snowfall of twelve inches during our winter. Jason Knapp and I spent several hours in the early morning after the snowfall helping people get out of the ditch in front of the com-pound and giving quick hints and suggestions about how to drive in the snow.

The impetus of that year in Roswell continued for quite some time after my return to Bloomington. It was visible in my work and in the attention I gave to time in the studio—realizing the significance of the "Gift of Time."

Robert Jessup (1980–81)

Bob Jessup arrived about midway through Pozzatti's grant, in March of 1980, overlapping also with Betsy Cain; he and his then wife Roxie (also a painter) became good friends with the Schooleys. At that time, Bob was a figurative painter, using "invented and stylized figures and settings to explore themes of personal mythology and dreamlike narratives."[22] When he applied for the residency, he listed his "day job" as a part-time laundry truck driver in Rhode Island. Bob says:

> I still have dreams about Roswell. In them, I usually have several paint-ings going on at once; they're stacked against the studio walls and the shuttered windows. They are usually quite adventurous and I feel as though I am just on the verge of really getting somewhere with them, finding something new. The sense of excitement and creative potency in these dreams is intoxicating. Always in these dreams, the Roswell artists' compound is never home, but a remote place to which I have traveled, where the vastness of the space and clear intensity of the light ensure a sense of unlimited possibility and freedom.
>
> It is this overall sense of being totally submerged in the self-directed program of making my paintings that is the essential memory of Roswell for me. Of course there are individual memories of people, things, and incidents. The pink soil—I remember that the colors of Roswell made it far more attractive than I expected from the pho-tographs in the black and white brochure back in 1979. I loved the colors—the dusty green of the sage against the pink earth. The large metal drum in which we burned our trash stays with me—the image

of its glow on summer evenings. The excursions from Roswell were always somewhat daunting—especially up to Albuquerque and Santa Fe, when it took hours before you would reach the mountains and trees. But, when I finally went west through New Mexico's Hondo Valley, to Ruidoso and then down through the lunar landscape of the salt flats and the spectacular Organ Mountains, I knew I had found a landscape of the heart right at my doorstep.

Being an artist at the Roswell Artist-in-Residence Program was my first "big break" and it changed my life. Deep inside my painter's memory, I have never left my Roswell studio. I am painting more than ever.

Jessup returned to Roswell later, after he and Roxie divorced, and Don Anderson fixed up the building he owned downtown (121 West Third Street), so that he could live and work there. After that, he got a teaching job at Cornell and began to show all over the country. He and his second wife Faith are now at the University of North Texas, and he still has several shows a year in major cities. His work has evolved from the very large and ambitious three-dimensional painted figure pieces he did in Roswell, with quirky subject matter, having to do with balloon-riders, astonishing innocents, and voyeurs, to two-dimensional oil paintings, thickly and richly painted in brilliant colors. He continues to have a distinguished career.

Diane Marsh (1980–81 and 2002)

Diane Marsh studied painting at the State University of New York at Buffalo, receiving her MFA in 1978. Her painterly skills are breathtaking. She has chosen a difficult path, exploring figuration that carries a profound psychological and symbolic charge, and complex, evocative landscapes. She and her family now live near Abiquiu, New Mexico, at the heart of the landscape they love, and she continues to show her work widely. "I came to the residency in Roswell three times," says Diane.

The first time, I was twenty-five, right out of school, right out of New York City. That was my first time in the west—I'd never been beyond Chicago. It was so important for me to have had that time, a year to learn to live the life of an artist. I was so elated—working all day painting, then learning country and western dances at local bars. It was the *Urban Cowboy* era. I learned to ride horseback, too.

Diane, the lovely city girl, became enamored of horses and ended up going on a three-day trail ride into the mountains, to her own immense satisfaction. Sally Anderson sees this as one more example of how artists

arriving in Roswell reminded the local residents about the many possibilities to be explored in the area. Diane was close friends with Betsy Cain and with Rosie Bernardi, another fellow resident, while they were there.

Richard Thompson (1981)

Richard Thompson is a realist and a narrative painter who has won numerous awards (including an National Endowment for the Arts Individual fellowship) and whose work has been included in two Whitney Museum Biennials, as well as being shown in many prestigious galleries all over the country. He taught for many years at the University of Texas at Austin, and more recently has served as dean of the College of Arts and Sciences at Alfred University in New York. He was also an important part of that early '80s group on the grant: the lively and witty New York sculptor Pedro Lujan, and the painter Aaron Karp from Albuquerque, whose printmaker wife Jane Abrams visited often; later she was a resident herself.

Ann McGarrell reported a conversation in April 2004, while she and Richard were both visiting Roswell. Richard Thompson pushes himself away from the poker table early in the evening. "I have to get up early and go fishing," he explains. Nancy Fleming, former residents James McGarrell and Sue Wink, current residents Jo Ann Jones and Michael Beitz, and Bob and Aria Finch (good friends of the artists, and excellent poker players) all stay in the game. Thompson asks Jones and Beitz, the two youngest artists-in-residence, if they have any prospects for teaching jobs. They look astonished. "I'm going to keep on getting grants," says Jones firmly. "I'm not sure about teaching," muses Beitz. "I just want to make stuff." His studio is currently filled with ceramic feet that trick the eye across games of scale and distance, and he is building a bicycle-powered collapsible house in the adjacent meadow.

Later, back at the Anderson house, Thompson sighs: "Kids," he says. "When you're young you honestly believe you can do anything." He leafed through an album of slides and Polaroids of his 1981 show at the Roswell Museum. "I thought I could tell the whole history of the West through my family." He shows how he carefully mapped the Roswell Museum installation of *The Ancestor's Dream*, his 1981 series of paintings building a narrative of his family's journey across the continent.

Richard muses: If I were to build a model for my experience it would certainly have a spiral as its armature. As an artist, as a person, I don't move in a straight line; rather, I am always spinning, turning with one experience, one image always coming back on another at a different time and at a different place. Always coming back and adding meaning, richness, and depth—and also adding new images, further complications, and further contradictions. One painting, one idea, one concept doesn't exist

Richard Thompson
preparing for his
exhbition. 1981.
*Courtesy Roswell
Daily Record.*

for me; instead it is the unfolding of images one into the other, one on top
of the other, one on top of the other spiraling around up and down.[23]

Describing *The Ancestor's Dream*, Thompson says it remains a highly
personal story within the context of his work, "centered around my own
questioning about my being an artist at all, coming from Oregon farm
roots and loving parents who had other dreams, other ideas about my
route. In thinking this over and over, I can only fantasize about my father
and his dreams, and his father and his dreams. A genetic trail obscured
by time that I can only see through imagination and art. I approach this,
questioning, the best way I know how. I set the stage with images, char-
acters, and ideas and try to pull out patterns and meanings. Take what
you can."

The exhibition included not only paintings and drawings, but interpolated objects: clocks, candles—props for the imaginary play performed by Thompson's long-dreaming ancestors.

Thompson remembers: "I dedicated my exhibition at the Roswell Museum to my father, Vernon Henry Thompson, 'born July, 1911, Dayton, Oregon, farmer, amateur astronomer, and one-time builder of radios.'"

Since then Thompson has had a long and distinguished teaching and exhibition career, but his work continues to be imprinted with the passions and imagery of the West.

He speaks of the inspiration he found in Luis Jiménez's work and friendship. "Luis had such great honesty and conviction," he says. "Such presence. It was very strengthening to know he was working nearby."

Thompson and Jiménez share a love of trout fishing—"yet another way—like making art—of participating in parallel worlds."

David Hollowell (1981–82)

David Hollowell received his MFA from Yale in 1976 and went on to teach at a small college in St. Louis before arriving in Roswell. After leaving Roswell with his wife Terry, Dave taught at the University of California

David Hollowell, *Artist and Model.* 1982. Oil on canvas. 80" x 110". *Courtesy of the artist.*

CHAPTER THREE

at Davis, and showing his large, realist canvases at galleries all over the country. Terry Hollowell remembers:

Dave and I arrived in Roswell in December, 1981. I remember how amazed we were at the generosity of the grant. A house, a separate studio, a monetary stipend. They even furnished us with linens and dishes—everything we could possibly need. The house they gave us was enormous, and I converted one big bedroom into a darkroom. I had always lived in big cities, and was apprehensive about being out in the country with artists for neighbors. Would they be friendly, or would we feel isolated? It took a little while for them to warm up, but it did happen, gradually. We soon fell into a routine of luxurious time to do art, with no limits even on the amount of supplies Dave could order for his work. It was rumored that there had been a sculptor who spent so much on gold leaf that the limitless art supply allowance finally reached a limit soon after we left.

I liked the way the residents changed. One by one as the months passed, an artist would leave, to be replaced by another, instead of everyone leaving at once. We were able to absorb new acquaintances little by little.

We started having Wednesday night poker games, for nickels and dimes, the biggest winner hosting the next week's game. I had a graphic design job for the TV station in town, Channel Ten I think, and one night I brought home the husband of a work colleague to join us for poker. I don't know how this guy did it, but he had spectacular hands every time, and the bets kept getting higher, and finally everyone was mad at me for bringing home a ringer.

We got our monthly stipend each month on the twentieth. It's weird, but even now, twenty-three years later, I think of this when the twentieth of each month rolls around. It's funny, what you remember and what you don't. I remember so much of that year, probably because it was so different and stimulating. One of the strongest memories is from when I went up in the hills with a group who was castrating lambs by biting off their testicles. There was an artist who wasn't on the compound, but part of the scene somehow, and he was a part-time cowboy. There was a rancher/banker who raised sheep up in the hills, and in the spring he and a bunch of workers would go up there and castrate sheep the ancient Basque way, by biting. I went to document this bizarre practice. One man held the lamb tightly against his chest, and another would open the sac, squeeze, and bite off what popped out. A quick dab of paint on its back to show it was done, a shot of antibiotics, and it was tossed in with all the other poor little lambs to

look for its mother. Lots of blood was splattered and I photographed the whole process from start to finish.

The people I remember best are Skinny and Gussie Schooley who lived across the street. They were like a set of free parents, along with everything else the grant offered. It was inspiring to see two artists of that age who continued to do their thing. Pedro Lujan, who had the oldest dog I'd ever seen—we called her "Moldy Oldie." Aaron Karp, the abstract painter from Albuquerque; Ed Vega the sculptor, and Irene Pijoan, who is the only person from Roswell we still see occasionally, since she lives in California.[24] All these people were photographed by Dave and me, and many made it into Dave's paintings, and are still being used now. When I look at a recent painting I see a mix of people from St. Louis (pre-Roswell), Minnesota, the Netherlands (post-Roswell), California, but mostly from Roswell.

One result of having a big studio and limitless supplies was that Dave's paintings became very big. Toward the end there he finished a 10' x 20' painting on canvas. It was called *The Opening* and was filled with Roswell people. This painting was the culmination of the year's work and went in the end-of-grant show at the museum. When our time was up, we unstretched this monster painting and rolled it. After a couple of years, we had unrolled it a couple of times to restretch and show it, and it began to get rather frayed at the edges. When we arrived in California, Dave laid it out on the driveway and took a razor and cut it up in little pieces. Many years later Dave made them into fake wall fragments. I made up an elaborate story about them being part of a destroyed fresco Dave did in Italy, and we showed them as such in a gallery last year.

Terry and David Hollowell. 1982. *Courtesy of the artist.*

I remember Don's amazing house and an enormous sculpture/ hideaway [*The Henge*], curving around on a hill, with a secret roll-away door. I remember Don's enthusiasm for everything, and finding him out in our backyard at the compound with a backhoe. He had just accidentally dug up the sewer system.

I remember actually seeing a roadrunner, running down the road past the compound.

There's too much to remember. It was an incredible experience, my last year of being footloose and fancy free. When I left Roswell, I was pregnant. I remember going to a Halloween party as a woman who was barefoot and pregnant. Now there are Loie, 20; Lucia, 17; Adrienne, 15; and Jack, 11. I'm still doing

Group photograph. November 1982. (Seated around table L to R): Jason Ebie, Ed Vega, David Hollowell, Terry Cronan Hollowell, Irene Pijon, Alexandra Ebie, Gwyn Ebie, Martie Zelt, Susana Jacobson. (Standing): Bill Ebie. *Courtesy Roswell Artist-in-Residence Program archives.*

art, graphic design, but digital has replaced darkroom chemicals. I photograph and design art posters for artists having shows or just wanting reproductions of their work. Dave has been teaching for twenty years at the University of California at Davis, still putting little dots of paint on panels (no more canvas).

Martie Zelt (1982–83 and 1989–90)

Originally from Pennsylvania and schooled at the Pennsylvania Academy of Fine Arts, Martie Zelt has subsequently lived in several different countries, including Spain and Brazil, before settling in southeastern New Mexico. Her work is characterized by varied cultural references and influences. She was originally well known on the East Coast for her woodcuts, but she later moved "out of the restricted range of traditional print media and materials. Her works broke free of the picture plane and got more physical, taking on the object-like, three-dimensional qualities that [characterize] them as 'constructions.'"[25] These delicate, probing, mixed-media works on paper have also come to attract nationwide attention. Her largest work is the impressive thirty-two-foot mural on public display in the lobby of the Roswell Civic Center: an immense landscape created from a profusion of materials: tile, mirror pieces, shards, marble, and Pecos Valley Diamonds, to name a few.[26] Her work continues to

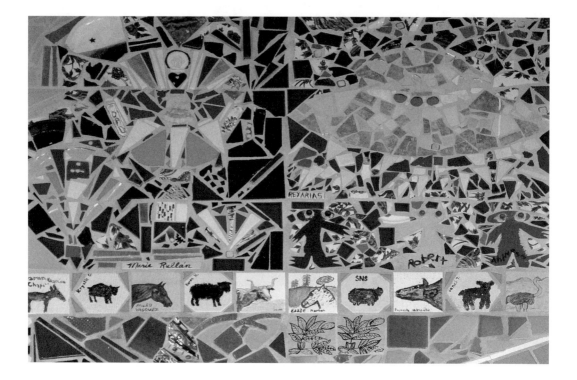

Martie Zelt.
Detail of *Roswell Strata/City/Skies*, 32' ceramic tile mural at the Roswell Civic Center. 1995. *Courtesy Roswell Artist-in-Residence Program archives.*

attract attention all over the country, and she has had solo shows in several major museums.

Jerry Williams (1983)

Jerry Williams was based in the Boston area when he first applied to the grant. He had studied art at the Rhode Island School of Design and in Mexico City, and was working on "the relationships between painted space and real space; natural light and artificial light; painted forms and real forms."[27] To do this, he created small boxes, miniature tableaux. Jerry relates:

> When I first arrived in Roswell in 1983, I stopped at a fast food restaurant. I asked the waitress where the Roswell Museum was. She said she didn't know there was a museum.
>
> As I left the restaurant I glanced across the street at what looked like and indeed turned out to be the Roswell Museum. My first impression was that art wasn't very big in Roswell. Later on I made friends with a great many Roswellians, all of whom knew where the museum was.
>
> Soon after I arrived on my first residency I drove to the nearby gas station/convenience store, and there was a rattlesnake coiled and rattling in front of the door. Business came to a complete halt. Customers

stood outside staring until the owner came out and whacked it with a shovel. This really was the Wild West.

Big things happened to me after my first residency: I had my first one person exhibition in New York City and soon after that, I left for Europe [and took up residence in Sweden].

Stuart Arends (1983–84 and program director, 1987–93)

Stu Arends, now a prominent figure in the international art world, is a particularly American artist. Born in Iowa, educated in Colorado, Canada, and California, Arends makes elegant minimalist works that reflect both his love for the monochrome New Mexico desert landscape and its tenuous infrastructures. In recent years he has shown with elements of the Italian arte povera group in several prestigious venues.

His surfaces have been described as a series of superimposed skins: a base of wood, metal, or cardboard, coated with wax or oil paint, which is in turn covered with another pigmented layer. These skins may be wounded, pierced, or rent in the process of recording the artist's marks. His recent works—a series of "Saki Boxes" three and a quarter inches square—are paintings about painting, employing brilliant reds and blues, in contrast to the reductive neutrality of his earlier work. These tiny objects demand perfection. Stu says:

> I look on the paint I use like blood, the wax like flesh, the wood and steel like bone, and how these elements all function in the space of the structure. If you go down inside yourself, there is a level of concentration that means you are . . . in tune with what you are working on.[28]

Arends first came on the grant in October of 1983, overlapping with Jerry Williams, Mark Packer, whom Stu remembers for "his amazingly quick wit and insane machines," and John and Astrid Furnival from England. Stu remembers:

> As I was leaving the inner city of Los Angeles for New Mexico (a place I had never been) a friend who had grown up in the deserts of California said to me that they had a saying: "If you take somebody out of wherever and put them in the desert and make them live there for a year, they will never live anywhere else." I was thinking of this as I was approaching Roswell across that great, empty expanse, and I said to myself, "Man . . . this is going to be a long year."
>
> The first evening (I hadn't even spent the night yet) Jerry Williams came by and said, "Let's go for a ride." So I said to myself, "What the heck. Just got here. Might as well go for a drive." So we went out to a

vantage point in the desert and watched the most incredible lightning display I had ever seen. I was hooked. That first night on the compound turned out to be the beginning of a very short, fast, productive year. By the end of which, I had become, and remain, a hard-core dedicated desert rat. And my one year in the desert has become more than twenty.

Some of his memories from this first year include: Astrid Furnival's tomatoes, which she coaxed to ripeness out in front of their house; John Furnival's accent, which was often incomprehensible to people in town, especially in the post office, when he was requesting "normal stamps," as opposed to foreign air mail ones. He also remembers late night fires, after potlucks; sometimes flies; always stars. Lots of studio time, lots of work done.

After his grant, Stu and his then wife Vicky, a lawyer, moved back to Los Angeles, but within a few years they returned to Roswell and stayed in the building Don owned downtown. Then in 1987, he was appointed program director of the residency. Stu recalls memories from this time:

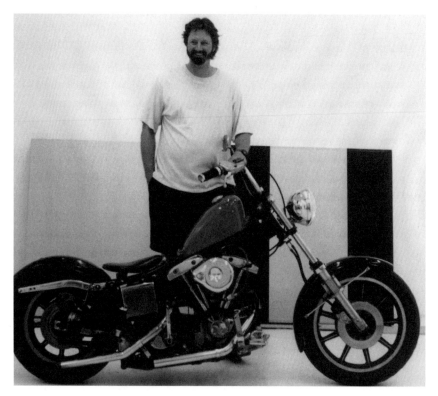

Stu Arends with motorcycle. 1992. *Courtesy Roswell Artist-in-Residence Program archives.*

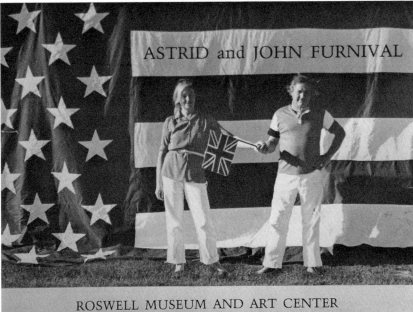

Evening Margaritas on Biff and Daisy's porch; the band, Nightcrawler.
I also remember some of the artists who came from Los Angeles to the
grant at the end of the eighties: Wild Ray [Waldrep] who requested
blackout curtains in his house; [he had never been away from home
before and ate almost every evening meal with Stu and Vicky because
he couldn't cook.] Robbie Barber's golf bag sharks [made a big impres-
sion.] And then I have recurring memories of Don on his front loader,
and Sally's work on the Navajo dictionary.

John and Astrid Furnival (1983–84)

Astrid Furnival's medium is fine wool yarn. I first saw her work at
maximum splendor when she knitted a sweater for Jonathan Williams,
incorporating Samuel Palmer's self portrait. She works exclusively with
natural vegetable dyes. During her Roswell year, she was stimulated by the
comprehensiveness of the Navajo language (Sally Midgette Anderson was
helping to compile a lexicon of that rich tongue during the early 1980s).
One of her pieces in the Anderson collection incorporates the permuta-
tions of the Navajo word for blue.

John Furnival, graphic artist, concrete poet, wit, has frequently col-
laborated with Jonathan Williams at Jargon Press. The Furnivals live in
the Dordogne region of France. John Furnival says:

Our year in Roswell was a marvelous experience for us, as, basically, there was nothing to do but work, completely free from the ordinary worries of everyday existence. Getting off the plane from Albuquerque was quite a climatic shock, as we had flown in from Kentucky (where, being November, it was already pretty cold) into the oven of Roswell air. We soon found out that it isn't always an oven. The next evening, having settled into our little house, we decided to go for a walk in our summer clothes. By the time we had gone around the pecan plantation, the temperature had dropped to well below zero. A kind lady stopped to offer us a lift, saying that we would "freeze to death," but we declined, only to realize a little further on that she actually meant it. We got lost. All the houses seemed the same to us, so in the end we were obliged to knock on a front door to ask the way. The door belonged to Jerry Williams, our next door neighbor, so we were saved.

By the time Don gave his annual Christmas party, the weather had gotten really cold. We had a friend staying with us for Christmas, Richard Loncraine, the film director, and he, being a pyromaniac, set up a fireworks display on and around *The Henge*. I don't know if Sally remembers, but when we all went out to watch it, she slipped on an icy step and landed on her bum, but no harm was done.

Robert Tynes (1984–85 and 1991)

Bob Tynes studied at Eastern Carolina University, where he earned a MFA in 1981. He is a painter whose technique is to superimpose objects (mostly commonplace ones, like pencils or pieces of fruit) on a painterly abstract background, with startling effects. His goal is to explore the "mystery and humor inherent in the nature of illusion and life itself."[29] Bob relates:

I have begun to remember more than I thought I would, with the help of my wife, Bette Bates, who was there with me both in 1985, and on our return during the summer of 1991. Bette, also an artist, was given her own studio during both residencies.

In thinking back to my time at Roswell, what I remember first of all is how great I felt when I learned that I had been chosen for a residency. At the time, I had been teaching only for about two years at Humboldt State University in northern California, but I was elated to be given the opportunity to focus entirely on painting for a full year. As I recall, we arrived in Roswell at the end of December 1984.

It may have been the first morning after we arrived that we heard someone trimming limbs out in the yard beside our house (House E). It was a man with white hair who was driving an old station wagon

that had a Mickey Mouse decal on the side. Well, it turned out to be Don Anderson himself, and we soon learned how down to earth and truly generous he is. He wanted to be sure we had everything we needed. Artists were invited out to Don and Sally's wonderful house on numerous occasions: to a fabulous string quartet concert, to a pool party, and to dinner and a tour through *The Henge*.

The main thing I remember about Roswell was the incredible amount of time I had to focus intensely on my work. And when I was there in 1985, we enjoyed the benefit of having all our materials and supplies provided if you used them. What an incentive to get work done! I really can't imagine a better "dream come true" than that year was for me, at that time in my life. I have continued to paint since then, but because I returned to teaching college full time, I have not been able to match the level of production that I had during my year there. But Roswell showed me what I could accomplish given the time and commitment, and it keeps me looking forward to spending summers, and eventually my retirement, in the studio.

Robert Tynes. *Courtesy of the artist.*

One of the biggest advantages of Roswell, besides offering us time and space to work, was that it was a community. A community that slowly changed over time, but nevertheless gave us all an opportunity to share and learn from each other on an informal basis. Indeed one could choose to have as much interaction with the other artists as one wanted. I personally found it helpful to have others around for inspiration, in addition to being able to provide feedback and share ideas.

Besides memories of the beautiful landscape, the many spectacular sunsets in Roswell were unforgettable. We would often spread the word around the compound when there was a particularly dramatic sunset, and we would gather our folding chairs, plant ourselves on the grass just outside Studio E-2, and enjoy the sky together.

I also recall much of the wildlife we saw right there at the compound. Besides the noisy grackles that were plentiful among the mulberry trees, we especially liked the burrowing owl and prairie dogs that we kept watch on through binoculars across the desert field. In addition, we were impressed by the large family of skunks we saw walking by in a single file one day, not to mention the occasional roadrunners, jackrabbits, and tarantulas we saw while there on the compound.

Skinny and Gussy Schooley were former artists-in-residence who lived just across the street. They both had colorful names, and characters to go with them. We enjoyed visiting them, loved their irises, and remember well their aggressive geese and how we fended them off as we arrived and departed from their yard.

When our time was up at the beginning of 1986, Bette and I had been accepted to the Ucross Foundation Residency Program in Wyoming, but we were not scheduled to be there until mid-March. So Alison Saar, a resident who was leaving soon, was kind enough to suggest, with Don's permission, that we move into her house (House F, I think, directly across from my E-2 studio) and extend our stay until we left for Ucross. It worked out fine for us, as Alison had three bedrooms and two studios, which allowed us to store our stuff and keep on working for a couple more months.

On an excursion into Roswell one day, Bette and I found an old department store that was closing and we were able to buy a female manikin that we named Ruby. We put her in a red dress and everyone who came to our house for a visit would inevitably jump within a minute or two, startled to see someone standing in the corner of our dining room. When we were leaving Roswell, Don expressed an interest in "adopting" Ruby. Bette and I were happy to be able to leave her with Don and Sally, where I assume she still is.[30]

Elen Feinberg (1985–86 and 1991)

Elen Feinberg received her BFA from Cornell University in 1976 and her MFA from Indiana University in 1978. That same year she accepted a teaching position in painting and drawing at the University of New Mexico in Albuquerque. By the time of her first residency in Roswell, Elen had exhibited her paintings in New York, Houston, Los Angeles, Phoenix, and Santa Fe, and had become deeply involved in the teaching and administrative life of the university. Her sabbatical year coincided with the Artist-in-Residence award. "Impeccable timing," she would say later. She was not yet thirty years old.

The drive from Albuquerque to Roswell was exhilarating. She perceived it as a passage back to her life as a painter after six years of intense and uninterrupted teaching. She recalls:

> I distinctly remember driving through Tijeras Canyon, just past the city limits, then slowly creeping up toward the rise that opens up into a landscape of limitless beauty. Just as I crested that rise, a vast, sublime, unending landscape unfolded before me, and I felt it. Distinctly. Viscerally. The monkey that had landed heavily on my back in July, 1978

(the year I metamorphosed from student to professor) leapt off and disappeared, right through the roof of my car. Poof! Gone.

I was as light as a feather. I was a painter again, that was my only title, my only mission, my only responsibility. Twenty minutes into my RAiR grant, yet I knew I was approaching a transformative experience.

My arrival at the compound was particularly sweet. Bill Ebie showed me "my" house, larger than anything I had ever lived in since I left my parents' home years and years earlier. Then "my" studio. I remember we had a difficult time opening the double doors: the supplies I had ordered had already arrived and were stacked just inside, blocking one of the doors. We finally pushed the doors open and I saw what appeared to be a mountain of art supplies, all marked with my name. Had I gone straight to Painter's Heaven, or was I simply being spoiled rotten? French oil paints! Belgian linen! Sable brushes! Huge stretcher bars complete with cross-braces! And then there were the soaring ceilings, tall north windows, great banks of lights, an eight foot sink, a painting wall the size of Kansas—and back up space! Seemingly endless back up space! I almost burst into tears.

Bill left me and I found myself practically dancing across the compound until—only slightly embarrassed—I was spotted by two of my neighbors, one of whom I had known previously from Albuquerque, the painter Aaron Karp, and his next-door neighbor grantee, printmaker and painter, Dan Socha. They were sitting outside their studios having a beer to celebrate an impending rain. They welcomed me; I joined them and so began the beguine.

I had brought virtually all of my still life props: my tables, my objects, my textiles—with me to Roswell. But at once I saw that it was the landscape that would consume me. Surely enough, as I began to paint, a disappearing act also began. It started with an appearance, the apparition of a small window containing an image of the Roswell landscape—at night, of course, since as yet I really had no idea how to approach the landscape. But I looked. And I watched almost every day sky and night sky and sunset, encountering rattlesnakes (no bites) and scorpions, and desert centipedes. I kept on looking, watching. It was a time when big, "bad" painting was all the rage. So I worked toward the sublime, and painted, yes, sunsets. I wanted to paint them without being saccharine or sentimental. I wanted to paint the extraordinary in the ordinary. And that's exactly what happened. Slowly the windows in the still life paintings got bigger. Then the floor disappeared, then everything but the table top disappeared, then the table top disappeared, morphing into a window sill. The objects

remained, but with bigger and bigger landscapes behind them. Then one day, the objects disappeared. I was outside. Years later, even the land disappeared and turned to water which itself disappeared and I was left up in the skies, in the cosmos, the place where my paintings still reside. My year in Roswell expanded my artistic sensibilities. I was free, finally, to mix the thoughtful with the playful, the careful with the adventurous, the reflective and the elegiac. It made me grow. It was like being in a hot-house for artists: one doubles, triples, quadruples, and in condensed time, plants roots which spring into complex plants, even trees which bloom and leaf. The amount of uninterrupted time I had was astounding to me, the expanse of an entire year. When I first arrived I painted for twelve hours a day.

This lasted for over two weeks before I realized that I would not survive week three of forty-eight if I didn't slow down my pace. So I did.

Our group flourished together. We had weekly poker games, weekly video night, morning aerobics, afternoon burritos, birthday parties, cookouts—and we helped each other—when asked—with our primary endeavor, to make art. We looked, we critiqued. We photographed, we built crates, we prepared for openings. It was a commune that would have been the envy of the '60s. My friends became friends for life. One in particular, my friend, Dan Socha, taught me about how to embrace all that was both elegant and lively in the life of an artist. His own life and work continue to inspire me.

The sadness at the conclusion of my grant was profound. Leaving that contained space, quiet, productive, playful, supremely joyous, intensely clear, was like leaving Eden.

The Beyond, (beyond my dread of leaving for The Beyond) consisted partly of my not having considered how I was now going to have to move all those eight and ten and twelve foot paintings I had merrily been working on as if I'd never be moving again.

I suddenly realized that I had the equivalent of a family of ten small children: the care, the feeding, the moving, the shelter. I was honored that the Roswell Museum purchased a nine foot painting, and a local lover of the arts acquired an eight foot one, but that still left many to tow. What a long, sad procession from beloved Roswell—and what a huge truck from U-Haul! Happily, almost every painting I made while at Roswell, especially the large ones, has found a home.

My return, with Dan Socha, a few summers later, proved to be yet another productive, wondrous, and memorable time for us both. This time, when we left Roswell, we took a souvenir: Abby, an endlessly playful chocolate Labrador from the Roswell pound, an animal who

was a marvel and a constant companion until this past December, when, one month short of her fourteenth birthday, she slipped away.

That year in Roswell was pivotal. In fact, that year has never stopped being pivotal. It has remained my touchstone, my beacon of light throughout my artistic life.

Ted Kuykendall (1985–87)

Ted Kuykendall, the extraordinary photographer, had been around the compound intermittently for several years, working for Luis Jiménez and befriending many of the other residents at various times, before he came on the grant himself in December of 1985.

> Before I went to work for Luis in 1973, I had no ideas about art. I was glad to be involved in something entirely new to me. I began photographing in 1975, while still working for him. I bought a camera to take on a planned trip to Venezuela. I didn't go on the trip but I kept the camera. Later a painter I had come to know [Richard Shaffer], who now lives in Texas, was painting downtown on top of a building. In fact, I helped him find the place. I knew the town, having grown up here. I visited him a few times on the rooftop and took the camera with me. I remember trying to photograph what I thought he was painting. Later I wandered around and looked for other things. A friend from a local camera store offered to show us how to develop and make prints.

Ted Kuykendall. Photograph by Richard Shaffer. *Courtesy of the artist.*

We printed about sixty small black and white prints, all in one night. They were all underfixed and began to turn brown and fade almost right away. They looked older than they were. When Richard left town for good I gave him all of the small prints. It felt right; I had learned a lot. Just recently I saw him in Texas and asked if I could see the prints. The answer was no; he had sealed the prints in a block of paraffin along with his diary of that time.

Kuykendall's photographs are a stunning record of his flowering as an artist and of friendships formed at the compound.

Stephen Fleming: "Ted Kuykendall was very intense and raw, with a cowboy accent and a keen radar for any kind of pretension."

Richard Shaffer: "I loved this guy, and he is a brilliant artist-photographer."

Rebecca Davis:

One memorable excursion was with Ted, a young man who helped Luis with his sculpture. The following is from journal notes that I made after our trip to his ranch.

Ted, with his gentle eyes, open face, Sears and Roebuck work pants, worn out tennis shoes, hair that never quite lies down or quite stands up, had invited us to visit his family's ranch. We loaded our sleeping bags in the back of his red Datsun car, and he mentioned that he had vacuumed out the car till the vacuum broke. I got in the back, Roger Asay in front. The dust was thick over everything; the car was red like the earth all around us. The salts in the soil were eroding the rubber and paint. The speedometer didn't work and was covered by a photograph of a farm. Several knobs were dangling free from the dash, along with one Chinese coin on a leather thong, There were several photos on the dashboard and pictures drawn in the dirt by Richard Shaffer from an earlier drive.

We drove quite a ways north of Roswell along the Pecos and off, for sixteen miles or so of dirt road. The land was a striking contrast of red earth and green mesquite. Ted pointed out a trail on the mesas to our left that he said has been an ancient route of Plains tribes. On we went, watching the intensely deep sky and the shifting forms of the land.

Dipping down into a gully, we saw a large diamondback rattle-snake in the road. It had beautiful black and white stripes in front of the rattle and the rattle vibrated with a crisp warning. The snake coiled and then moved slowly off. What an impressive beast! We just got going down the road again and there was another rattler! We got

out of the car and followed it a ways as it moved to safety under a mesquite tree.

Ted pointed out an outcrop where lightning hits even in storms that bear no rain.

We entered the ranch and Ted described some of what is involved in their farming and ranching. The house where we stayed was strikingly empty, stark white, no curtains, dusty. For dinner we ate beans, Velveeta cheese, and white bread.

This morning Ted brought us to his horses and a magnificent ride through open land. The land here feels so full of surprises, wisdom, and stories. With reluctance but with fresh inspiration we began our journey back home.

Experiences like these feed into your being, and though you may not be conscious of their effects they become part of your perception.

Bernard Schatz, formerly L-15 (1986–87)

Stephen Fleming:
I guess you've heard about L-15? It turns out everybody had nightmares about him, sometimes the same nightmare, hiding in tunnels under the compound to escape from old "L." He started doing ceramics at the museum. Aria [Finch] said she sensed a demonic presence when he was there and had her prayer group come in and do a cleansing service.

An outsider artist whose work has been exhibited internationally, L-15/ Bernard Schatz speaks of receiving angelic visitants, Golk Golk and Moh Moh, who enumerated his entire artistic production: 1,812,915 pieces of art by the time of his Roswell residency in 1986. They also affirmed his status on Earth as an Intergalactic Guru Artist, and dispensed the advice that, according to the poets William Blake, Rainer Maria Rilke, and James Merrill, angels always seem to give: "Keep working," "You must change your life," "Prepare."

L-15's work has been widely exhibited in the U.S. and Europe, and is in the permanent collections of the Museum of Visionary Art in Baltimore, and the Musée de l'Art Brut in Lausanne, Switzerland. L-15/Bernard Schatz recalls:

Perhaps the most memorable event vis-à-vis myself and the Artist-in-Residence Program is that I got the grant in the first place. Tom Patterson, my agent, had been by the museum and had given a slide presentation that included some of my work. As a result of the presentation I received a grant application.

Now, I desperately needed that grant because I was extremely poor, as usual (the driven-artist syndrome). However, my overblown artist ego prevented me from filling out the application (after all, I was Master Artist L-15).

Week after week passed with that application collecting dust on the shelf, when I hit upon a solution. I printed out a form that the museum would have to fill out and send back to me. If they filled out my form, then I would fill out theirs. My form ran something like:

[1] How long have you been a museum?

[2] List five reasons why you became a museum.

[3] Send descriptions of ten projects you have presented in the past twenty-four months. Include five slides of each project. Etc.

Astonishingly, not long after sending my form off, I received a phone call informing me that I had won a grant position. I later learned from Don that the day my form arrived in Roswell was the final day of deliberation about who would receive the next grant. The applicants had been narrowed down to three when the selectors took a lunch break before deciding who the finalist would be. Don went to his post office box, found my form, and for some reason or other felt that I was just what the program needed.

I remember the welcoming dinner that Don presented to newly arrived grantees. I believe it was a regular little welcoming ritual in which Sally prepared her culinary specialty. Cinda (sadly, we are now

L-15 (Bernard Schatz) in his school bus, ca. 1986. Photograph by Joe Grant. *Courtesy of the artist.*

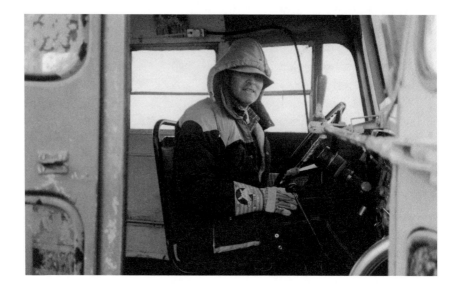

CHAPTER THREE

divorced) and I arrived to find it was a pork dish. We were vegetarians of some twelve years' standing. We glanced at each other as ample servings were heaped upon our plates. We couldn't insult our generous host by declining his offering, and so we dug in with pretended great gusto. Actually, it was delicious. So ended our vegetarian period.

Being a doting father, almost everything revolves around daughter Anna. I think the ages two to four are particularly wonderful, and that is how old Anna was then—ergo a great many happy memories of the compound. (By the way, Anna is now twenty-two, and is an artist in her own right. She does wonderful kinda Tibetan puppets, some life size. She is about to graduate from William and Mary. She is applying for a Teach America grant. Her first choice is a Native American reservation in guess where?—New Mexico. But don't get me started about Anna.)

A non-Anna memory that comes to mind was an expedition to the bird sanctuary that took place in my old, battered thirty-two-foot school bus. All the seats had been removed so as to carry around my art from place to place. Fellow artists, museum folks, and the Andersons brought folding chairs on board so all could view the birds through the washed-for-the-occasion windows of the bus. Looking back on it, I am afraid I got a bit carried away, and thought I would give the travelers a thrill by driving at breakneck speed down the dusty road to the sanctuary. Somehow we all survived although the chairs were bounced around somewhat. I think we all enjoyed the visit. Come to think of it, however, I was not asked again to ferry a group out to the sanctuary.

I spent three months making a maquette, using the bus as a model, for a sculptured thirty-two foot bus. My plan was to drive around the country in the elaborately decorated bus, stopping here and there, giving a little speech on art, and then driving off after inspiring the onlookers, especially the children, to do art themselves. Nothing came of the project.

By the way, one of the wonderful things that happened at my recent exhibit was how many people told me that my stuff inspired them to make art. It reminds me that one of the reasons I do art in the first place is to excite latent creativity in others.

Eddie Dominguez (1986–87 and 2002)

Eddie Dominguez is a ceramist and mixed media artist who studied at the New York State College of Ceramics at Alfred University, receiving his MFA in 1983. He taught briefly at Ohio State University and was supporting himself as a wood finisher and antiques restorer when he applied to the grant. Eddie says:

I applied as a mixed media artist because it really seemed the direction I wanted my work to go, but without the grant that's pretty difficult. I had the idea for the bedroom [the installation he did for his show at the Roswell Museum], and I thought gosh, a bedroom in itself has so many different materials—there's wood, there's paint, there's tin, there was carpet and fabrics and they were offering me all that, said it was okay to go ahead and do that. So you know that alone gives you this incredible freedom to be creative. They're saying, "Go for it," and you can! And you do—at least I've tried to do that. The fiber for example, sewing—I'm not a tailor, but it was something new to learn and something that had to be done within that environment because I wanted a quilt. I wanted to make that quilt because I wanted to control those materials. Working on it day to day, resolving a problem, can really get things done. I am a ceramic artist, so before that I was making dinnerware sets or environments for dinnerware sets, but I thought the grant offered something else and I wanted to explore a different area. I mean they give you a complete facility, they give you the materials, they give you time—real time. So I thought what better way to use that time than to try to invent something new?"[31]

Stephen Fleming remembers:

I was so fortunate to have been here with Eddie; his glass is half full, even when other people are trying to empty it. Eddie had been curated from a New Mexico regional show. He was so ambitious and gifted, really good at everything he touched. He did this installation, *The Bedroom*, and built every bit of it, making a quilt, furniture, everything. It was wonderful.

Dominguez seeks constantly to explore the relationships of humans to the natural world. His work is about going beyond the medium of the moment, be it ceramics, painting, or sculpture. Endlessly inventive and personal, his objects evoke not only the New Mexican landscape but the artist's interior life.

Stephen Fleming (1986–87 and 1991–92, codirector with Nancy Johns Fleming, 1993–present)

Stephen is probably one of the best-traveled of the residents, having lived in California, Arizona, Mexico, the West Indies, Holland, and London as well as New Mexico. He received a certificate in painting from the Royal Academy of Art in London, as well as an MFA from the University of California at Davis. His art is also extremely versatile: when first on the grant,

he was painting enormous floating nude figures, ethereal and surreal at
the same time. Later he took up ceramics, "pushing the envelope" with
strange unearthly sculptural forms. Stephen elaborates:

> I first heard about the Roswell grant from Dave Hollowell, who was
> a new faculty member at the University of California at Davis where
> I was doing an MFA. I'd been studying with the painter Wayne Thie-
> baud and the sculptor Bob Arneson, who were sort of polar opposites.
> Wayne was a cultivated thinker who could speak fluently about Dutch
> still life or Matisse with equal ease. He was a great lecturer. Bob Arne-
> son was more of a drill sergeant, pugnacious, combative, and competi-
> tive. He was contemptuous of East Coast aesthetics and didn't mind
> telling you about it. But they both had personal charisma and a great
> work ethic. I started doing these big figurative paintings, and Arneson
> said, "How much longer are you going to copy Rubens?" Bob was well
> known for being a provocateur. Knowing this, I played dumb and said,
> "Gee, I never thought about it that way, Bob." And then added, "Do you
> think I could do a little work in clay?" To which he didn't reply directly,
> but added later, "See you down there," meaning the sculpture build-
> ing. Soon I had a second studio for clay work. I was treating clay as a

*Stephen Fleming
and Eddie Domin-
guez, Tucumcari,
New Mexico, ca. 1989.
Courtesy Roswell
Artist-in-Residence
Program archives.*

drawing medium and making deep reliefs, exploring the distortions created by certain kinds of perspective systems. When Bob referred to my work as "weird," everyone said that it was a great compliment!

At this time, I was making these big, over-life-size paintings, and the idea of having access to some large canvases captured my undivided attention. Roswell appeared to provide a rare opportunity really to grow my work. When they accepted me, I was beside myself with anticipation. Then my department chairman called me in and told me that I had better mind my manners and watch my step when I was in New Mexico. I was a bit flummoxed. What had I done to warrant such a caution? Years later I finally found out that another Davis graduate had been caught abusing the materials budget, and Bill Ebie had called my chairman to say that if I didn't toe the line, there would never be another Davis grad on the grant.

I drove out from California in July. It was hot, but the summer "monsoon" rains had already begun to turn the high plains lush with tall green grass. So tall in fact that on the road heading south and after a tremendous downpour, I found myself driving through a landscape devoid of any signs of life whatsoever. No houses, no other cars, no animals out in the fields.

It was with a weird sense of relief and anticipation that I saw the old Star Tool Company place north of town, and the outskirts of Roswell rolled into view. When I arrived on the compound there wasn't a soul around: another bizarre, sort of haunted moment. I looked and found the only unoccupied house and studio. An hour later Gwyn Ebie walked over and said, "*There* you are." (They had been at a party.) Later that evening I was out on the porch of another house trying to photograph a lightning storm, as if I was the only one of us ever to think of it.

The studio was a blank white cube with a broom. It was full of promise in an intimidating sort of way. I was still under the admonition from my chairman: "Don't screw up!"

The opportunity you get from the grant produces a unique anxiety. It's so open-ended: a solo voyage, with a suitcase full of fears. The only stress is self-imposed. The grant becomes a Rorschach test around the central enigma: "Am I good enough? Do I deserve this?" You have to learn to relax.

During my stay on the grant, all the artists were men. There was a slightly military feel about the place that year. Let's just say, not much internal social grace. Everyone, until (Bob) Colescott arrived, seemed like a displaced person cast up on this island oasis burning with energy and ambition. I was thankful that Eddie Dominguez had brought a

houseful of furniture, was a good cook, and was so full of innocent good will and optimistic drive that we were all able to get a good meal once in a while that helped keep our darker demons at bay.

Also, at that time, Diane Marsh, who'd been a resident in 1980, returned to Roswell, although she was not officially on the grant. Diane recalls:

Eddie Dominguez holding Anton, and Diane Marsh at the thirtieth anniversary celebration of the Roswell Artist-in-Residence Program. *Courtesy Roswell Artist-in-Residence Program archives.*

I really needed to leave New York, and Don let me come and use a loft building he had; he really gave me a home to come back to. That was a time of healing for me—I first met Eddie then, who is now my husband, and Ted Kuykendall—such a beautiful artist, a completely pure and generous spirit. Other artists on the grant at that time have become lifelong friends, as well.

Stephen Fleming says:

Diane returned to Roswell in 1987 after a personal tragedy. She was living in a house trailer across the road and had her studio downtown. An impressive female, not shy; so gorgeous, so much larger than life that one couldn't even harbor fantasies about her. And Eddie, the gentlest and most protective person on the compound back then, is now married to Diane. Destiny, fate, whatever you want to call it.

Diane Marsh and Eddie Dominguez were the first couple to meet on the compound; they married and lived outside of Santa Fe for a while, before Eddie got a job teaching at the University of Nebraska. Diane continues:

Our son was born in 1997. Eddie and I came back with Anton to the residency in 2002—the charmed third time. We both accomplished work we couldn't possibly have done under the circumstances of normal life.

Stephen:
Here's a photograph of our group at Benny's Plaza Café taken in the spring of 1987 by Ted Kuykendall. We would stop the conversation in the place just by showing up. Any group that included a black person, a Hispanic, and a beautiful woman (Diane, who was hanging out with us) along with L-15 and Ted, tended to get everyone's attention. Those

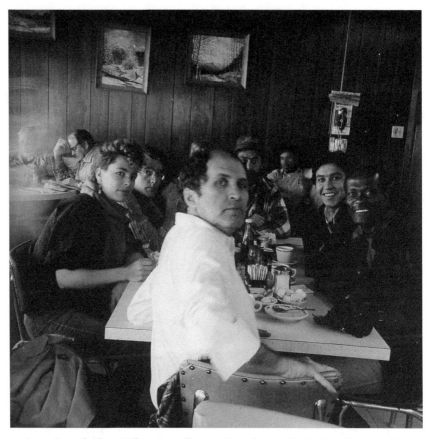

Artists at Benny's Plaza Cafe in Roswell. 1987. (Seated around table L to R): Diane Marsh, Stephen Fleming, Ted Kuykendall, Eddie Dominguez, Joe Grant, Bernard Schatz (in front). Photograph by Ted Kuykendall. *Courtesy Anderson Museum of Contemporary Art.*

were still the days when the waitress would serve you with a cigarette hanging from her lip. "Y'all want coffee darlin'?" Some of my best memories of that time are from those breakfasts, even though I was half asleep from staying up so late the night before. The photograph also gives you a little taste of the tension between Eddie and L-15.

It seemed to me that L-15 had become just a little envious of Eddie. Who, after all, was still so young that his innocence was genuine. [L-15 was probably in his fifties.] Also, Eddie and I were making full use of Aria Finch's ceramic set-up down at the Roswell Museum. So "L" started making those loose little figures from clay. Weirdly, they looked very like an installation, made many years later, by Anthony Gormley, but that's another story. L-15 had made hundreds of these things and needed a way to get them up off the floor, which was out of bounds at the Roswell Museum. So he went around to all the houses and took the

bed platforms that Don had made out of plywood and four-by-fours. These things were awkward to move and "L" was going to put them in his yellow bus, through those folding school-bus doors. He needed help. Ted, who was pretty much self-taught and who had never bought into L-15's "outsider" artist shtick, said, "Suuure, I'll help ya' out Mr. Fifteen!" with a little gleam in his eye. Eddie and I started to work together and that left Ted and "L" paired up. Eddie and I, with some effort, would load a bed through the narrow doorway in a few minutes. As he and I were catching our breath, Ted would let "L" back into the bus and out of his line of sight. Then Ted would begin a beautiful slow sabotage of the whole process by twisting the bed in all sorts of unproductive positions. All the while "L" would be giving Ted orders to do this or do that, and Ted would be saying, "Ya mean like this!" and would give a great shove that would send "L" over backwards. You could tell that "L" was getting sore but he was too shrewd to show it and lose our assistance. Eddie, sweet as he was, kept trying to "help" by suggesting that one or the other of them do this or that. Of course they were already way beyond listening any more; it was performance art of the highest order (or perhaps a "Three Stooges" routine), without the audience it deserved.

During the year of the residency, the dynamic changes as artists leave and new artists arrive. While I was there, the well-known painter Bob Colescott arrived. Soon after his arrival there was a dinner party. At some point, the conversation turned on something to do with race. Eddie, who as a ceramic sculptor had never heard of Colescott or his paintings about racial issues, said, "Gee, I didn't know you were black; my skin is darker than yours!" Colescott was, I think, shocked that some of us didn't know him or what his art was about. Eddie didn't even know what the purport of his statement was until later when we told him. Admittedly, Colescott did treat us more or less as graduate students. One day he came to my studio and said, "I have some paintings in my studio going out to Phyllis Kind (Gallery in New York City); will you wrap them in plastic for me?" At that moment it didn't seem that unusual, but later Diane Marsh said I should have been insulted. In fact, I got to see a lot of Bob's work-in-progress, which was a very interesting opportunity. The point is that the program is sort of a leveler. Everyone gets equal treatment, no matter how far up the cultural food chain they might be. On the few occasions when celebrity artists come to stay in Roswell, they soon find out that few people here have heard of them. The prestige machine just doesn't run on Roswell time. The Roswell Artist-in-Residence Program is all about your creativity, and not about your career.

I was here at an important time in the life of the program. [Bill Ebie, who had been the program director for fifteen years, was appointed director of the Roswell Museum, and so had resigned as director of the program.] Stu Arends took over as program director early in 1987, and for various reasons, the Roswell Museum cut back on its administrative functions relating to the Artist-in-Residence Program. Stu was busy making his own art and had a refreshing, no-nonsense approach to everything.

When the time for my show *Naked on the Pecos* [featuring gigantic, if indistinctly rendered nude forms] came around, someone, out of the blue, said that my work might be too controversial for the Roswell Museum. I think what actually happened is that someone said something like "Is it possible that someone might think this work is, well . . . ?" And then someone else interpreted that as being an objection. In any event, I suggested putting up a cautionary sign (a common practice these days), but Bill Ebie actually laughed at that suggestion. Eventually, everyone got over it, the show went up, and no one freaked out.

Stephen continues: Leaving the grant has got to be one of the toughest propositions an artist can face. Some grantees have places to go back to and people to reconnect with. Many, like me, had become sort of art vagabonds, leaving one strange place and heading for another. I'd been officially off the grant for a month and was living with Eddie on the compound. I was broke and wondering what I would do next. Then I received an NEA grant. I was really lucky. A second-hand truck and a few dental crowns later, I was able to move on to another residency at Bemis, and from there to a teaching gig at the Kansas City Art Institute.

Joe Edward Grant (1986–87)

Joe Grant is a Californian from Los Angeles, and he got his MFA from Otis Art Institute, which is where he met Stu Arends. At that time Joe was creating mostly wall pieces with found objects, including window frames. He "plays literal and figurative elements off each other [with] wit and a sense of the incongruous . . . reversing our expectations."[32] Joe remembers:

I came to Roswell in March of 1986 and stayed through March of 1987. I applied for the grant because Stuart Arends, a friend and fellow student at Otis Art Institute had received it. He was very excited about his time there, and encouraged me and some of our other friends to apply. I thought, "What have I got to lose?" I applied and promptly forgot about it until one of the persons I'd used as a reference called

me to say he had been contacted and asked about me. Shortly after that I was awarded one of the grants. I couldn't believe it. I hadn't been out of school that long and didn't have much of a résumé. This was the first big opportunity I had ever received.

Meeting some great people in the town and at the museum, along with my fellow artists on the compound: Ted Kuykendall, Eddie Dominguez, Steve Fleming, Diane Marsh, the painter Elen Feinberg, and the unforgettable L-15 (Bernard Schatz), marked my stay in Roswell. It was the perfect opportunity for working and thinking without having to worry about money or how to pay for materials. The house to which I was assigned had a studio attached. I was from southern California, so I greatly appreciated that, especially in the winter.

Joe Grant. *Courtesy of the artist.*

After we had all been there for a while, we decided to have a once a month get-together to catch up and be social, having a barbecue or potluck, depending on the weather. All of us were spending a lot of time alone. At one point I didn't start my car or leave the house and studio for one whole week, just stayed in and worked. WOW! Another time we decided to have breakfast at the local café once a week. This became a regular event, and L-15 volunteered to pick us up in his bedizened bus, itself a conversation piece.

I'd been there for several months when Robert Colescott, his wife, and baby son Cooper came. L-15 had left, and the Colescotts moved into that same house. Colescott was a great influence on me; for years I tried to achieve the same kind of surfaces he had. He was the best painter using acrylic I have ever seen. He painted large canvases that glowed from underneath, looking just like oil. He gave me some tips on how he was able to achieve those rich surfaces. He also played drums and would pound away when he had time in the afternoons.

One of the things I remember most fondly is the ceramics class I took at the museum with Aria Finch. To this day we still exchange Christmas cards. Not only was the class fun, it also offered a chance to meet some local artists. After I took that class, Eddie Dominguez took me under his wing and let me fire his kiln when he wasn't using it.

In those days I was a runner and decided to get up early and run on the track at the Wool Bowl (the football stadium). Eventually I met two men who were walking there and we became friends. After we finished running and walking, they would take me to a café for coffee and fill me in on local gossip and history. Their names were

Earl Allman and Jack Montgomery. They also introduced me to some of their friends—a retired superior court judge and some local ranchers. Somehow I was invited to be a guest on the *Roswell Today* TV show, giving me a few minutes of local celebrity. I remember they interviewed me right after a young man from the Boy Scouts, and we became friends.

Perhaps the most memorable moment of my stay on the grant was the show at the museum. Besides the artists from the compound, other local artists and friends I'd made during that year came, and also some people who'd seen the televised interview. I loved it.

Since that time, my résumé has grown to several pages. I've had museum shows and two other grant awards. I've taught collage and mixed media at the elementary and college levels, and I'm represented by several galleries and in a number of collections.

I can't begin to express what receiving this grant meant to me. It validated something I thought I had, and gave me the opportunity to work on it. Most of all it gave me a chance to dream.

Robert Colescott (1987)

Portland, Oregon, 1959. Bob Colescott is teaching at Portland State College. His solo exhibition hangs in the Faculty Office Building at Reed College. A local reviewer describes his paintings as "French-looking." Curiously enough, it's true—landscapes with poplar and cypress trees, classical dancers, a beautiful sure brushstroke. "Léger[33] taught me to fill up the canvas," says Colescott nearly fifty years after studying with him in Paris on the G.I. Bill. He continues:

Robert Colescott at Joe Grant's opening at the Roswell Museum and Art Center. 1987. Photograph by Joe Grant. *Courtesy of the artist.*

Painting taught me to fill up my life. After fourteen years in the Pacific Northwest, where everything is muted and hazy, like the weather, I was ripe, ready to burst into color. I got a grant to paint in Egypt, and my palette changed in that amazing light. Later I taught at the American University in Cairo. When all foreigners had to leave after the Six-Day War in 1967, I came back to France for a while, then to the States. The intensity of light and color stayed with me. I also realized that narrative could bring a lot of strength to my painting. That led eventually to the appropriation paintings, like *George Washington Carver Crossing the Delaware*. [This now well-known painting was at one point on the cover of *Time* magazine.] I hadn't

expected that they would be so controversial—that they would upset so many people at so many different levels: disrespect of art history, of African-American history. If I treated something as comic, was that political incorrectness? I had not set out to be shocking, only to improvise on some themes, like the jazz riffs I know and love.

My work was beginning to be recognized, but I still had to teach, still had to earn a living—it was like running in place. I had the choice of stealing time from teaching or stealing time from painting. I kept getting small grants—for models, or materials, or for a month's residency someplace.

Roswell is a different creature entirely. They don't just hand you a check and a pat on the head, they give you a full year, a place to live, a studio, materials, a little money—just about enough to live on. It was hard for me to get my head around that. If you read Vasari on the lives of Renaissance artists—here's somebody carving a door for ten years or something like that. Well, nobody does that anymore. We don't savor time. Time has become something to be consumed as quickly as possible now, like a cheeseburger. But in that little house with my young family, in my big bare studio any time of day or night, I had the most amazing sense of luxury—the luxury of time.

Colescott is among the most celebrated painters to have come to Roswell. His work continues to elicit intense critical reaction:

Powerfully ugly pictures. Painted in raw strokes and garish colors, swarming with rubbery popeyed cartoon characters who act out wildly scrambled blackface burlesques of race, sex, violence, and death. [The paintings] are also beautiful, smart, and poetic [with] a lush, painterly sensuality.[34]

He himself says about his art, "If you decide to laugh, don't forget 'the humor is the bait,' and once you've bitten, you may have to do some serious chewing. The tears may come later."[35]

Stewart MacFarlane (1987–88 and 1990–91)

Stewart MacFarlane arrived a month or so after the previous group had left, and he became the first of a new and congenial grouping of artists. He has spent a great deal of time traveling back and forth between his native Australia and the United States. Before the first of his residencies in 1987, he spent several years in the States, receiving a Bachelor of Fine Arts (BFA) from the School of Visual Arts in New York City and showing his work at various galleries. One critic describes his paintings as "powerful of image,

rich in color, sometimes shocking—MacFarlane's pictures uncover the intense human drama that runs beneath the civilized order of society."[36] Stewart recounts:

In the summer of 1976, I was a fellow at the Skowhegan School of Painting and Sculpture in Maine. That year resident artist Willard Midgette gave a lecture that had a lasting and profound effect on me. Firstly, Willard's powerful figurative work, of contemporary scenes, proved to be a key influence on my own work. Also, Willard talked about and showed slides of a residency he had completed in Roswell, New Mexico a few years earlier. The work was wonderful and the residency sounded like no other I had heard about or experienced.

I sought out the information for the Roswell Artist-in-Residence Program soon after and completed my first application. They finally accepted me, however, about ten years and three applications later, in 1987. By this time I was based back in Australia where I had resettled after spending seven years in the U.S.

When I arrived in Albuquerque, after a stay in New York City, I breathed in a whole new world. New Mexico had a spaciousness to it, streets and sky, that I was unused to, like a set from a John Wayne western or a Steve McQueen drama, a little dilapidated, with a sense of history, yet pretty and proud.

The bus ride from Albuquerque to Roswell (a few hours) through the small towns, bus get-downs, and spare desert landscape gave me a chance to let go of my old notions of cities and water.

Artist Stuart Arends was looking after the artists-in-residence at that time. He met me at the bus depot and organized my settling in. He was efficient, friendly, with a quick humor. An immediate rapport was established between us. Stuart's own work ethic in his studio was a fine example to follow. That residency of nine months in 1987 gave me the opportunity to bring my career up a level or two, to carry on with new strength and resolve.

During that period there were many social occasions organized that made it easy to feel at ease and meet friends. It was a wonderful privilege to be given a solo exhibition at the Roswell Museum and Art Center. This made it possible to show the public what had been going on in my studio for several months and meet yet more friends. Through my exhibition I met local art-lover Carolyn Schlicher who commissioned me to paint her children, Coe and Christine, and her dog Banger. I met Brinkey, Brinkman Randle, a good friend, good host, and good cook. Carolyn introduced me to Juanita Stiff and her husband Glen Stiff, as well as Peter Rogers, the artist. Juanita, a

Stewart MacFarlane in his Tasmania, Australia, studio, ca. 2000. *Courtesy of the artist.*

long-term board member of the Roswell Museum and good friend to many of the artists, was always charming, generous, and a lovely person. She collected and supported artists' work and made them feel welcome in her beautiful home. Peter Rogers's studio in San Patricio was always an amazing place to visit. Carolyn took me there two or three times during my first residency.

During that residency, the models for my paintings were people who lived nearby. Stuart Arends sat for a painting along with Jennifer Brewer, the Andersons' neighbor. To get more information for this

painting (*Strangers*) at one stage I needed to get them to pose, fully dressed, in Don and Sally's swimming pool.

Diane Marsh and her then boyfriend Donnie Rubenstein lived near the residence compound and mixed often with the artists. I remember several late nights dancing and drinking at the local traps and greasy breakfasts at the diner the next morning.

I would also get visits from Charlie, the large cat who was living with Stuart and Vicky Arends next door. I am a cat and dog lover and was happy to have the company of a big purry cat. There was a cat-flap already in my front door, so Charlie would come and go as he pleased. Often he would stay for the night. When he did, he chose to sleep in the bedroom directly across the hall from mine. One night I heard the cat-flap slap shut and a noise in the kitchen. It was late; I was already in bed, vaguely asleep. I wasn't sure if Charlie was already inside. I opened my door and called, "Is that you, Charlie?" Looking through to the other bedroom, I could see a startled Charlie staring back at me, just as puzzled as I was. Stepping cautiously toward the kitchen I saw a skunk with tail fully elevated, to perhaps three and a half feet, ready to spray. Charlie and I got the message. We backed slowly into our rooms. I closed my door and left poor Charlie to fend for himself. From the kitchen there was the racket of an upturned garbage bin followed by a long period of rifling through the treasure revealed. There was no way either Charlie or I was coming out of our rooms. I phoned Stu next door at daybreak, not sure if the skunk was still there. He responded quickly, ready for anything. His investigations revealed an empty but trashed kitchen. It was safe for Charlie and me to emerge. Mercifully, the skunk had not sprayed. From then on, Charlie had to knock.

Georgia Elrod with sunflowers, ca. 1988. Photograph by Daisy Craddock. *Courtesy of the artist.*

Daisy Craddock (1988)

Daisy Craddock and her ten-year-old daughter, Georgia, arrived from New York City in January of 1988, overlapping with Stewart; Biff Elrod, Daisy's then husband arrived shortly afterward. Originally from Memphis, Daisy studied art and received her MFA at the University of Georgia but she and Biff had been living and showing their work in New York City for a long time when she applied for the grant. She is a

landscape painter, whom one critic described in this way: "Harking back to Impressionism, her dry, drab green, dreamily hazy pictures of big oaks or magnolias in the Old South are about light, atmosphere, and space; and they are about the old Modernist play between illusion and abstraction."[37] Daisy remembers:

Daisy Craddock and her daughter, Georgia, at Burrito Express in Roswell, ca. 1988. *Courtesy of the artist.*

What a rare privilege the grant was. A whole year to paint without interruption, house and studio, art supplies, the community of artists, a museum exhibition. It was a painter's paradise.

The Portal: Some of our best times were spent out on the portal between the two studios. On a visit back to Roswell last year I was touched to see that the wooden barrels Vicky Arends and I had hauled back to the compound to plant flowers in were still on "our" porches. Georgia's third grade birthday party was celebrated out there. We went to a movie first. (Oh, those three dollar matinees!) The portal was where we spent most evenings, too, watching the sky move across a horizon of pecan groves, irrigated fields, and the encroaching subdivision. Often we'd go back and forth to Stu and Vicky's for drinks and whatever happened to end up on the grill that night. I started my high plains drawings on the portal with a format I still use today. Mornings I'd tend my so-called garden and drink coffee while watching the ongoing battle between the swallows and the sparrows. Georgia had a squirrel we nicknamed "Pretty Boy" who would come down to beg for pecans.

New Mexican Food: The "Breakfast Burrito" at the Burrito Express is my favorite. It's a heavenly combination of eggs, steak, potatoes, cheese, and green chile. Try as I might I haven't been able to duplicate it. The breakfast burrito comes wrapped in aluminum foil, which allows you to get it back to the studio before it goes cold. Before Roswell, who knew that chile came red or green anyway?

Don Anderson: Don is a true visionary. First he comes up with this rather utopian idea of the Roswell artist-in-residency. Then he actually makes it happen—hauls these wonderful stucco tract houses back from Texas [mostly from Midland, Texas and from the abandoned air force base south of Roswell] and arranges them on a tract of land. He builds studios for the artists, funds their stipends himself over the

years, and has the good grace to step back and just let them do their work. I feel fortunate to be able to call him a friend, and I can tell you that he's as happy on a front loader as he is holding a paintbrush.

Georgia Elrod recalls:

We lived in Roswell when I was in the third grade. I loved exploring the compound and visiting the other artists in their studios. I would go bike riding, pick pecans, play on the hammock. I also loved crossing the huge field on my way home from the school bus stop. This was wildly liberating for a kid from New York City!

It was in Roswell that I fell in love with the West. I eventually returned when I went to Colorado College where I studied art.

Biff Elrod (1988–89)

Biff Elrod. *Courtesy of the artist.*

Biff Elrod was brought up in Fort Worth, Texas and received his MFA from the University of Hawaii in 1968. When he applied, he described himself

as a "self-employed artist." A review of his 1988 show at Schreiber/Cutler Gallery in New York City begins: "Biff Elrod is essentially a muralist. His large, somewhat grainy canvases glow phosphorescently with nervous primaries as if to compete with the vulgarity of the daily street life they depict."[38] Biff recalls:

Many of us will remember the sky in New Mexico, where it is so often the visual setting, with the land forming the backdrop. This is especially true near Roswell. Although I spent part of my youth in northern Texas, I had not been aware of the subtle but dramatic difference between the two places. There is what can only be described as a magic quality to Roswell, and this becomes evident after only a short time there.

When I was there with my family in the late 1980s, I spent long, involved days in the studio working on large paintings of crowds of New Yorkers, and on several commissions. Life picked up for me there, and interest in my work from outside increased, rather than the reverse, which I had initially feared. I was able to work long and productively almost every day.

I had no job to take a break from. My income was from selling my work through private dealers, and filling in with itinerant construction work, or whatever was available for short duration. My gift of time delivered me from the throes of anxiety. I was helping raise our daughter Georgia in New York City, and she was nine at that point. To be able to sublet the loft in (the old) SoHo, and have a studio with materials to work and meet new friends from Roswell (and everywhere) proved to be just the tonic I needed.

There are too many anecdotes to recount in a short space, but several come immediately to mind: One memory was of collecting Pecos Valley diamonds from the surface of the land just off the highway near town. These were called diamonds but were in fact small coppery crystals, frequently very well formed. Something about this collecting felt very timeless, attuned to a timeless setting.

My friend Stu Arends and I would spend some non-painting time at the Roswell Billiard Parlor, where I learned to play snooker to a degree; in the process I became a better regular pool player. Very difficult to beat Stu, however.

From the artist-in-residence compound to Roswell proper was a short drive, but long enough for a meditative transition to the sleepy focus of Roswell of that time. This included places to buy saddles and farm gear, a Salvation Army store that sometimes had very nice secondhand cowboy boots, a Chinese eatery, and an assortment of

nightlife spots, mostly along the highway. One roadhouse we visited with friends involved much crowded dancing of the Texas Two-Step around a large dance floor to a live country-western band. Ranch hands and high school sweethearts, long neck Pearl beer, and the occasional—expected—Saturday night bar fight composed the scene. All this conducted with less destruction than one might imagine.

In town the next morning, a spectacular breakfast burrito from Burrito Express was big enough to hold you till late afternoon.

On one occasion my daughter and I decided to go camping in a state park to the south of Roswell, near Carlsbad, home of the famous caverns. So we packed the pup tent and the pup, our dog Herb, and headed south. We arrived in the park area just at sunset, and found little to indicate a campground, so we kept pushing further into the park. It turned out to be quite large. In full darkness, I remember driving slowly along a high ridge with the headlights showing only a few short and windblown mesquite trees. The road itself became indistinguishable from the land, and it finally seemed prudent to stop and see what was ahead. Just twenty feet in front of the car the land fell away to a deep wide gulch at least two hundred feet below. We stopped there and set up the tent, found some stray wood and built a fire to make hot dogs. The wind was blowing the fire, and weather was moving in. The dog decided he preferred to stay in the car, but we put out the fire and retired to the tent. An hour passed there in the dark on the ridge. Soon we were seeing the lightning flashes through the tent fabric. I began to think about the approaching rain, and of the lightning strikes that would inevitably come with the water flowing around the tent. So everything went back into the car with the intelligent dog, and we turned around and drove to a motel in Carlsbad. So much for the city slickers' camping trip.

Artists seem to carry their context with them, and a group of them anywhere will create at least a touch of carnival atmosphere. However, those serious enough to focus in the studio for any length of time will need this atmosphere to cut through the self-imposed solitude. In our pluralistic culture, with hegemony at bay, a retreat to an art community like Roswell is a great equalizer and a great relief. I will always remember my time there, and the good people I found there who are still my friends.

Susan Marie Dopp (1988–89)

Susan Dopp arrived in Roswell in June of 1988. She had received her MFA in painting from the San Francisco Art Institute the previous year, and was then located in Oakland, California, working as a house painter to

support herself. She and "Lucho," her then husband Agustin Puzo, spent a happy year in Roswell. She cites one recurring memory:

> I would be painting away, happily or not so happily depending on how the work was going in my studio. In the afternoons on hot summer days (I spent two summers there), the sky would darken ominously; distant rumbling would roll in off the plain. Violent storms would rage through the sky, thunder shaking the studio so deeply that at times I was actually afraid. Then the storm would pass and the sun return, everything glistening wet and the happy birds chirping. I reveled in it and continued painting.
>
> One of the best paintings I did while on the grant, *The Narrow Escape*, was an image of me carrying a basket of ripe pears, having stepped into a little rowboat. Escaping a lovely domestic scene in a tree house that was engulfed in flames. Lucho's foot was poised on the edge of the boat. Near the end of my stay, curators from New Mexico State University in Las Cruces came to my studio and purchased the piece. I have always been so pleased that that painting remained in New Mexico, as it was so emblematic of that body of work from my time in Roswell, and of the feeling of being in New Mexico.
>
> Thrift shopping was quite interesting in Roswell. I began a series of paintings on found objects. I found a strange cast-iron object shaped like a flower with petal shaped indentations. I gold-leafed it and in the center painted a miniature called *Me With Very Little Hair Left*. Near the end of my stay in Roswell I found another of these objects, but it was many months later that someone who knew told me what it was: a nail dispenser for a shoemaker.
>
> [Toward the end of my stay,] I went to the Roswell Museum to look at the site where the exhibition of the work I had completed in Roswell would be held. I was looking around the space and through a small cutout window I saw an icon of the *Virgen del Lago de San Juan*. I walked into the room to look at the painting and entered a magnificent room that I hadn't remembered seeing before. It was the original adobe building of the museum, with a high vaulted ceiling from which iron chandeliers were hung. Vibrant New Mexican light poured in from windows set in the upper walls. There were two carved Spanish style benches in the center. I immediately thought this space would be perfect for my work, as it was, in part, influenced by traditions of icons and the Mexican devotional paintings called *retablos*. I had always tried previously to house my work in an environment that related to its content (i.e., elaborate installations which I designed and constructed). I asked the director and the staff if there were any

possibility of using this space for my show, and after some deliberation they decided that they also found it completely appropriate. This experience was consistent with the graciousness and understanding of artists' sensibilities that envelops the experience provided in Roswell. I made a painting of the *Virgen* who led me to the room on a plaster mold I found.

The museum was doing a catalogue for my exhibition and they asked for a photograph of me. Lucho and I decided to recreate a tableau based on some of my images. That night we made a two dimensional cardboard boat and a papier-mâché pear, images which recurred in the iconography of my work. In the morning I dressed myself in an elaborate jeweled costume and we set out with Judy Richardson, a fellow grantee who had offered to photograph us, to one of the pecan orchards.

I was in a bad car accident up in Albuquerque near the end of my stay. My back was hurt so that I had to lie in bed for three weeks. Everyone on the grant and in the community (especially Brinkey Randall, Carolyn Schlicher, a neighbor, and Juanita Stiff) was so generous in bringing me food and checking on me. When I could move around again I had no car. Juanita loaned me her old pink '50s Cadillac with fins. I'd always wanted a car like that.

Being on the grant was so beneficial to me. I was able to be so productive. I made friends there to whom I am still close.

The Hiatus

Stewart MacFarlane summarized the general situation in the late 1980s:

> After my first residency it was back to Australia—Sydney, then Melbourne, enriched, to deal again with the real world. It was around that time that Wall Street and the world economy down-turned heavily. It was oppressive and far-reaching, lasting through the first half of the 90s. Even the Roswell Artist-in-Residence Program seemed as though it might be threatened. Survival for all the art world was very tough.

In fact, given that the oil and gas business was also in a slump, some of the expenses of the compound would have to be cut back for a while. The biggest loss was the unlimited budget artists had been allowed for their materials. (Many of them had run up bills of over thirty thousand dollars during their stay.) The stipend was temporarily halted as well, but artists were invited to come and stay free of charge in the spacious furnished houses, with all utilities paid.

Susan Marie Dopp and Agustin Puzo (in boat) in the pecan orchards west of the compound. 1989. Photograph by Judy Richardson. *Courtesy of the artist.*

Stephen Fleming relates: "By the summer of 1989 the residency was beginning to slow into what we now call *the hiatus*. Stu invited Nancy Johns (now Fleming), whom I'd met at the Kansas City Art Institute, and me to stay for the summer in one of the houses and studios."

Other artists were issued the same invitation, and most eagerly accepted. There were two major groups of artists who wanted to take advantage of the opportunity: during the following two years, a great many former residents returned to the compound, as well as a different group of newcomers who were good friends of Stu Arends. He had been one of the returnees himself, and he and his wife Vicky who was working as a lawyer in town were living in the downtown loft that Don had refurbished. He had many artist friends in California. When Stu agreed to take over as program director, he and Vicky moved back to the compound in order to supervise. The compound continued to function fully, because of the devotion of the artists to what was still, in effect, a gift of time.

By the early 90s the markets—including the oil and gas business—fortunately began to rally and the funding for stipends was resumed (although the generous allotment for materials was not provided again).

About that time Stewart MacFarlane returned from Australia where, in addition to his painting, he had been performing in a rock band. He recalls:

> I was invited back to Roswell in 1990–91, and Roswell became my sanctuary for a year. I met more friends, getting to know Susan and Luis Jiménez, Stephen and Nancy Fleming, playing music with Stuart Arends. I met Tom Jennings, later to become mayor of Roswell, through Carolyn Schlicher.
>
> On Sundays I would often attend church meetings in Roswell. One small group was led by Len Hall, serving as pastor. It was here that I discovered another model for my paintings, Maggie Evans. Maggie was about ten when she first sat for my paintings. She is featured in about four major works done at this time.
>
> There was some turbulence for me during this residency due to human problems. I had come to Roswell with a young girlfriend, Lucy, from Melbourne. Initially all was smooth sailing, but Lucy had stars in her eyes and after she was accepted for the lead in a Roswell Little Theatre production, things changed, then deteriorated, between us. We parted before the end of the residency, but not before things got a little public. Life can unravel, even in Roswell. [Stu Arends has a vivid memory of "Lucy in *Red*," the long red evening dress she occasionally wore around the compound; also of Stewart sunbathing in his backyard.]

CHAPTER FOUR

(1991–2002)

Expanding Boundaries

The Anderson Museum

A major event of this period of the residency was the evolution of the old warehouse that Don owned at 409 East College, just off Main Street in Roswell.

Stephen Fleming describes it as "the industrial space that Don used as a sometime office and storage space for his own paintings [and for Luis Jiménez's gigantic Progress pieces]."

In the early '90s Don created a new entrance in front, leading to a small gallery space, where he hung a group of his own paintings. The Roswell Museum had distanced itself somewhat from the residency program and was not always offering shows to the artists.

When Robbie Barber was denied a show at the museum, he remembers his naive boldness in asking Don to empty the gallery of his own work and install Barber's show. He also remembers Don's poker face and "Let me think about it" response:

> A little while later, Don called and gave the go-ahead. He let me haul in all this stuff, including several tons of scrap metal and steel, shelling out his own money and time for this. We printed a card, had an opening, and had a band play: Nightcrawler with Stu Arends, among others.

One of the main features of the show was Robbie Barber's series of sharks made from golf bags, suspended from the ceiling, displaying their teeth

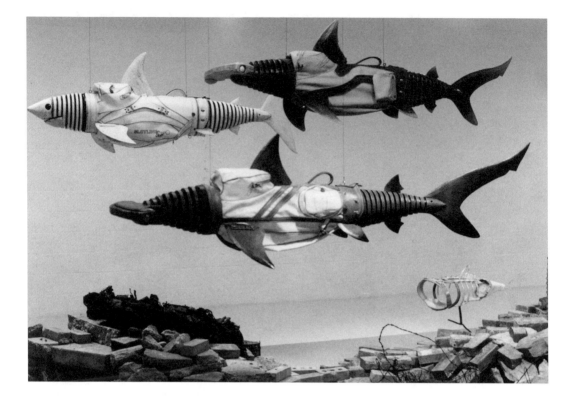

in wonderfully self-satisfied grimaces; these can still be admired in the permanent display at the Anderson Museum. Stephen Fleming:

> The show looked great, and from that time on, the space at 409 East College began to evolve. [A second small gallery was added the following year.] The next big step was this wacky, free-form protest show put together by Luis Jiménez [in 1994]. It was a protest against a proposed plan to store spent fuel rods from East Coast nuclear power plants on the Mescalero reservation, over by Luis' place. We called the show *Dumb Dump,* letting anyone who wanted to protest show a piece. We got lots of media coverage, and the fuel rods never arrived. After that show, we mentioned to Don that things would be easier to install in the space if he put some drywall over the cinderblock walls. Almost the next day, construction work began transforming the space and hasn't really stopped since.

Robbie Barber adds:

> [my show] eventually led to the *Dumb Dump* protest show—I was not there for this. It then led to the physical expansions and an explosion

of collecting/exhibiting of residency artwork. I hate to take credit for starting all this, but someone has to.

Stu Arends, together with Tom Bromley, a massive man with a big beard who ran a landscaping business, had founded a band in Roswell, which they called Nightcrawler.

It consisted of Stu on the guitar, Tom on the harmonica and vocals, and several other local men filling out the roster on piano, bass, and percussion. Sometimes there was a guest player, such as Ken Field, Karen's husband, a professional saxophonist. Stewart MacFarlane who had had a rock band of his own back in Australia, also played guitar and sang for the opening of the *Dumb Dump* show. The band was very successful for a while, touring the state and appearing on the air several times.

The exhibition space became known as "Gallery 409." Soon, however, Don conceived the idea of creating a permanent collection of the works of all the residents who had been on the grant. Shortly after, in 1994, he moved his company offices from the building across the street, simultaneously creating a gallery/museum space and offices for the Anderson Oil Company. Marina Mahan was hired to run both the office and the gallery and was enormously influential in its development. As the collection became fleshed out, Don added more galleries to accommodate the works, until Sally jokingly pointed out that the building was much too big to be just a gallery, and it became the Anderson Museum of Contemporary Art.

The first group to arrive after the hiatus was one of the strongest and most cohesive of all: the Barbers arrived initially, followed by the painter John Jacobsmeyer and wife Trish; then sculptor Adam Curtis and his poet wife Louise Kennelly; and finally the animator Karen Aqua with her musician husband Ken Field.

Robbie Barber (1991–92)

Robbie Barber received his MFA from the University of Arizona in Tucson in 1991; during his studies, he earned a living as technical assistant at a foundry, and as a fabricator of artificial environments.

NIGHTCRAWLER BLUES BAND *will perform at* "UP YOUR ALLEY", corner of Brasher Road and SE Main on **August 20th and 21st.** $3.00 cover at the door. Proper I.D. required. Call 623-7627. **Band starts playing at 9:30PM. Cassettes available for $10.00.** *Photo - Jack Rodden.*

Ad for the *Nightcrawler Blues Band*, ca. 1993. *Courtesy Roswell Artist-in-Residence Program archives.*

He describes his work as "basically deal[ing] with the transformation of and/or the utilization of found objects . . . I want my work to be seen as both raw and sensuous; funny yet serious."[39] Robbie recalls:

> I came to the residency straight from graduate school at the University of Arizona (Tucson). I was twenty-seven years old. Debbie and I had been married for three years.
>
> Our daughter Hannah was conceived and born on the residency. I remember us discussing this most important decision of our life at the time, and forging ahead with excitement, eagerness, and anticipation. We felt the residency offered us the perfect opportunity to start a family.
>
> Don agreed to help me find a home for the very large piece I had done in Arizona: [it consisted of a small house trailer which he had partially converted to an army tank, with caterpillar treads and guns mounted on the front. It was called *Going Mobile #3*, and the ambiguity was completed by the lawn chairs and barbecue out in front.] Again, I remember naively asking him to get involved, the poker face, and his simple, delayed response of OK, let's do it. This gesture basically saved the piece. It had to be moved or destroyed. It now sits in his yard. I feel good that it has had a quality home for so long.
>
> I created the outdoor steel sculpture *Goddard Nomad V*, influenced by the Goddard collection in the Roswell Museum and Art Center.

Robbie Barber with his piece, *Goddard Nomad V*, on the compound patio. 1992. *Courtesy Roswell Artist-in-Residence Program archives.*

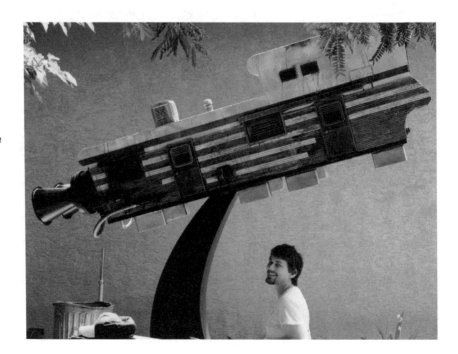

Steve Fleming and I drove it to Knoxville, Tennessee to be exhibited in the Sculpture Tour Exhibition. It was a wild trip, with all Steve's stories. I am still exhibiting this piece with lots of positive response.

I traveled with Luis Jiménez to help him install *The Fiesta Dancers* in Tijuana, Mexico, at a border crossing. It was a memorable trip. It was interesting to see how Luis handled the physical issues of creating and installing a very large piece of public art in a public space. It opened my eyes to many of the cultural issues between Mexico and the U.S.

Robbie Barber holding Hannah. 1992. *Courtesy of the artist.*

We established many key relationships, with Steve and Nancy (and Sienna) Fleming. Nancy created several memory books/objects that were wonderful. These helped us get through the tough times that were coming. Steve is like an old sailing ship: he stays the course, gets you home, and is tough as nails. Our friendship eventually led to our having another child, Ellis, who is five now: Nancy was our surrogate mom.

My memories of Roswell are bittersweet. The night of the shark opening Debbie was admitted to the hospital, which began the year from hell for us. Debbie was six months pregnant. Shortly afterwards she was taken to specialists in Albuquerque, and we spent three months up there until Hannah was born. Debbie had and still has spinal meningitis, caused by a fungal infection, and will never be cured. To this day we are still dealing with the issues of that illness. I have a lot of mixed feelings about this period, ranging from highs to very lows. I basically left Roswell flat broke, no job, with a newborn; my wife barely able to function in any capacity. But after a few years, things got better.

I received two artist grants not long after the residency, and eventually landed a teaching job, and wound up in Texas. I recently received tenure at Baylor University in Waco. I mention these accomplishments because I think the prestige of being in the residency, and the work I was able to make there, led to this kind of success. I grew up in a lot of ways that year. I started a family, faced mortality for the first time, and basically had to figure out what I really wanted to do with my life, and yet I still managed to make some good work. The fact that I could still produce under such extreme circumstances proved to me that I might actually be an artist. As a teacher, I tell my students that, from one perspective, life is a battle, especially for anyone who wants to be an artist. Every day things will happen that will keep you from creating art, and you have to fight, scrape, and claw for the opportunity to be an artist.

Debbie adds:

I came to Roswell as a spouse. From day one, everyone on the compound was an instant neighbor: the family member you liked to have around. Our group was basically five reasonably young couples. (Flemings, Curtis/Kennelly, Jacobsmeyer/Kelly, Barbers, Stu and Vicky Arends). Stu (who was still program director then) welcomed us, told us about things (moths, birds, etc.) . . . then went to his studio. Everyone respected everyone else's privacy and studio time. If you didn't want anyone to bother you, no problem.

Our group felt special, though. We had all arrived at about the same time. We jibed. It's kind of like when you sense you've met the "right" person. It just felt right. There were spontaneous game nights, movie nights, trips to White Sands, the Alamogordo scrap yard, flea market runs, etc. When October came, Robbie stopped making sculpture and began designing and making a Halloween costume. They must have thought he was nuts. There seemed to be an unspoken competition among three of the male artists (Robbie, Adam Curtis, and John Jacobsmeyer). He would egg them on to do things. We went to Bud's (the nearest local cowboy bar) and entered their Halloween Costume Contest! A local won, Robbie and I got second place, and Adam and Louise third. Wow! We felt as though we were part of something. The Thanksgiving feast was yummy. Christmas: snow, group photo, trip to North Carolina. Debbie got sick. Boom.

From January to late April, my memories are from my hospital bed in Albuquerque. Steve Fleming was great. On Friday he would drive four hours to pick up Robbie, who was with me in the hospital in Albuquerque, leave Nancy to be my weekend roommate, then do the reverse trip on Sunday. The fever, meds, and side effects have blocked out some of my memories, so I do not recall how many of those trips were made. I do know that the women of the compound came and visited. They asked all those pregnancy questions that get discussed— you know. They also supplied small amounts of stimulating gossip. Meanwhile, Robbie stayed with me and managed my health care; hung cards, photos, and memorabilia on the wall so I wouldn't feel left out. I missed his opening at the 409 Gallery. He built the *Goddard* piece on his trips back. This was an important year for both of us. We became much closer to one another. After several close calls, Hannah Pearl Barber was born on April 24, 1992.

When we arrived back at the house on the compound, I remember the smell of freshly cut grass. The house was prepared for us. We had not been able to do the prep work needed to get ready for a baby. The

house was decorated and full of baby gifts, formula, and various baby carriers, a crib, playpens. We received so many gifts, flowers, candy, cards, and such warmth that on that day the house became something else. It was a home.

The love everyone gave was really a bit overwhelming for me. I still had to get a lot of treatments. Babysitters were pretty easy to come by. One even did an oil painting of Hannah while she slept. On Hannah's six weeks' birthday, Nancy made chocolate cupcakes for all of us. We were really a family group, like it or not.

The Roswell Artist-in-Residence Program is a unique gift, and it brought together this group from different regions of the country, but with similar interests and talents. It created something for us that we would never have experienced anywhere else.

Karen Aqua (1991–92 and 1995)

Karen Aqua was also part of this close-knit group, although she arrived slightly later. Her husband, the musician Ken Field, also visited frequently and participated fully. Karen began working in animation while working on her BFA at the Rhode Island School of Design. She produced her first animated film there, which subsequently won awards at two different international film festivals. Her films are screened regularly, and she has won numerous other awards. She also teaches at Emerson College and Boston College and is a frequent guest lecturer. Her film, which she completed in Roswell, is entitled: *Ground Zero/Sacred Ground* and references the physical proximity of the Trinity Site near Roswell, where the first atom bomb was exploded, and the Three Rivers Petroglyph Site, containing over ten thousand petroglyphs created between 900 and 1400 AD. Karen remembers:

My time in Roswell began in October 1991, when I came for the first of my two residencies. I drew like crazy, pastels that grew in size as the months went on. At the same time, the seed of a new animated film began to germinate and develop. This was the start of a project which would direct my life for the next five years. I returned in 1995 specifically to work on the film: researching, gathering material, and animating. I also did a series of pastel insect drawings and worked in clay. Finally, I visited again in 1997 for the film's premiere screening and a drawing exhibit at the Roswell Museum.

Celebrations, Holidays, Gatherings

I first arrived in Roswell a few days after Halloween, in 1991. Since Don and Sally had been out of town during the festivities, they invited

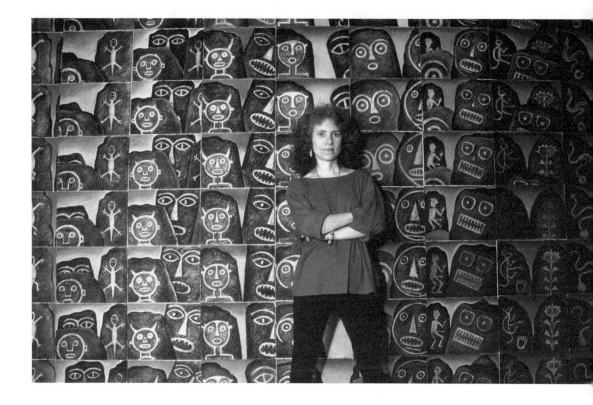

the residents over for dinner so they could see their amazing award-winning costumes. My fellow artists had won almost all the prizes at the costume contest at Bud's, the cowboy bar down the road. I went to the dinner, along with a samurai warrior and geisha, a medieval knight and maiden, and a minotaur.

Later, during dinner, Don passed around some cardboard masks for us all to enjoy. Needless to say, it was an unforgettable night.

Other celebrations and gatherings: Thanksgiving feast at a huge banquet table set up in Stu Arends' studio. Christmas dinner at former resident Martie Zelt's home. Academy Awards night at Adam Curtis and Louise Kennelly's place, complete with a giant Oscar poster.

We threw a New Year's Eve party at neighbors Thomas and Cora Bromley's place. Dancing to live blues music by Nightcrawler, the band, with Thomas on harmonica and vocals, Stu Arends on guitar, and my husband Ken Field on saxophone.

Around the Compound

One day John Jacobsmeyer started dragging huge rocks around and set out to build a pyramid at the edge of the compound. The other

women and I had a little ritual there one night, hiding some power objects inside. It's especially nice under a full moon.

My evening ritual: in the warm months, I would ride my bike west on Berrendo Road to my favorite sunset-watching spot, next to the yard where some donkeys lived. In winter, I would turn off the lights in my studio and watch the colors animate outside my windows.

Around Town

In addition to my fellow residents, my other Roswell family was the clay gang, the group of wonderful, funny women I met at the Roswell Museum's clay studio, run by Aria Finch. I would ride my trusty bike to the swimming pool at New Mexico Military Institute for a dip, then work/play at the clay studio. The gals were welcoming and enthusiastic. Compared to my usual work of making animated films, working in clay seemed like instant gratification. I painted and scratched away on my clay pieces, happy as a clam. Although I share a studio with a clay artist when I'm at home in Boston, I never get around to working in clay except when I'm in Roswell.

(All in masks): Karen Aqua, Sally Anderson, Stuart Arends, and Vicky Arends, attending party at the Andersons'. 1991. *Courtesy Karen Aqua.*

Ken and I recruited some fellow residents as willing participants in an impromptu "band" to parade around and play percussion at "Art on the Lawn," an event held by the Roswell Museum (we were trying to recreate Ken's Mardi Gras band in Boston, the Revolutionary Snake Ensemble). Everyone looked smashing.

Some favorite hot spots: Boot Scooters, the bar where we learned the Texas Two-Step; Roswell Livestock and Feed, where we bought horseshoes; Roswell Seed Company, where I bought corn kernels to animate in my film, and souvenir red pepper seeds for friends back home; UFO International Museum and Research Center; the junk store at the old silo; the rodeo; and the livestock auction. Then there were the amazing purple boots I found on sale at the mall, of all places.

My main project during my two residencies was my animated film, *Ground Zero/Sacred Ground*. I also created pastel drawings and clay pieces. The film was inspired by the Three Rivers Petroglyph Site between Tularosa and Carrizozo, New Mexico (two hours from Roswell) and its proximity to the Trinity Site, where the first atom bomb was detonated. I took numerous research trips to the Three Rivers site and other amazing rock art sites. With Matt Barinholtz, another resident, I also visited the Trinity Site on one of their open house days. We paid our respects and bought souvenir T-shirts.

I came across the ruins of an old schoolhouse east of Roswell, so I dragged Nancy Fleming out there one hot June day to film her cavorting under the brick arch there. Thus was born *The Letter N*, a thirty-second segment for *Sesame Street*.

Wild Life

I loved watching the swallows build their mud nest below my porch eaves, and I enjoyed their family life: baby birds appearing, growing, and joyfully fledging. The first batch of offspring left, and a second

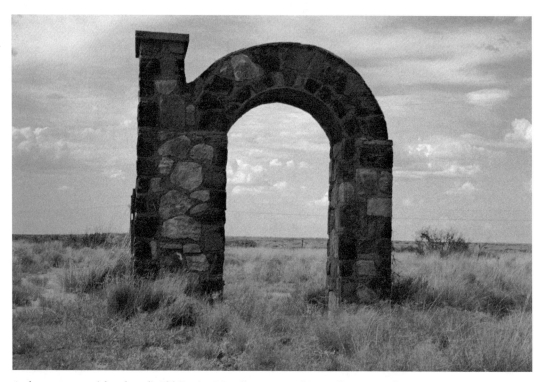

Arch entryway to (abandoned) Old Frazier Schoolhouse east of Roswell, ca. 1992 where Karen Aqua filmed a segment for *Sesame Street*. Photograph by Karen Aqua. *Courtesy of the artist.*

batch was born. Then one day I noticed the nest seemed to be empty. The next day I saw the roadrunner jump up on my table and leap up to the nest. I was horrified that this creature (whom I'd been so tickled to see at first) had done away with the baby birds. Life is cruel in the wilds of Roswell.

Don't ask me why I took in two baby grackles that had fallen out of a tree. Everyone warned me not to do it. It turned into the saga of the bird who would never leave. We named him Squawky, and once he finally ventured outside, we had to feed him in a tree every day. When my first residency ended, I had to hope that he would learn to be independent.

Our Fifteen Seconds of Fame

My husband Ken and I were walking out of the post office in beautiful downtown Roswell when we heard someone say, "There's a trendy couple!" It must have been our sunglasses, Ken's black leather jacket and African scarf, and my bright purple scarf. We were approached by a woman with a microphone and a man with a video camera; they asked us if we'd like to be in a car commercial. We asked how much we'd be paid, and although the only payment was two free movie rentals at Blockbuster, we said yes—we were more interested in exciting new experiences than in money anyway. The script went like this:

Offscreen voice: "What do you want from your next new truck?"

Ken: "Show me a real value!"

Karen: "Yeah, it's gotta be a good value."

The commercial aired numerous times, which naturally created quite a buzz around the compound.

Ken's Music Project

[Ken relates:] I was unable to be in Roswell for Karen's entire residency period, but during her 1995 stay I came out for the first and last months. I used a vacant studio to practice my saxophone, and enjoyed the huge amount of reverberation in that empty room. At one point Karen and I were talking with Don and Sally, and I mentioned that I loved practicing in the studio. Don graciously offered the use of the Anderson Museum for practicing. I declined, but asked about the possibility of playing in *The Henge*, which I remembered had great acoustics. Don said sure, I could use *The Henge* while he and Sally were out of town for the next week or so, and he told Ron Young, his groundskeeper, to let me in whenever I wanted.

I decided to make the most of the situation, so I went down to Fat Dog Sound and Light, the local source for sound equipment, and

Subterranea Ken Field

Compact disc jacket for Ken Field's *Subterranea* album, recorded in *The Henge*, May 1995. Photograph by Cathy Nelson. *Courtesy of the artist.*

rented an eight-track digital tape deck and some mikes. I got some help from Carl Erdmann of Nash Street Media, one of the producers of the car commercial that Karen and I starred in. I spent the next week recording some layered improvisations on sax and flute and percussion (including a double drum that Matt Barinholtz rigged up for me from a putty tub).

About a year later, these recordings were released on the O.O. Discs label as my first CD, *Subterranea*. It received a tremendous amount of press and radio airplay, and was an extremely significant turning point in my musical career. On the basis of the compositions on *Subterranea* I was selected as a resident at the Ucross Foundation, another residency program in Wyoming, and subsequently I've released several additional CDs of my compositions and improvisations.

Stephen Fleming joined this group a few months after Halloween: In the winter of 1991 Don invited me [and Nancy] back for another year. Feeling like we were coming home, we arrived on Christmas Eve with snow falling. Very romantic!

[We joined] the other artists there; we had a great time together. We all became so close, a group of young couples, with whom our lives are permanently intertwined—much youthful exuberance, many parties. Nancy loved it. Nancy and I slipped off on a two-week Mexican odyssey and got married. Later we helped out when Debbie got sick before little Hannah was born.

In September of 1992 I was called back to teach painting at Kansas City Art Institute. The next spring, Stu let us house-sit on the compound in exchange for some yard work. Nine months later he told me his career was going so well that he was going to stop being director and that Don wanted me to take over the job. Two years later, Sienna our daughter was born, and as they say, the rest is history.

By 1992, Stu Arends, who had served as program director for five years, had become internationally known, and he left to pursue his career full time. He still lives in New Mexico and feels that his work has been enriched by the isolation and austerity that the desert brings to him.

Stu asks: "What better life is there? I'm not so much interested in how I do my work but more importantly what it's like to spend a lifetime being an artist. I think I have more to offer."

After his divorce, he built himself a beautiful small house and studio a few miles from Roswell, but as the area became more developed, he moved to an even more remote spot in Willard, New Mexico, about a hundred miles from Roswell. He divides his time between his house there and his gallery in Italy.

Phillis Ideal (1992–93)

Phillis Ideal's arrival coincided with the departure of Karen Aqua, John Jacobsmeyer and the Barbers. Louise and Adam remained in Roswell for several years and were still considered part of the compound. Phillis has a BFA from the University of New Mexico and an MFA from the University of California at Berkeley. Her remarkable abstract paintings have been shown at many distinguished galleries in New York City and around New Mexico. She has also held teaching positions at San Francisco State College, the University of California at Berkeley, and Sarah Lawrence College. She now divides her time between New York City and New Mexico. Phillis remembers:

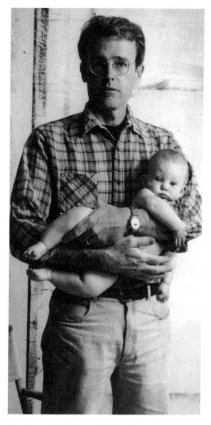

Stephen Fleming holding Sienna. 1995. Photograph by Cathy Nelson. *Courtesy of the artist.*

My three-year guest teaching position at Sarah Lawrence was coming to an end when I applied to the Artist-in-Residence Program. This required me to balance an odd mixture of emotional ingredients. I had been born and raised in Roswell, and spent most of my high school years planning to escape. I'd never had any plan for growing up and returning, but suddenly I was without a job and in need of support. My acceptance into the program meant that I was going back to live in the very town where most of my conflicts had started—the same town where my mother lived.

She was old and failing now, and seemed to be waiting for me to be there for her. She had no other family than myself, and we had never gotten along. I already knew on some level that my work in Roswell was going to involve more than painting.

Roswell was not exactly the heartbeat of the nation in the 1940s, but it was a wonderfully realistic stage set for the countless stories of pioneer life I heard growing up. My family had ventured to the West in the late 1800s to make a new start. They owned and operated Everybody's, Roswell's first clothing store, right on Main Street. I was an only child, being raised mostly by my grandmother, and supported

by my grandfather's store. I used to puzzle over my relationship with my mother: Why had she handed me over to my grandmother? My father had died when I was five weeks old, plunging my mother into a state of mourning and distraction that continued all through the years in which I was supposed to be growing up. Since then, I have spent endless hours in therapy, talking about my mother. I always felt that I had no resources for dealing with her criticism of me. I learned how to avoid painful contact by handling her from a great distance, rather than trying to relate to her. I visited her dutifully, once a year. I sent presents to distract her from the negative energy that passed between us in phone calls and in my short visits. If one of us attempted some tentative interaction, it irritated the other. Old wounds became raw again.

When I came to live at the residency in 1992, my mother was ninety years old, continuing in her long commitment to reclusiveness. Her isolation was broken only by visits from her black housekeeper three times a week. In the previous year she had been in and out of the hospital repeatedly. Old age had attacked most of her body. I knew this would be our last chance to change our relationship, and I didn't know if I could pull it off. For the first six months I acted as if I were free of hostility even though all my defenses really were intact. I became the mother, the care-taker: holding her, touching her, feeding her, combing her hair—physical contact with her to which I had always had an aversion. But it started to work. She began to soften to me as well. I was not the mother who brought her into the world, but I was certainly there to help her leave in peace. And this resolve was one of the most meaningful achievements of my life. She died on Mother's Day, the end of my grant year as well.

As for my painting, when I wasn't at the hospital, I was in my studio. The painting changed drastically. I threw away much of it. I started pouring paint and slathering it on the canvas in a very uncontrolled manner. This was definitely "process abstraction." This was a style of risking, and then editing out what survived this act of faith. As it turned out, most of it didn't make my A list. Gallons of paint episodes and applied canvas were tossed almost daily. Several of my fellow grantees would peer into my dumpster on different occasions and say, "Phillis, what was wrong with that one?" I cropped drawings, cutting out what worked and leaving the rest—similar to Frankenthaler, or for that matter, Pollock. I kept the trimmings that didn't work and put them in other paintings. I was constantly walking through islands of paint pours scattered on canvas or paper on the floor of my studio. I felt lost and that I was just making a huge mess—a crazy

Group photograph. 1993. (L to R): Adam Curtis, Stu Arends (director), Jerry Williams, Phillis Ideal, and Carl Bronson. *Courtesy Roswell Artist-in-Residence Program archives.*

backwards process. I was grateful when the painting held me, looked back at me.

Contemplating this painting process that developed more than ten years ago on the grant, I realize that I laid the groundwork for the painting that I do now. I wrote this statement for a recent exhibition:

"My process emphasizes the ecology of the found in which miscellaneous objects are transformed and seen again. The process is self-referential, in the same way that a crazy quilt reflects the vignettes and life patterns of its makers. The poured paint pieces are collected and relegated to a pile much like a collection of articles of clothing on a table at a flea market—many times perused, examined, and rejected. Finally a paint piece that has been there all the time waiting for discovery strikes an intuitive chord and is added to the painting. In this way

I keep my process open through reshuffling disparate collected pieces and assembling them in equally disjunctive sequences. Each painting carries with it the potential of evolving into an alternative painting."

I have often heard the Roswell Artist-in-Residence grant described as a "gift of time;" it can be up to a year of uninterrupted time in which to work. For me, it was much more than that: it not only opened up my painting process, but enabled me to grow up. I will always be indebted to Don Anderson's residency program for giving me the opportunity to come home again.

Phillis now divides her time between Santa Fe and New York City, where she shows her energetic, painterly abstractions frequently.

Jerry Williams (1993)

Several more former residents returned to the grant after that, including Jerry Williams. He had been living in Sweden since 1988; he was now married, with a daughter and a stepson. He was showing his work extensively in Sweden, Germany, and the United States. One critic describes his work in these terms: "Dreams are still built under the menace of banality. To express this, he has chosen a language which is neither painting nor sculpture but motionless theater, stopped in the middle of action. He may be an outsider, but he is definitely a rare artist."[40] Williams says:

> After my first residency in 1983, I had settled down in Sweden with my new family and I have been a resident of Sweden ever since. I still have a gallery in Boston, so I come back for an exhibition every five years or so. In 1992 we were invited back for another residency, so I was able to show my Scandinavian family the great Southwest. They fell in love with Roswell.
>
> I was married with a stepson and a small daughter. The family and I were swimming in Don's pool when we noticed a tarantula, swimming with us. I scooped him out with the pool cleaner, but the family didn't believe me when I said they were not particularly dangerous creatures. There was the occasional encounter with scorpions. Kjersti was a little paranoid about them.
>
> I have many good memories from my times in Roswell and I still have good friends there. It really was a "gift of time," and that's the best gift you can give to an artist.

Marcy Edelstein (1993–94)

Marcy Edelstein, a printmaker, and her husband, sculptor Walter Jackson, arrived for the year from Brooklyn, New York, in the fall of 1993. The move

was a drastic change for them. Marcy received her MFA from the University of Iowa; she has also taught drawing and design at the University of Tennessee and drawing and printmaking at the University of Virginia. Walter received his MFA from the University of Tennessee and has taught there and at York College of the City University of New York. Both Walter, the sculptor, and Marcy, the printmaker, have shown their work widely, especially in the East and the Midwest. Marcy remembers:

It was my first trip to the Southwest. I was profoundly moved by the space and light, the strangeness of insects and plants, the jays in the morning, the boat-tailed grackles that seemed to inhabit every bush on the compound. Watching for UFOs shortly after our arrival, we saw a large flaming object falling from the sky. More than two weeks passed before we learned that a fighter plane had gone down over White Sands.

There was a Chile Pepper Festival and an Electric Light Parade; my first Super Bowl party; parties at the residence (one night the mayor got drunk), at the Jiménez compound in Hondo, and at Don and Sally's home. Every major holiday was a potluck with the best food and best company imaginable. I must have baked more than twenty pies over the course of the year. Sally's birthday was celebrated at the Jiménez home in Hondo. Our gift to her from the compound was a book of small paintings, drawings, and prints; my contribution was one of a series of monoprints—little miniatures that set me off on a solid month or two in the print shop and resulted in more than forty images. It had been years since I'd had access to a print shop. Once I started, I couldn't stop.

Our community consisted of six sculptors (Julia Couzens switched over from painting while she was there), a 2-D person (me), two writers, four dogs, two horses, and at least three cats (although the cats kept a low profile and the horses were boarded out). I arrived with a couple of suitcases of clothes, two boxes of art supplies, and two obsessions:

Gymnastics—my answer to a mid-life crisis. When I left Brooklyn, I was in the habit of attending classes four or five nights a week. I had been at it for less than a year and was totally lacking in grace and expertise. Nonetheless I was generously adopted by the Roswell Gymnastics Team, a small band of mostly pre-adolescent girls with aspirations of becoming Dallas Cowboys Cheerleaders. Whatever they thought about my pathetic efforts at handstands and cartwheels, they kept to themselves. New Mexicans are so damned polite. Perfect hosts. I performed cartwheels down Main Street with the group during one

of the local parades. For the remainder of the year strangers would stop me and ask, "Didn't I see you. . . . ?" It was my fifteen minutes of fame.

Birdwatching—an obsession that goes way back to my years in Virginia. Skinny Schooley found me out early on and took me to Bitter Lakes National Wildlife Refuge many times; he taught me names of the ducks, waders, shorebirds, and songbirds that belong to the western half of the country. Many were new to me. The compound itself was frequently visited by a manic roadrunner and a great horned owl; flocks of cranes circled overhead in the mornings, and little burrowing owls ducked in and out of abandoned prairie-dog holes along the road out front. During an unusually hot stretch of the summer, heat-stroked barn swallow fledglings threw themselves from their nests onto our front porch; most of that batch didn't survive, but another round of nestlings arrived later that summer and did better. But my most special and unique birding experience was a 4 AM visit with Skinny to an obscure patch of overgrazed prairie where we witnessed the mating rituals of the lesser prairie chicken, described as "local and declining" in my favorite bird guide. Only a die-hard and passionate birder like

Walter Jackson and Marcy Edelstein at the Gran Quivira Ruins, Salinas Pueblo Missions National Monument, New Mexico. 1994. *Courtesy Roswell Artist-in-Residence Program archives.*

Skinny would have known where and when to see such an event. In the predawn light, as he'd promised, they performed a ritual of stomping, strutting, inflating brilliant yellow bladders on the sides of their heads, and "booming." Periodically they danced on the hood of our truck, which seemed to provide some kind of territorial advantage. I still have difficulty believing I saw them.

Wildlife in general was the prevailing theme: brilliant black-and-yellow striped centipedes, a multitude of scorpions, and the many-million-moth infestation that burst upon us when we returned from a short trip to Santa Fe. We battled them for hours, through most of the night. Hordes emerged from every corner of the house. We fought back with everything we could lay our hands on, but there were always more. The next day they disappeared. No one could explain where they had come from. There were bull-nosed snakes, a rattler we almost stepped on during a trip to see the petroglyphs, toads everywhere underfoot on the compound during the spring. Everything made it into my work, albeit a couple of degrees removed from reality. I brought it all back to New York with me in paintings, drawings, and monoprints that are the basis of the ceramic sculpture I'm making now. It wouldn't be a stretch to say that I might not have begun to make sculpture if I hadn't been to Roswell. The forms that evolved in my work there jumped off the page and demanded three-dimensional realization. (Perhaps too it was the experience of being completely surrounded by sculptors.)

Community was the other prevailing theme, something sorely lacking in New York City. Geography and a lack of time seem always to work against it here. Roswell provided a greater sense of being welcome than I had experienced in years. This sense extended from the compound to the town and throughout the state. Walter and I rode into Roswell and felt at home. This was a gift.

A lesser Prairie Chicken near Roswell. *Courtesy Roswell Artist-in-Residence Program archives.*

Walter Jackson (1993–94)

Walter Jackson writes:

> *Roswell Recollections*
> RAiR the beginning.
> Open space, crystalline sky.
> Marvelous sunsets, star-charged nights.
> Thunderstorms that fill you with awe.
> As lightning illuminates the terrain.
> Recreating the panorama before you.
> RAiR the middle.

LINKAGE
Scorpions in the light fixture.
Vinegarroons at the studio door.
House of moths.
Swallows nesting on the porch.
STAND
Pilgrimages.
Exploring ruins.
Sightseeing.
Treks across the plain.
SNAP COLUMN
Holiday gathering.
Birthday celebrations.
Watching sunsets.
Fireside cocktails and storytelling.
ILLUSION OF CONTAINMENT: IMPRINT
Art openings.
After party until.
Away openings, overnights,
Studio visits.
Exploring ideas.
RAiR the continuing.
THE GIFT
The compound, Roswell, museum
UFOs, Hondo, sunsets, parties,
Openings, excursions, work–
A year of work.
A year of new experiences.
A year that began new friendships.
A lifetime of memories.

In December of 1994, Stewart MacFarlane came back to the United States from his home in Australia and paid a brief visit to Roswell. Stewart continues:

I passed through Roswell again. I had been at the Bemis Center for Contemporary Art in Omaha, Nebraska and was driving my old Cadillac to Mexico. I saw Don briefly before heading south and he said if I needed to stay in Roswell a while, there was an empty house available for several weeks. Don and Sally were heading off to England for Christmas. I drove on to Mexico but everything went wrong. I struggled with the formalities and paperwork of getting the car and

myself across the border. Once that was done, I got mugged in Juárez on the first night. I decided to turn back and take up Don's offer of a stay in Roswell for a few weeks before selling the Cadillac and flying into Mexico later on, which I did.

The car in question was a big yellow Cadillac, on which Stewart had mounted a set of enormous horns from a Texas longhorn bull; it was an impressive variation on an artifact of cowboy culture. He goes on with his story:

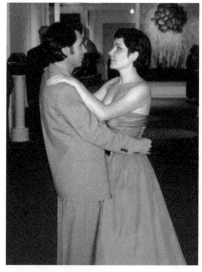

Stewart MacFarlane and Jane Creasey MacFarlane at their wedding reception in the Anderson Museum. 1996. *Courtesy Stewart MacFarlane.*

> Back in Australia, this time in Brisbane in 1996, I met the love of my life, Jane Creasy. Marriage was for us and the place we decided to do it was Roswell. I wrote to Don and Sally, proposing the idea but not expecting the generosity of their response. They happily wrote back and invited us to get married at their house. They asked us to come and stay before the wedding, and to invite the wedding party of Jane's parents and our best man Sean and his wife Monica Farrell to stay as well.
>
> It was wonderful. Fifty guests were present for the ceremony on December 7, 1996. There were nerves and tears, as could be expected, but all went off beautifully, including the weather. Don had arranged for a friend of his, a district judge, to marry us, with help from my friend, Pastor Len Hall. The reception was held at the Anderson Museum of Contemporary Art. Brinkey Randle was so generous in providing the fabulous food for more than fifty people. Juanita Stiff supplied a beautiful wedding cake. At the last minute, Jane and I had seen a notice pinned on the Roswell Health and Racquet Club bulletin board for a ten-piece Mexican band. I called the number, and thanks to a cancellation in their schedule, the band was able to play for our reception.

Don Anderson and friends dancing at the MacFarlane wedding reception at the Anderson Museum. 1996. *Courtesy Stewart MacFarlane.*

Dore Gardner (1996)

Dore Gardner is a documentary photographer of great distinction. Her book, *Niño Fidencio: a Heart Thrown Open* had just been published when she arrived on the grant. The book documents the life in a small Mexican village and the profound effect

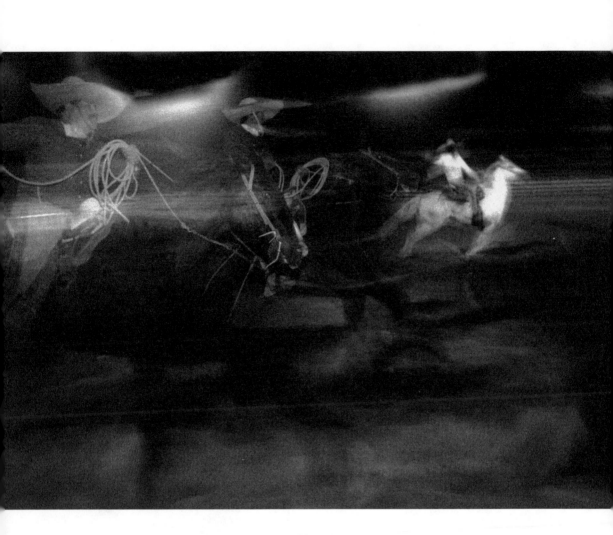

Dore Gardner, *Rodeo Fairgrounds. Roswell, NM. 1996.* Photograph. *Courtesy of the artist.*

that this famous (now deceased) healer had on the lives of the villagers. Though an outsider there, Dore was very much caught up in the cultural and religious spirit of her subjects, her photographs capture the deep emotion of the participants and show her deep feeling for the culture. Of her time in Roswell in the residency, Dore recalls:

> Living there it was the land—so much land, so much space, sky, dust, heat, and weather. Traces of the military, alien sites, cultures, tourists, and the myth of the West. A vast land, inspiring and complex, filled me with reverence, dread, and wonder.[41]

Dore now teaches at the School of the Museum of Fine Arts in Boston. She has been the recipient of an NEA Regional Fellowship, and *Aperture*, a leading photography magazine, lists her as "one of the ten finest emerging photographers from around the world."[42]

Sue Wink (1996–97)

Sue Wink was the first arrival in a congenial group which assembled itself within a few months: Laurel Farrin and Scott Greene with his wife Anne, all painters, and Yoshiko Kanai and Deborah Brackenbury, both sculptors working in mixed media. When Sue was awarded a public commission for the Roswell Civic Center, it was agreed that she would also receive a residency grant at the same time. She received her MFA in ceramics and sculpture from Indiana University in 1983 and then taught at Central Michigan University for over ten years. She left that position to come to Roswell, and has continued to receive public and private commissions throughout the region. Sue muses:

> Maybe the Artist in Residence grants are most important for a young artist: someone who's just out of school, who's been sneered at and told there are three or four hundred applications for every teaching job, so "maybe you can be a waitress." It's as though you've been rejected even before you've had a chance to offer what you can do.
>
> The residency literally validates you as an artist. It not only tells *you*, it tells the world, that what you're doing is important and needs to be taken seriously.
>
> I decided to quit my teaching job at Central Michigan University and pursue sculpture full time. You can imagine how scary that was. I received a commission to do a public sculpture at the Roswell Civic Center, a commission which was tied to the residency. This was an enormous opportunity for me. I learned so much about my own craft and about the resources available to me in Roswell. It led to a whole series of other commissions throughout New Mexico—Albuquerque, Portales, many other places. I made lifelong friends in Roswell and decided to buy a house and settle here. It still moves me very much when someone meets me for the first time and finds out that I'm the one who made a piece they've noticed, looked at, sat on somewhere in town.

Stephen Fleming, Sue Wink and Don Anderson at the August 1997 ribbon-cutting ceremony for Wink's stone and ceramic fossil form installation, *Oasis*, at the Roswell Civic Plaza. *Courtesy Roswell Artist-in-Residence Program archives.*

Wink's public works consist of earthworks and large functional stone or concrete shapes–planters, benches—whose surfaces are animated by mosaic. They evoke the gardens and fountains of Colonial Spain, Gaudì, and Wink's own antic vision.

Yoshiko Kanai
with her piece,
*Home Sweet
Home*. 1997.
*Courtesy Roswell
Artist-in-
Residence Program
archives.*

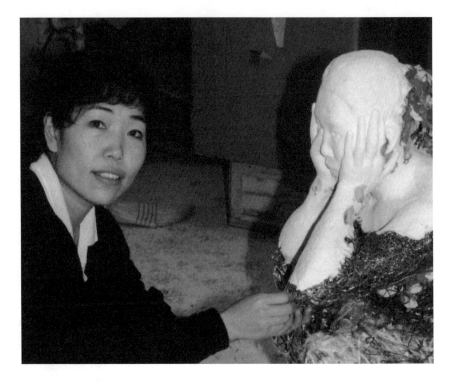

Yoshiko Kanai (1996–97)

The Japanese-born sculptor and installation artist Yoshiko Kanai makes works that express her concerns about women and their conflicts with tradition and society. Does the fact of being a woman artist imply rejection of traditional sexual identity? *Home Sweet Home* represents a realistic seated plaster figure, clothed in an intractable "fabric" that resembles dried moss and grasses. The figure's left hand is pressed against her cheek, covering an eye, suggesting concealment. Emotion is kept painfully in check.

During her time in Roswell, Kanai formed a particular and daughterly friendship with the late Ralph McIntyre of the Anderson Museum staff. When news of his death reached her after her return to New York, she felt a crushing sense of loss, reflected in her recent installation, *Hunger,* with its musings on sexual and societal roles and the passage of time in a woman's life. Yoshiko adds:

> When I got the Roswell residency I wondered how I would adjust to living one year in New Mexico. Since 1993, when I came to America from Japan, I had lived in New York. My English was not good; most of the people around me were not American; I didn't have any real American friends.

I wanted to learn about America, so I decided to travel by train all the way from New York to New Mexico. I crossed over the wide empty land, and after the long journey from the Albuquerque train station to Roswell, my bus stopped at a small bus stop and there Ralph McIntyre waited in warm autumn twilight. He introduced me to Roswell and became my first American friend. We stayed in contact until his death. Through Ralph and the program I met many beautiful people. My anxiety about living in New Mexico soon vanished and a new anxiety touched me—how could I return to living the hard life of an artist in New York?

Scott Greene (1996–97)

Scott Greene and his wife Anne, also an artist, came to Roswell in September of 1996; they were (and are still) based in Bernalillo, a small town north of Albuquerque, where Scott was and still is codirector and master printer at Hirsh-Greene Press. His work on the grant consisted entirely of large paintings, witty send-ups of early, famous paintings such as Gericault's *Raft of the Medusa*. Scott says:

Group photograph. 1997. (Seated L to R): Scott Greene, Anne Hirsch Greene, Sue Wink, Yoshiko Kanai. (Standing L to R): Deborah Brackenbury, Nancy Fleming holding Sienna, Stephen Fleming, Laurel Farrin. *Courtesy Roswell Artist-in-Residence Program archives.*

When I tried to think of anecdotes and experiences from our time on the grant, nothing immediately jumped to mind beyond dinners and social functions with the other artists, and obviously the quiet sanctuary of studio and time. But the more I thought about it, the more I remembered.

Things like: Don Anderson doing a little landscaping around the grounds with his personal full-sized frontloader. Don's sturdy legs (he likes wearing shorts). Don purchasing my impossibly big-ass painting [Scott's eleven-foot by sixteen-foot reinterpretation of *Raft of the Medusa*, featuring a large truck in place of the raft], for the new wing in his museum (a couple of wings ago). Artist Laurel Farrin wearing Scotch tape across her forehead to keep squint lines from appearing— a pre-Botox technology solution for staving off the effects of time. Stephen Fleming on the rooftops maintaining sixteen swamp coolers every season (no small feat). Sue Wink's silhouette across her living room curtains, frantically, comically, and ineffectually swatting at a moth infestation. Stepping back from a table in the print shop and squishing a big scorpion under my heel (big as a Texas belt buckle). The grand festivities celebrating the fiftieth anniversary of the Roswell alien incident. The overlap of residents starting and finishing, and the supportive community of people related to the residency—Don and Sally, Stephen and Nancy, Marina Mahan, who ran the Anderson Museum, Brinkey Randle, president of the Roswell Museum's board and close friends with all the artists in residence, the Jiménez family, and the organic farmers (now gone) who supplied us with the most amazing vegetables and flowers.

My memory of the experience is also bittersweet. The grant came at a time of great personal tragedy for my wife Anne and me following the loss of our first-born daughter to Sudden Infant Death Syndrome. The residency allowed us an opportunity to reaffirm our commitment to art, while putting our lives back together. Both of us continue to build on the foundation of ideas and feelings established while on the grant all those years ago.

Jerry Bleem (1997–98)

Several months after Scott Greene's residency, Jerry Bleem arrived and helped to create another close-knit group. He is a fiber artist, a Roman Catholic priest, and a member of the Franciscan order. He is from Illinois. He received his Masters of Divinity from Catholic Theological Seminary at Chicago in 1982, and his MFA from the Chicago Art Institute in 1992. Jerry made many close friends on the compound, in particular with Al Souza, Jane South, and Anne Harris and her husband. He also became

Group photograph. 1998. (Seated L to R): Steve Levin holding Cleo, Anne Harris holding Max, Nancy Fleming holding Sienna. (Standing L to R): Aida Laleian, Jerry Bleem, Paul D'Amato, Jane South, Al Souza, Stephen Fleming. *Courtesy Roswell Artist-in-Residence Program archives.*

close to many in town, where he often substituted at Mass at St. Peter's Church. Jerry recounts:

My strongest memory of the Roswell Artist-in-Residence Program is what I imagine to be the most typical: the wonderful gift of time that the residency provides. I have often described this as having enough time to fail—precisely what all artists need to grow. This was an amazing luxury. As he later describes it: the length of this residency gave me the opportunity to experiment, to leave a path I had struggled to clear [in order] to consider other possibilities. Often I was uncomfortable and confused as I tried to give physical form to ideas that had, up to this point, existed as some kind of ghosts. Some nights I went to bed convinced my art-making skills had deserted me—if they had really existed in the first place. Happily, taking the chance to fail and waste my time produced results that were worth the effort.

I have been accused of having eremitical [hermit-like] tendencies to which I plead guilty. Roswell suited me perfectly. I lived in my own house, cooked my own meals, and could, if I chose to, avoid everybody else. Though each [resident] can bring his or her family, the population of the compound is rarely more than a dozen or so, and that includes the director and his family.

This can also be a dangerous situation. With so few people, any division or disagreement has the potential to polarize the group and color one's time there. Of course, the experience I had is also possible. A year with a small group of people gave me the opportunity to get to know them at a reasonable pace. With months upon months to share our work and our lives, there was no rushed intimacy, but one that developed at a more natural pace. Any invitation declined simply left room for the next time. We respected each other's work habits, got art made, had parties large and small, shared sightseeing discoveries: we created our own kind of community. There are days when I still miss it."[43] Concretely what that "gift of time" produced was the first of the postage stamp collages; up to that point I was mounting stamps on objects, and the move to a complete surface made the work stronger in my mind. I also produced the first insect wing pieces. The latter was thanks to the grasshoppers in the untended land that bordered the residency compound on the south and west. These grasshoppers' wings were such a striking color that I had to keep looking at them until they became an artmaking material.

Sienna Fleming, Jerry Bleem, and Hannah Sparagana hunting grasshoppers, ca. 1998. *Courtesy Roswell Artist-in-Residence Program archives.*

The next strongest memory I have from Roswell is the kindness of the people: Anne Harris and her husband Paul D'Amato having me over for dinner night after night (pasta with red sauce, salad, and wine over and over again, and we never grew tired of the fare). They would never come to my house because Max, their small son, was bathed and put to bed right after dinner and it was easier this way.

Jane South bringing gin to every potluck. I can't have a gin and tonic without thinking of Jane.

At one point I invited too many people to stay in my house. Just at the very moment I was getting overwhelmed, Eric Snell and his wife Joanna Littlejohns took me over to their house for cups and cups of good tea and cake. It was exactly what I needed and my hospitality was preserved intact.

I still have the book that Sally and Don bought me, *Salinas Pueblo Missions,* because they thought I might be interested in this piece of New Mexican Franciscan history. And I am, and I went to see the missions. It was a kind act that really touched me.

The joy of working with the staff of the Roswell Museum and Art Center on the mounting of my exhibition; they were helpful and professional.

As I became involved with St. Peter's Parish in Roswell as the church where I went to worship and occasionally as a substitute priest, I became acquainted with members of that congregation. A group of men always went out for a meal after church and they always took me along. Several couples of that group went out of their way to make me feel at home during my time in Roswell.

Other things I remember fondly: Maria Rucker (fellow resident) yelling to the grasshoppers, "Run for your lives, he's coming!" when I would go out to catch grasshoppers in the field across from her studio.

Laurie (the new Director of the Roswell Museum) and Mike Rufe insisting that I had to come to their house to collect grasshoppers because they were "overrun." I doubted them. Finally I went, and they *were* overrun. I spent days there catching grasshoppers. I had so many that I had to devise storage methods. If anyone needs to know how to freeze grasshopper wings, you can refer them to me.

The sky—the big huge amazing sky. The wonderful sunrises and sunsets. The flatness of the land and the flora of the place that is so different from the upper Midwest.

Seeing New Mexico: White Sands covered with snow in late December 1997, Chimayo during the Good Friday pilgrimage, the ruins of early Franciscan churches, going thrifting in Alamogordo and seeing some unusual airplanes taking off from the air force base there. These "experimental" craft led me down the road to unbelief when it came to Roswell's "alien" history.

As is probably clear, my time in Roswell was both a joy and an important part of my development as an artist.

Jerry is fondly remembered by many of the members of St. Peter's Parish, in particular by Howard Herring, owner of Super Meat Mart and

his wife Elizabeth, who says: "We never called him 'Jerry,' only 'Father Bleem.' Howard and I sort of adopted him; we became close friends, and had many long conversations, especially about our faith. I have known many priests, but he is the one with the deepest spiritual sense that I have ever known."

Jane South (1997–98)

Jane South is an Englishwoman, a sculptor with a highly developed sense of humor, which is often reflected in her work. At that time, this consisted of densely painted canvases filled with fantastic detail: intertwined objects and tiny figures darting, falling. There were also the monumental sculptures in concrete, amorphous forms which seemed to be covered with cloth and bound with wires (all of which was cast concrete.) She studied art and theater design in England, then settled in Brooklyn for a while before going to the University of North Carolina at Greensboro to get her MFA. She says, "I am interested in the bizarre qualities of logic, and the absurd, which can be simultaneously tragic and hilarious."[44] Jane remembers:

It turned out of course that although the time I spent in Roswell and the space that it gave me to make work did indeed hold infinite possibilities, it was the people I met there that made the most lasting impression—in fact I am still in touch regularly with virtually all of my fellow artists-in-residence and other folks I met there, without whom not only would I not have learned how to play poker and identify a vinegarroon, but whom I can call for advice on how to put together a beginning drawing class or handle a frustrating time in the studio.

Perhaps the day that stands out most for me and the event that also seems to encapsulate the "can do" Roswell spirit was when, toward the end of my stay, all my large and rather heavy sculptures had to be moved out of the studio to the Anderson Museum for an exhibition. [Since the Roswell Museum staff felt they were too heavy and would damage their floors, Don had offered to exhibit them in

Don Anderson moving Jane South's sculptures into the North Gallery of the Anderson Museum. 1998. *Courtesy Anderson Museum of Contemporary Arts archives.*

his museum.] After much noisy deliberation among the gang as to the various complicated ways and means of doing this, all involving collapsible winches, hoists, and God knows what other hard-to-find and expensive equipment, a sotto voce announcement came from the quietly contemplative Don that he would simply drive his front loader over and into the studio, strap the work to it, lift it up, and move it on out—problem solved.

Steve Levin (1997–98)

Steve Levin overlapped exactly with Jane, and he and his wife Aida and daughter Cleo became good friends of hers, as did Jerry Bleem and James McGarrell, with whom he overlapped briefly. Steve received his MFA from the University of California at Davis and also studied at the Art Institute of Chicago for a year. He has been teaching art at Williams College for many years and has exhibited his work widely. Steve says:

Cleo Levin and Sienna Fleming. 1997. Photograph by Aida Laleian. *Courtesy of the artist.*

That year in Roswell is still so absolutely present in my thoughts. "Present" seems like the right word: there are many memories that feel as though they come from experience just days or hours past. That time remains magic for me, and I'll always be grateful for it.

Before that year, I had always dismissed talk of some special quality of light, particular to a place, as hyperbole. But it is true, and it was not subtle—it was immediate and obvious. I can clearly summon up a memory of the light in my studio, in the early morning. It may be as much a feeling as a visual memory; it is tied to a sense of calm. There is a hushed quality, despite shrieks from the grackles. I also remember a sense of clarity, in the literal sense, as though everything in the studio shared a uniform sharpness of focus. But the clarity was also within: a feeling that I knew what I was about, a sense of rightness. I don't remember being especially conscious of the light while I was working, but I can still summon up the sensation of the moment when I would first go into the studio and take a few minutes to look around, get my bearings, become inhabited by the light.

Aida, my wife and Cleo, my daughter, and I arrived in Roswell at a pretty odd time. That year there was a lot of snow right around Christmas [rare in Roswell]. Having come from New England, there was nothing so strange about snow. I remember being even a little

amused, watching someone plowing the snow with a backhoe, another wiping snow off his car with a scrap of cardboard box. But I could see that the snow did lie strangely on that landscape. Stranger yet, on one of those first mornings I saw an antelope in the field just east of the compound, far from the road. I looked more carefully, and saw that there were a few. Over the next few days, as the snow began to melt, these few had grown into a herd, grazing on the grass that was now uncovered. I counted fifty antelope, right across the road. The Department of Fish and Game determined the antelope should be moved to some more suitable rural location. They improvised a kind of round-up, using jeeps instead of horses, communicating with walkie-talkies. I learned later they'd successfully herded them into trucks to transport them to more likely pastures. (I think it was up near Fort Sumner, several miles north.) There is a strong current of resourcefulness in the Roswell population.

I came to know the Roswell Museum very well. I spent three or four hours each week sketching in the museum; some of the objects that I drew there still pop up in my paintings. My favorite section was the re-creation of Goddard's workshop. [Robert H. Goddard was the designer of the first liquid-fueled rocket; he lived in Roswell during the '40s, and the Roswell Museum has recreated his workshop, which was originally located on his ranch on Mescalero Road.] I liked the idea of "rocket science" springing out of this kind of back-room operation. It was satisfying to see these homely metal cylinders and pipes tied together with baling wire labeled as a "rocket thrust chamber!" I also made a lot of sketches of Native American objects, of artifacts of the Old West and of even older Spanish armor. The museum is not large, but the collection is broad, and I've found few other museums like it.

It was so easy to bring everything back to the studio. It felt as though daily life and my studio meshed more completely there. The studio adjoined the house, and it also looked out on the center of the compound where the kids were playing. Now I can see a lot of that in the paintings I made there; they had a lot of play in them.

Another good place for sketching was at the zoo. Cleo turned six midway through that year, so the zoo was a place that was good for both of us. It was small, and didn't have a lot of exotic animals—virtually all of the animals were "locals." How many zoos have a prairie dog colony and a herd of longhorns encircled by the train ride? In any case, we were discovering a lot of animals that seemed "exotic" to us right outside our doors (e.g., horned toads) not to mention those inside our doors (e.g., vinegarroons). Fauna was a big part of that year, and that worked right into the studio as well.

Aida met Aria Finch (how's that for an operatic pairing?) when she wanted to hire a "student" ceramist to make porcelain tiles for her photographs. Aria insisted that she would teach Aida to make them for herself (again that Roswell self-reliance). In spite of Aida's protests that she couldn't do it, Aria proved the stronger willed (hard to imagine), and the tiles were made!

Just before we left, Mary Stickford, a librarian at the public library, gave Cleo a box to open when she got back to Massachusetts. Inside was a "memory box," a homemade box in the shape of New Mexico, containing bits of turquoise, an arrowhead, rattlesnake rattles, a roadrunner charm, and other souvenirs of the state.

We remember our year on the compound with great affection.

Cristina González (1998–99)

Cristina González arrived with her companion David Glass and overlapped with Steve and Jane South, and then became part of another close group with the arrival of painter James McGarrell and the German sculptor, Maria Rucker. Cristina has a BA from Yale and received an MFA from the University of Washington in 1997. She has taught at Santa Fe Community College and at Indiana University. She is also an accomplished flamenco performer.

The paintings of Cristina González can be divided into two principal modes: a group of portraits and self-portraits painted from direct observation, evocative of ancient Roman painting; and an ambitious series of figures in landscapes or interiors, using as models *muñecas*, the brightly

Bob Finch, Cristina González, and David Glass. 1999. *Courtesy Roswell Artist-in-Residence Program archives.*

painted papier-mâché dolls of Mexican folk art. This latter work is as disquieting as it is beautiful. In *El Jardín de la Memoria*[45] in the Anderson Museum, the doll sisters wait, charged with expectancy, in a *hortus conclusus* [enclosed garden] that appears to tremble in its own vulnerability. Cristina says:

> I find my own words to be so clumsy when I try to talk about profound change that takes place in the studio, and in the heart. And my Roswell year was all that, and more.
>
> Some of my best memories are of sitting on the lawn watching the sun set over the pecan grove to the west, drinking wine, feeling perfectly loved. And, of course, the weekly drama of the poker table, over which Jim [McGarrell] presided. The other, most persistent memory is of one day gliding seamlessly into the next. Day after day of going to the studio. (If not for poker, I would have lost track.) There were no distractions in Roswell. No great cinema or bookstore. It should be a dull and commonplace city, with its Main Street strip of Wal-Mart and Target and all the chain restaurants that grace interstate highway cities across middle America. Roswell should have nothing to offer, but weirdly, it does. I know this is largely Don and Sally's doing.
>
> The Roswell Artist-in-Residence experience is a perfect reflection of the local landscape. At times it is stark—a vast, lonely place where one confronts the self. Other times it seems infinitely embracing, and everything becomes possible. The land, so open and endless, can be alternately terrifying and exhilarating; exactly how it feels to enter one of those big empty studios for the first time.
>
> The physical isolation of place is both a blessing and a curse. Distractions are hard to come by. Suddenly the artists have so much space (literal and metaphorical) to themselves. Many face solitude for the first time. And just as importantly, many of the artists find companionship. Either way, the experience is vital for the studio life.
>
> Unlike other artist residencies of this caliber, Roswell's intensity does not result from high-powered connections or a competitive art scene. It is disarmingly simple and straightforward and generous: come for one year and your basic needs will be provided for, while you are free to work in your studio. Your gift is time and space to do with whatever you wish.
>
> Anyhow, that's what the Roswell year was for me: one day after another, shuffling over to my studio and feeling as though I had the time to look and think. It was anxiety-producing in the beginning. Yes, I'd had a lot of time in the studio by myself in graduate school, but this was different. I was facing myself and my work in total solitude

for the first time. I can't really explain what happens in those hours (nor would it be madly interesting), but that was really the core of my Roswell year. Punctuated, of course, by blossoming friendships, and my growing love for David.

Cristina and David married; they live and work in Las Vegas, New Mexico with their new daughter Maya Xochitl Azul Glass.

James McGarrell (1998–99 and 2000)

McGarrell, an old friend of Sally and Bill Midgette (whose teacher and mentor he had been), wrote to Don Anderson in 1998. Since one of the galleries representing him was closing, he wondered if Don would be interested in buying one of his best and largest paintings for the Anderson Museum at a discount, since he had no place to store it. Don wrote back explaining that only former residents were on display there, but would Jim consider being a resident for a few months, so that he could qualify? Jim readily accepted, adding a great deal to the artists' group, for several winters, by his presence and that of his wife Ann. Almost seventy at the time of his first grant, he became an important mentor to the group of younger artists who were there; the same thing happened when he returned the subsequent year. McGarrell wears his great distinction as a painter lightly (he has exhibited widely in the United States, Europe, and Asia and has won major awards in his field). After a lifetime of painting the figure, his recent work has moved in an entirely new direction. Jim reflects:

> I can't think of anything better than Don Anderson's idea of the residency in Roswell being a "gift of time." That seems to me to be the bottom line prize of the generous residencies there, as it ought to be in most.
>
> Before we went to Roswell, I had never applied to any artists' residencies; I never felt the need of studio space I didn't already have. When Don offered me this senior residency, however, and with it a place on the wall of his museum for one of my most important paintings, there were a couple of factors that persuaded me to accept, but not before he assured me that I would not be displacing a worthy younger painter. For one, I had retired from teaching, and I was able to be absent from my home studio for long periods. For another, I don't have a wall big enough here to accomplish a project I was contemplating, a really big painting: a triptych of three sixty-by eighty-inch canvases, 180 inches wide. It couldn't be done on the wall in my current studio. Also, my wife Ann had had pneumonia two consecutive winters in Vermont. The idea of being in a warm place, especially during the bleak gray

dwindling part of winter, sounded very attractive. We packed our two favorite cats, Mewsie and Eglantine, and brought them with us. They liked feeling the sun on their old fur and bones as much as we did.

There were several other bonuses I hadn't anticipated before I went to Roswell. One was the ceramics program, which I'll discuss in a minute. For another, there were intaglio and lithographic presses there. I had no intention before I went of doing monotypes, only that big painting. But the presses were there, crying to be used. I could print at times of my own whimsical choosing, a few steps from my cottage and studio.

For the first time in many years, too, Ann had her own large studio. She was able to write a long cycle of poems about the painter Gwen John, a series that eventually became a novel (not yet published), so it was a richly productive time for her, as well.

One Sunday afternoon I was in the print studio with Ann, getting ready to pull a monotype impression. Suddenly we heard a bang and the lights went out just as we were lowering the paper onto the plate. We rushed outside. A young hawk had crashed into the electrical wires in front of Skinny Schooley's house across the street. Immediately a guy pulled up in a truck, flung the hawk into the back, and drove off. The registration was off on that print we were doing blind—I fussed with it, but couldn't save it. The Atlanta Falcons were in the Super Bowl that year. I decided not to ignore the omen, so I didn't bet on them. I was right.

Jim McGarrell and Don Anderson examining Jim's ceramic tiles. 2000. *Courtesy Roswell Artist-in-Residence Program archives.*

I had started drawing on ceramics about eight years before I went to Roswell, so I knew a little bit about the medium—but not nearly as much as I learned from Aria Finch. To have had her as an informal teacher and collaborating artist was an incredible boon. All the facilities were there. I could go every day if I wanted to. I found myself working with increasing intensity in that medium, to such an extent that I've bought a kiln and installed it in my summer studio in Vermont.

Particularly for me as an older artist, exchanging studio and extra-studio lore with younger artists was a refreshing experience; a collegial rather than a mentoring or pedagogical one. We now have life-lasting friendships with several of the artists we first met at Roswell."[46]

The place and the light, of course, persist in my memory, and continue to inform many of the paintings I have done since then.

Mary Josephson (1999–2000)

Living in Portland, Oregon, Mary Josephson has supported herself as an artist all of her professional life. Her work is in many public spaces and private collections. Her intent is "to tell the stories of people caught up in the heroics of everyday life, the commonplace events which color our lives and shape our days."[47]

Mary Josephson's arms embrace a huge salad bowl as she brings it to the potluck table. It contains greens, slices of beetroot, orange segments, pecans—and is consumed so quickly by the crowd of guests that it's hard to identify the other ingredients. Painter, chef, marathon runner, army brat, Mary Josephson grew up at the edge of the California desert. Roswell's remoteness and austerity would never daunt her exuberance and energy. Mary recounts:

> Some of the things I remember most vividly are those events involving wild creatures around the compound. There was a spot where the yard ended and the field began where I could almost count on catching a horned toad. When it came time to paint one into a painting, I went out and brought one inside for reference, just like going to the resource library.
>
> Riding my Harley-Davidson after working all day in the studio, heading into the sunset or under the stars was sublime. One night I headed toward the mountain, riding slowly down a small dark road. In the motorcycle headlight I could see many different kinds of animals. Suddenly two rabbits darted across the road, one from the right, one from the left—they ran under my bike between the two wheels and I did not hit either one!
>
> One morning my husband and I were having our coffee outside on the front porch couch in the frosty cold of winter, waiting for sunrise. It was perfectly quiet before the day began. At dawn we saw a pair of jackrabbits moving along together as animals do when they are at ease, without fear. We watched them like that for a moment until they sensed our presence and ran away. In that instant I realized what paradise must be like.
>
> On the morning of my forty-sixth birthday, Groundhog Day, 1999, I saw a huge meteor enter the atmosphere, streak red across the sky and explode over the desert.
>
> In the spring of 1999 I completed my first public commission in the beautiful, large, and well-lit studio I was given.

I rejoiced at being able to work with Aria Finch, a truly great artist, teacher, and enabler at the Roswell Museum and Art Center.

During her time in Roswell, Mary completed several large public murals, including a mural on the outside walls of Military Heights Elementary School, and one which brightened the walls of the entrance hall of UNITY Center (for at-risk teens), in addition to producing a important body of work.

Maria Rucker (1999–2000)

Maria Rucker arrived in Roswell, from her home in Munich, Germany in early 1999. She makes her ambitious sculptures by carving directly in stone. In the absence of marble quarries in the Roswell area, she was delighted to find that large chunks of local alabaster were appearing as by-products of a highway expansion project. She managed to transport enough alabaster boulders for a year's work, and exhibited a stunning group of monumental animal parts (noses, muzzles, paw pads) at the Roswell Museum and Art Center at the end of her residency. The weekly poker games became a metaphor for her experience of the compound:

Seven Card Stud: The very first evening in Roswell, after having been imported directly from Germany, I met all the artists-in-residence at the weekly poker game on the compound. I was frightened because poker seemed to be a very scary game to me, and also because my English was so bad that I could hardly understand a word of what people were saying to me (not even to mention technical poker terms in English!) and because I was jet-lagged and disoriented and didn't even know what a nickel and a dime were. Nancy [Fleming] tried her best to explain the game to me.

High Spade in the Hole: I had to lose many games until I understood some of the rules and terms, and was very concerned about losing all my stipend at this social event every Wednesday.

You can go high hand or low hand or both ways: Aria Finch took away some of my fears by pointing out that playing poker is really good cheap entertainment compared with other distractions, which in any case do not exist in Roswell.

The Perfect Low: All of a sudden, poker was not scary any more. It seemed to be the best therapy for

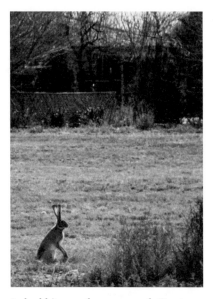

Jackrabbit near the compound. *Courtesy Roswell Artist-in-Residence Program archives.*

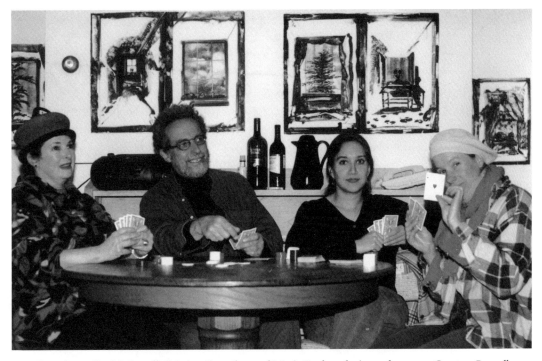
Mary Josephson, Jim McGarrell, Cristina González, and Maria Rucker playing poker. 1999. *Courtesy Roswell Artist-in-Residence Program archives.*

anything, particularly for losing one's fear of losing. You came to notice that the money didn't vanish; it just made its rounds through many different pockets and would return time after time as you won many games in a row.

When you go both ways you have to win both ways: I realized the many benefits of that weekly poker game: you get together with the other artists and some local people and you get to know them very well, because poker is not only strategic, but more than that, very psychological.

Motherwell: A highlight of every poker evening was the diverse studio visits. During the first months of my stay we had the chance to witness the progress of Jim McGarrell's gigantic food painting. Jim was the founder of the poker round and hosted the game for many months in his house. He had played poker with Robert Motherwell, who invented his own game called *Motherwell*.

Red Dog: Speaking of benefits: the contact with local people at the poker game was very helpful if you had any kind of problem: in my case, for example—where does a stone sculptor find rocks for her work, and how to carry big chunks into the studio? No problem, many

suggestions were offered by Sue Wink, Bob Finch (Aria's husband, a farmer), and David Glass.

Many pleasant common undertakings were also planned at the poker game, like spending five days at Bob Finch's condo in Pagosa Springs, Colorado; gambling at San Ysidro, visiting Mesa Verde, or creating a Moat Monster or a float for the Electric Light Show.

High Chicago: Bob Finch would eventually lend me his big truck and trailer for transporting a whole show to Santa Fe.

The Southern Cross: He would also invite artists to visit his farm in Dexter, a small town a few miles to the south, in quest of inspiration. He would introduce you to Willard, his huge but tame bull, and he would take you to a real cattle branding, an amazing event, with his partners, a crew of a dozen cowboys, where one could learn and practice how to brand a calf, or for the very tough ones, how to castrate one (not for me!!).

Jacks are Better, Triples to Win, Split Pot: Charity was not lacking. We donated money from the poker pot to the home for mistreated and repudiated kids, and from time to time we received Thank You cards beginning, "Dear Creative Poker Round."

After an extended stay in Roswell, Maria Rucker was the recipient of an Anni Albers fellowship, a Vermont Studio Center residency, and a Krasner-Pollock grant. She continues to work on major public projects in Germany and Italy.

Eric Snell (1999 and 1999–2000)

Eric Snell, an Englishman from the Channel Island of Guernsey, and his wife Joanna Littlejohns with their daughter Ella divided their stay in Roswell into two parts because of their schedule, overlapping with two different groups. Eric studied art in Great Britain, Germany, and France, and his work is represented in many private and public collections in Europe, North America, and Japan. In one piece created in Roswell, he burned a wooden chair and then created the work from it. He says, "I see myself as the catalyst, transforming a wooden object into a surface of blackened ash. I am trying to capture visually the very essence, the very spirit of that object, a memory. I wish to suggest that the object in effect still exists, and that it has just been transformed into another energy—transformed from Reality into Abstraction."[48] Eric remembers:

At thirty-five hundred feet above sea level, Roswell is a small town with about forty thousand inhabitants and is surrounded by desert. Distances are huge and the car is essential. You have to drive for three

hours in any direction before you get to the next big town. For most of the year it's dry and arid and the "swamp coolers" (simplified air conditioners) are essential. With temperatures in the summer regularly hitting the hundreds, it's too hot to sleep; and in the springtime you choke on the red dust of the land which is picked up by the warm westerly winds that sweep across the high plains. But I don't believe that anyone can live in New Mexico and not be affected by the vastness of the place; the sheer natural beauty of the landscape is breathtaking. I shall always remember—for it is absolutely unforgettable—the silence of the desert. And, of course, there is the light. Everybody always talks about the light, and really it is incredible—but it's just taken for granted.

Arriving as we did in the middle of October [for the second stay], I could not help but be impressed by the wonderful southern New Mexico light. And where there is light there are shadows. Each

Eric Snell in his Roswell studio working on Shadow Painting #1. 2000. Ash of the table mixed with linseed oil on canvas. 61" x 56" *Courtesy Roswell Artist-in-Residence Program archives.*

morning our apartment [was] filled with the most amazing, warm intense orange light that is all-consuming, casting long thin shadows over the flattened landscape. The light is so intense that you feel that you can just peel the shadows off the wall. This thought triggered yet another idea.

I kept on thinking about painting, an area that till now I had not really explored. I kept on thinking about something that I had read some months earlier, that, according to an ancient myth, the origins of painting can be traced back to the play of darkness and light. Also, the philosopher Pliny the Elder recorded that Debutades' lover was forced to take leave of her, and in order to preserve his presence she traced his shadow on the wall.

For me, the residency program was not just about being given time to bury myself in my studio—I could have done that in Guernsey. The residency program has given me the opportunity to look at things in a different way. By spending time living in, rather than just visiting, another country, one's senses are heightened. One can start to make comparisons between Guernsey and Roswell, even though at first one might think that they are two very different places. But you soon realize there are many similarities; you soon start to identify both the strengths and weaknesses of each community—but that's another lecture! Wherever we are living, we are always living among some of the best, most exciting ideas there are, just waiting to be noticed. Sometimes you have to travel six thousand miles before you are able to open your eyes and realize that sometimes the familiar is so familiar that the familiar becomes ordinary, so ordinary that it is often ignored or even dismissed. But of course that is not true: it is the ordinary that is extraordinary.

Jeannette Louie (2000)

Jeannette Louie is an artist who works with words and ideas; her work is shown widely on the East Coast, especially in New York City. She has her MFA from Vermont College of Norwich University in Vermont, and teaches at William Paterson University in New Jersey. Jeannette says:

My stay in Roswell was brief, but unbelievably gratifying. Memories of New Mexico surface constantly in my present life. I did not anticipate discovering so much about myself.

I remember that the year of my residency (2000) was a turbulent and climactic time. I had been living abroad in Italy on a Rome Prize Fellowship at the American Academy. Every view was infused with ruin and reverence. I was longing to return home, but also realizing

that my understanding of America had changed. I am a Chinese-American who was born and raised in New York. The Southwest and most of the U.S. inland states were foreign to me. I was curious about culture that was not dominated by an urban region. I will never forget the cross-country drive, along a southern route, in my tiny Ford Escort wagon. My sister joined me and we had an adventure speeding through Tennessee, Arkansas, Oklahoma, Texas, and eventually all [across] New Mexico. We were most affected by the visual illusions that occurred whenever we drove through the desert. How the miniature always became gigantic and how time was held transfixed by distance. We visited as much as we could, popular sites (Chaco Canyon, the Bandelier Monument, White Sands, Carlsbad Caverns) as well as local events (street fairs, casinos, Target). When my sister returned East, and I settled into a daily work schedule, we often spoke on the phone about the color of the sunsets, size of hail, and the smell of cow manure.

The one lesson I learned in New Mexico was that time could be utilized to shape the world. In Italy, man used a finite amount of time for building. Each molded brick represented a societal duty. In the desert, nature used time without thought or worry. Its purpose was not quite known. Both created monumental environments. The difference between the two was that nature worked in the dark (caverns) or repetitively (sand). I followed nature, built a photographic darkroom and papered the windows of my house. I never looked at a clock and let myself be. When the neighborhood dogs barked in unison then I knew night had fallen and another day had ended.

My husband who visited during Thanksgiving was similar to myself in that he was born and raised in New York, but of Jewish-American descent. He bounded off the plane in Roswell and exclaimed with delight how free he felt. I immediately drove him to White Sands to catch the sunset. For us, watching two Stealth fighter jets performing maneuvers over the geography of the sands represented art and its relationship to culture. We had another memorable drive. I have forgotten the route number; it is a road that begins at Capitan, journeys through ranch lands, and ends in Roswell. A restaurant owner suggested we go for a twilight drive after getting a full tank of gas. The dim light accentuated certain abstractions. Was that mountain near or far, large or small? Did I just see a wolf? Why is that cloud sitting on the ground? There were so many questions to be asked, but we decided not to answer any of them.

Shortly after, I had to return East as my husband experienced a terrible accident. I had spent three months in New Mexico and have

Jeannette Louie at White Sands National Monument. 2000. *Courtesy of the artist.*

always wished to return to complete a personal journey. I couldn't, though, as exhibits and other residencies took up time. It wasn't until 2002 while I was at the Marie Walsh Sharpe Foundation Space Program in New York City that I reclaimed certain memories. Everyone around me was busy laboring, breathing, doing, pushing, and maintaining ambitions and goals. The view from my window was of a palatial penthouse being constructed for some fortunate family. The Twin Towers had been destroyed earlier on and the air continued to be acrid, so we had to keep the studio windows shut tight. I wished for a view of an illusion. I wanted to see abstraction. I wanted to breathe some air that changed colors.

In 2003, my daughter Tula was born. I know her creation was motivated by my need to remember. She reminds me of how nature takes its time, doesn't care who sees, and moves with pleasurable purpose. And I make art in the same manner now.

Many artists questioned me about Roswell. I was at Yaddo, a well-known residency program in upstate New York, during one such inquiry. That artist was afraid to live in southern New Mexico and be so far away from high culture and society. I told him and continue to tell others that you ought not to be afraid of being by and with yourself.

Magdalena Z'Graggen (2001)

Magdalena Z'Graggen, a native of Basel, Switzerland, has lived all over the world, and spent several years in New York City. (She had been a student of former resident David Reed, who told her about the grant.) Her luminous

abstract paintings seem almost minimal, except for the astonishing range of color variation. "Layers of color, relationships of color, combinations of color and intensity of color are important elements in her paintings, and are central to her artistic vision."[49] Magdalena recalls:

Coming from Switzerland I was not used to life with a car, since I had been riding a bike since my seventh birthday. I arrived in Roswell April 1 of 2001. By April 3 I was already the owner of a beautiful blue truck—my first car. After only a few days, I felt that something was wrong: I needed a bike. I found one at the Roswell pawnshop for one hundred dollars, and that became my horse, taking me to the most important discovery of my stay: the landscape. I would bike nearly every day and usually ride about thirty miles. I would go on my bike at about five PM after a day in the studio. In the summertime I would have to wait until later, though, because of the heat.

One day in July I left around 6:30 PM. The sky was overcast, it was hot, but somehow the sun wasn't. Nice clouds were hanging in the sky so I thought it was a great day to bike. On my way up Pine Lodge Road, all of a sudden—as always happens in New Mexico—the sun came out. No trees, not a single bush where I could hide. It started getting hot, hotter and my breathing started getting faster and faster. I had to get off the bike because my strength was leaving me. I decided to push the bike up the hill, hoping to find some shade somewhere, although I could see it was hopeless. There are no trees or shrubs until many miles later, shortly before one gets to the plain, on the beautiful ranch at the right side of the road. My heart was beating ponderously and the sun was hurting my head and skin. I was feeling the power of nature and the smallness of being human. The helmet I was wearing wasn't enough protection from that sun, that immense heat. Suddenly I heard a car stopping, and a woman was talking to me: was I okay? Did I need some help? Would I like a ride to her house and a drink of cold water? A little rest? Cool water! What a wonderful idea! My salvation was standing right beside me—a woman in an air-conditioned car. How quickly I accepted. On the way to her house, the woman (who was a doctor) told me that the outside temperature was one hundred degrees. No wonder I felt kind of strange on my bike that day.

That April there were two dust storms in Roswell. Before that I hadn't known there was such a thing as a dust storm. The first one surprised me on my bike, of course, on the way to Bitter Lake. My first real experience with the power of New Mexican nature; it felt like skiing in the fog in the Swiss mountains—only that the breathing was harder, and it was nearly impossible to keep moving forward.

The grant. The given time. The house. The studio. The compound.
The grant: a gift indeed. All of a sudden, all that time, all that space, all of your life and personality free to fall onto yourself: a challenge. The given time: another challenge. The house: so comfortable, so practical, so beautiful, so welcoming. What a luxury for an artist to be living in such a spacious house with a porch and all those trees around! The studio: a very good place to work; quiet, practical. The compound: the trees and the birds made me feel as if I were in an aviary, something I knew only from the Basel zoo before I landed in Roswell, New Mexico. I was very happy with my studio—a sculptor's studio that suited totally all my needs—also the need to sit for hours on that yellow chair under the porch roof and reading and reading and looking out across the fields, listening to the sounds of working people building houses, cutting wood, mowing the lawn, the birds chasing each other. It made me approach Roswell's daily life in a very subtle way.

The landscape.
Beautiful and amazing. So much space. So sparse. No mountains, no forests. Where there were mountains they were so much wider than the ones in Switzerland. The eye could travel anywhere. The heat was so intense in summer that it could bring on depression. Only eating watermelons would help to get over it (it would take nearly a whole watermelon, though).

The scale.
It's of another world. The hours traveling without meeting anybody, without seeing a car, a human being, an animal, a tree. The silence that made you hear the bugs. The isolation that made you feel lost in space at times and humble at others. The importance of neighbors, of people, of something moving—the wind, for instance. The power of the space. The immediate sense of one's own body. The necessity of painting vertical stripes in order to place oneself in the landscape. The happy hours spent in the desert, on the plain. The proximity to life.

The people.
So incredibly nice and welcoming. Warm and interested. At times so far away from what was familiar to me. Such a different way of living, such different needs. So interesting to meet and talk to, so many questions still unanswered: Each time I met someone I would ask myself, "How did he/she come here?" "Why here?"—a question I would continually ask myself in the Southwest. I saw the settlers, the cowboys, the Indians—how they all fought for their lives. How they all left a

life to find a new one, if they survived. A living history. What a place to learn about America. I felt very privileged to have been given the opportunity to share my life for a while with the people of the compound, of the grant, of Roswell, to have known the generosity of all the people involved, and to have experienced their interest and openness.

The churches.
That many churches in a small town like Roswell? I knew that Rome would have a church on every corner, but Roswell? This made me think a lot; thus I could learn about another aspect of the United States that was foreign to me.

The car.
It isolates you. Becomes your second home at times. A whole new experience of life. A scary one in some ways: scary if you come from Europe because it alienates you from other people. It hinders you in some ways. Your body gets stuck between the seat and the steering wheel. The contact with the outside is only given through the window.

Dore Gardner. *Dust Storm. Roswell, New Mexico. 12 o'clock Noon. 1996.* Photograph *Courtesy of the artist.*

You do not smell or hear what is going on outside, unless you cross the path of a skunk. There is an inside and an outside, and that outside is so far away from you. On the other hand it is a blessing, since it allows you to move around in a reasonable amount of time. The car is a necessity in America.

The isolation.
Quite a strong experience to endure. It makes you feel how small you are. How big you are. How important the other is. How nice it is to meet the other. How nice it is to be alone. What a freedom it can be. What a threat it can be. One can expand or die. It forces you to be very close to life. There is no distraction to help.

The desert.
The desert made me see, more and more, and more precisely. In the desert all is immediate, straightforward, there to be seen and experienced. It is completely true and sincere.

My show at the Roswell Art Museum.
To have a show at the museum was an incredibly rewarding and involving experience for me. Not only was it an opportunity for me to exhibit the work I had done during the residency, but also to feel the deep interest people from Roswell and its surroundings showed toward my work and to art work in general. I also gave a talk about my work during the show. I was delighted by the chance to share my thoughts and concerns about my work with people who had a very different experience and background from mine. Art really is a universal language.

I come from a place where art has a long tradition and history—Basel. The attention brought to art and artists in Roswell is something I had never experienced with that intensity in my hometown.

Edie Tsong (2001–02)

Edie Tsong moved up from Baton Rouge, Louisiana. She received her MFA from Louisiana State University and was supporting herself by working in a frame shop. She works with found objects and quirky, far-out ideas in general, as she explains in her artist's statement for her show at the Roswell Museum: "I am interested in using found and collected materials ... because they already contain cultural and personal significance. By working in a slow and repetitive manner, I manipulate culture to reveal alternate meaning. Using my senses to make sense of the world around me, and therefore of my Self."[50] She recalls:

My year in Roswell was incredibly busy and incredibly productive. The grant in Roswell was the first time I received a grant as an artist. Since I had just finished my MFA in 2000 from Louisiana State University, the RAiR grant helped me understand myself as a professional artist. During my Roswell year, I met many interesting people and artists, I had several shows, and at the end of my stay, Don bought my first major piece, now in the Anderson Museum of Contemporary Art: *Matter of Fact.*

I had been working several jobs during school and continued to work at two jobs after I finished, so the time the grant provided came as a huge shock. Not to mention that I had never had so much space to myself. I remember that when Stephen and Nancy first showed me the house, I kept seeing it as my mind, cleared and open. I proceeded to fill the house and used every bit of its wall space. My house had two studios attached and the first thing I did was unload all of my belongings into the larger studio and take a photo of it. I called the photo *(Alien) Territory.* Because of the enormous amount of space, I started inviting friends to visit me and do a mini-residency. One of these friends was Pete Kuzov, who had been my beginning acting teacher at LSU. He came in May and we have been together ever since.

After Stephen and Nancy showed me around, I went to the Country Market to get some food. In the produce section I noticed a grubby old man lurking about, examining me. I turned quickly to him and barked, "What are you looking at?" He looked shocked, then sheepish, as he dredged up a pathetic reply, "the vegetables?" In my

first days at Roswell, it was apparent that I was a foreigner—an alien, both as an Asian-American and as an artist. I went to the public library and checked out books on aliens and UFOs. During the first weeks in Roswell I had several physically very painful dreams about my being embodied by ghosts and taken away. One night I woke up and saw a strange light on the bedroom wall. It looked like the sighting light from a rifle. To this day I don't know if I was dreaming it or not.

At LSU I was in the ceramics department (Stephen Fleming had actually been a visiting artist there for one semester). I was no longer working in clay, but when I got to Roswell and felt so completely displaced, I began by working in clay again, something familiar. Aria was so warm and welcoming, and helped me to set up a work space at the museum. I made several heads which I eventually smashed.

I knew whatever I was interested in as contemporary art was going to mean very little to the people of Roswell. I wanted to make something that was meaningful—and something meaningful to the people here would somehow have to include them. I came up with the idea for two community portraits which would form the nucleus of my show (*Portraits*) at the Roswell Museum and Art Center: first, the telephone book project, in which I wrote the names of everyone listed in their white pages, connected together in cursive; also a reciprocal portrait project where I would go and draw Roswell residents and then ask them to draw me. I made a carbon copy of my drawings so I could give the original to the person. I kept the carbon copy for myself.

The telephone book project was very, very beautiful. I wrote for one or two hours every day, and in the act of writing, I came to understand Roswell in a very unique way. There were names like "Arcenau" which I knew had traveled from France to Canada, down the Mississippi to Louisiana and across Texas to New Mexico. I started to understand, to become aware of how words, spellings, mutate, abbreviate, and assimilate. Most poignantly, I saw how names with such differing cultural origins all come to be treated in a democratic way. Language is a social code, systematic like numbers, like DNA. We think of our names as markers of our individual identities, but they are also simply codes that allow us to function as discrete units within society.

The reciprocal portrait project was more challenging. I started by drawing museum staff and friends. Marina Mahan at the Anderson Museum was the first person I drew, and then I drew the janitors and some staff at the Roswell Museum, the people I met in ceramics, at the library, in the park, at the shopping center, at Hastings bookstore. It was important to do something that people could understand as "art," but in the process, they, too, became the maker. It was also a great way

for me to get drawings by other artists. Stephen Fleming did one of my favorite drawings.

One early afternoon I was riding my bike home from the library. I passed an interesting-looking older man (fiftyish) standing on his porch, and I went back to say hello. I asked if he would let me draw his portrait and if he would then draw mine. He said his name was Johnny, that he wouldn't draw me, but his roommate Matt was an artist and might participate. While I was drawing Johnny, Matt brought out glasses of Mountain Dew for us. When I began to draw Matt, Johnny kept bringing out canvases, oil paintings Matt had done, all copies of reproductions of still lives from the *Reader's Digest*. While Matt was drawing me (with long flowing hair even though my hair was tied up in a sloppy bun), Johnny brought out a painting he had done. It was trippy, geometric, psychedelic. Who knows what went on in that house?

The project helped me really see the building of identity as a social project. Being in Roswell and isolated from the people I was used to being in contact with made me much more in tune with human interaction and relationships in general.

When I first got to Roswell I couldn't decide if there was some kind of conspiracy to put potentially subversive elements in society (artists) off by themselves somewhere, to isolate them in a remote area. I have been on several residencies since Roswell, for short periods of time, and I still wonder about this. The transition from residency to non-residency is always difficult, but no matter what, the time, however short, is always a gift. The gift is having the time undivided into segments so that all my thoughts and ideas can come together. We tend to view our inner selves as parts, separating our selves into divisions of mind and body, for example. The time is a gift in allowing ourselves to reconnect as a whole. I felt particularly connected to the stark landscape of Roswell and the feeling of exposure that I felt there. It was such a great environment to work in, especially coupled with the warm and supportive arts community in Roswell.

Rosemarie Fiore (2002)

Rosemarie Fiore grew up outside New York City and received her MFA from the Art Institute of Chicago. She also taught drawing at the University of Virginia. Her work deals with the complex relationship between art and technology in diverse ways: one delicate-looking drawing consists of a series of what look like crystals but on close inspection are formed by rubbings of guns, arranged to form ethereal shapes. She also created a series of drawings in which she stood heavy tubes upright on the paper

A Rosemarie Fiore drawing being created by an exploding firecracker. July 2002. *Courtesy Roswell Artist-in-Residence Program archives.*

and then exploded fireworks inside each one, producing strange and lovely effects. Rosemarie says:

> The Artist-in-Residence Program provided me with an extended period to focus on my work and pursue it without interruption. What a precious gift!
>
> Now that I'm back in New York City, I am beginning to realize just how much my experience in New Mexico has changed my work and life. The serenity and beauty of the desert and the exposure to southwestern culture forced my work into a direction that I would never have dreamed of had I stayed in New York. The desert is a unique and beautiful landscape. I was fortunate to see how it changed over the course of a year.
>
> I had the honor of getting to know some very interesting artists on the grant and in the museum community. [Her time coincided with Diane Marsh and Eddie Dominguez on their second grant; Kelly Newcomer, John Dooley and his family, and most importantly, Michael Ferris Jr., whom she later married.] My work grew from meeting and conversing with these artists, even though they worked

with concepts and materials different from my own. This was a unique opportunity.

Figures in a Field of Blue

Perhaps there are no perfect stories, no entirely happy endings. A few of the former artists-in-residence cannot be traced; it is not known if they still have any involvement with the arts. Fourteen have died, including, in 2004, the brilliant and opinionated Milton Resnick, laid to rest in his old hat and clasping a paintbrush for his last journey.

The nearly forty years of the program's existence has seen every possible permutation of international contemporary art: an apparently infinite range of figure painting from the classical figuration of Diane Marsh to Stewart MacFarlane's startling "noir" compositions, Abstract Expressionism, minimalism, arte povera, sculptors who carve stone or wood; ceramic and fiber artists, knitters, collage, every print and graphic medium, photography, assemblage, trompe-l'oeil, Jerry Bleem's champagne coupes dressed in grasshopper wings.

The compound grows subtly more ramshackle; yet how full of life and action it remains. There are plans for a new compound to be built a few miles east of here, where the threats of traffic noise and real estate developers will never exist. "Please don't change anything!" the current artists plead. "It's perfect the way it is." This is not Bogliasco, the prestigious residency on Italy's Ligurian coast, with its heart-stopping views over the Golfo di Paradiso and dressing for dinner at the main villa, or Bellagio, an older and even more formal program in northern Italy, with vistas of Lake Como and the Alps. Roswell is a desert place, a place without the slightest pretension to elegance, picturesqueness, or sophistication; a place to which artists have come from all over the world to live and work quietly, while producing dazzling bodies of work.

Living movement persists in the memory: a tall girl in basketball whites levitates, sinks a three-pointer. Strangers cheer. A slight young man sits on a maimed bicycle, pedaling backward, until the framework of a little house rises from the field west of the compound. Breathless, he stops pedaling; it sinks back into flat repose. Martie Zelt scolds the greyhound who has treed her black and white cat. At sunset, Lorna Ritz walks across the field. The last light glints off a red glass heart in the dust. She picks it up, rubs it on her sleeve, knows she will keep it forever. Aria Finch and Maria Rucker move elegantly through their T'ai Chi ritual dance at the edge of the pecan plantation. Inside, some are still working in their studios. Strings of fairy lights on porches are switched on to repel mosquitoes. Grumbling, Stephen Fleming moves the sprinklers one last

time, and tells cavorting children not to step on the beds of myrtle he has planted and willed into bloom. Twilight on the compound. Beloved ghosts approach and reassure.

The plain rough spaces of the compound have housed massive yearning, infinite exploration over the past four decades.

The new compound rising in the meadows east of town is washed with moonlight now. Other groups of artists are already scheduled to live and work there. Still others will continue to use the original compound until such time as the transition is complete.

When I write the word "time" in the context of the Roswell Artist-in-Residence Program, my hand hesitates. So many artists have been nurtured, validated, set free for months and years to make works that quite simply could not otherwise have been completed (or in many instances, even begun). Artists speak ruefully of needing a "day job," a "real" job in order to survive, or to support the habit of making art. The Roswell program strengthens artists by offering them the respect that inheres in "the gift of time."

Biographical Sketch of Don Anderson

Nancy Johns Fleming

It is hard to coax rain out of a cloudless sky. And it's just as hard to get information out of Donald B. Anderson about himself. He is not modest or humble for the sake of those virtues; he's just truly not interested in telling his story. But a book about the Roswell Artist-in-Residence Program—its history and its artists—would not be complete or as interesting without some information about the man who started it, funded it, and continues to this day to be the inspiration behind it. The information presented here, while not a biography, is at least a glimpse into the remarkable person without whom there would be no Roswell Artist-in-Residence Program.

Donald B. Anderson was born April 6, 1919, in Chicago, Illinois, to Hilda Nelson Anderson and Hugo August Anderson, both of whom were of Swedish decent. He attended the University of Chicago Grammar School and High School. As a child and teenager Don spent time at the Chicago Art Institute developing an appreciation for the treasures on its walls. While studying engineering at Purdue University in West Lafayette, Indiana, Don found a passion for not just looking at art but making it, and he has successfully maintained dual careers as artist and business-man ever since. Although Purdue didn't offer art classes, there was a shop with art materials where Don and another student, Patricia Gaylord, took up painting.

The bombing of Pearl Harbor coincided with Don's graduation from college. He joined the navy and during the war served as chief engineer-ing officer on different mine sweepers, escort ships, and a supply vessel in both the Atlantic and Pacific arenas. The navy had, of course, wanted to keep Don and his skills in uniform, but four years had been enough, and

Don was now a married man, having wed his painting companion Pat on a shore leave in 1945.

After leaving the navy, Don and Pat settled on a farm in Roswell, New Mexico, and he started working in oil and gas exploration and production. Over many years, he incurred successes and failures in England, Canada, New York, Pennsylvania, Mississippi, California, Indiana, Michigan, Montana, Wyoming, Colorado, Utah, New Mexico, and Texas. The business headquarters of Anderson Oil Company moved to Denver in 1963, and the company is presently drilling gas wells in Wyoming.

Don Anderson. 1945. Photograph by Patricia Anderson. *Courtesy Don Anderson.*

The Anderson family may have lived in Roswell, but the world was their education. Pat and Don would take their three kids out of school for weeks to go traveling—long cruises of the Mediterranean into the Black Sea, then Scotland, Ireland, England. They spent two Christmases in Ireland, two in Sicily, and two in Greece. They even traveled to Russia, Afghanistan, and Central Asia in 1962. The Andersons owned two large boats at different times in the '60s and '70s in San Diego, naming one *Berrendo* after the street of the residency compound.

Roswell, however, was not being neglected during these years. As soon as the Andersons arrived, Don began supporting the Roswell Museum and Art Center. The Roswell Museum was originally a Works Progress Administration (WPA) project and will celebrate its seventieth birthday in 2007. So too will Don celebrate sixty years of working *at* the Roswell Museum. He funded the construction of numerous galleries and wings to the museum, and by the 1970s, his Roswell Artist-in-Residence Program was supplying its walls with a modern art collection.

Don continued to paint during this period of family, business, and building. He exhibited the large-scale paintings he'd been creating in a building he owned in Roswell around about 1970. The paintings reflect his travels—not *en plein air* renderings done in front of the subject, but in his use of remembered but distant landscapes. It's as if among the souvenirs collected from abroad, Don returned with the color, light, and forms of these places and in his Roswell studio imagined them back to life on canvas. Numerous businesses and offices in Roswell to this day have Don Anderson paintings gracing their walls—and there is a waiting list of people who would still like to buy one. (Don stopped selling them in the mid-'90s.) His art career also included shows in Santa Fe, Taos, North

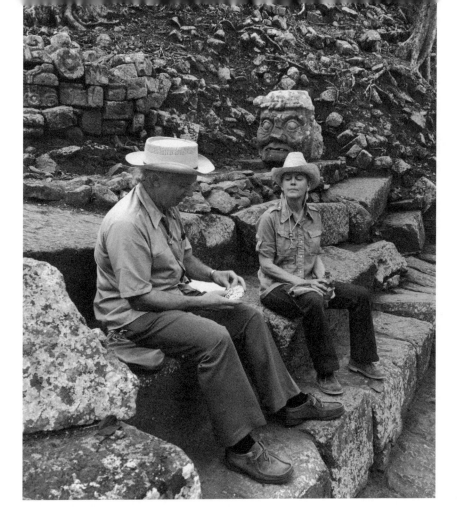

Don and Pat
Anderson in Peru.
Photograph by
Phil Schultze.
*Courtesy Don
Anderson.*

Dakota, and New York, and he regularly exhibited in the 1980s after he married Sally Midgette.

Sally's and Don's spouses had both passed away within four months of each other in 1978; Willard Midgette (one of the first artists-in-residence you will have read about in this book) of brain cancer and Pat Anderson of lung cancer. Sally Midgette was teaching in New York at St. Ann's School, where she had developed the language arts curriculum and department for the new elementary and high school (Bill was the school's art professor). By that time the Anderson children were grown and had left Roswell, but Sally was in the middle of raising her two children, Anne, twelve and Dameron, eight.

But love prevailed; Don and Sally married on March 15, 1980, and all four of them honeymooned in France.

To complement the typically dry New Mexico weather (Roswell averages ten inches of rain a year), the Andersons spend almost three months a year in the English countryside. Don has owned a farm called Corn Close in the Yorkshire Dales National Park for thirty years, where

Don and Sally Anderson, ca. 2003. *Courtesy Roswell Artist-in-Residence Program archives.*

he paints and enjoys the lush foliage, rolling hills, and, periodically, sheep at the doorstep. He's also had a solo show of his art work at an English museum.

Like most oil and gas producers, Don has had his fingers in other business interests as well. He once owned the El Rancho Palacio Motel, the Roswell Inn (which explains some of the furniture and silverware at the Roswell Artist-in-Residence facility), the Wilshire Shopping Center (adorned with Herb Goldman sculptures), and vacant land which is still being sold for housing today. His areas of philanthropic interest also included the School of American Research, an archeology and anthropology institute in Santa Fe, where he sat on the board for twenty-five years, and the Jargon Press, a remarkable poetry and photography press started by Jonathan Williams.

In 1983 Don received the New Mexico Governor's Award for Excellence for his patronage of the arts. But in true "Don" style, he did not attend, but graciously sent a friend to accept the award. A decade later, another organization would have a hard time finding Don to present him with accolades. The local Sertoma Club kept calling to arrange the presentation of their Service to Mankind Award, but Don would "conveniently" not be around. The Sertomans persisted and finally found Don at the Roswell Museum. A front page picture of Don in the *Roswell Daily Record* shows Don with a grin that to Sally says, "Well, you finally got me."

To sum it up, Don Anderson is a regular guy with an irregular generosity. He shops at Wal-Mart and buys his clothes from L.L. Bean. Artists on the residency have mistaken him for the gardener or a construction worker. He is frugal and generous at the same time. He has a great sense of humor but is not one to tell jokes. His Swedish heritage is evident in his demeanor—he is definitely a man of few words. But when he's relaxed or humored, he sparkles, "and it's wonderful to see when it comes out," said Sally. "At eighty-seven (in 2006) he's always learning new things, thinking of new things and trying new things; and that is inspiring."

Appendix

Chronological List of All Current and Former Residents

* means approximate birth date
(d) means deceased
† means represented in book

Name	Residency date(s)	Birth/death date	Medium
†Herbert Goldman	1963	1925	sculpture
†Howard Cook (d)	1967–76	1901–80	painting
†Barbara Latham (d)	1967–76	1896–1988	painting
†Brian Leo	12/67–12/68	1940	sculpture, printmaking
†Jerry "Geraldo" Kirwin	12/67–12/68	1932	sculpture
†John Wallace	2/68–8/68	1929	painting
†William Goodman	4/69–4/70	1937	sculpture, painting
†Thomas Stokes (d)	9/69–5/70	1934–93	painting
†Bruce Lowney	5/70–8/71 10/74–10/75	1937	painting, printmaking
†Willard Midgette (d)	1/70–1/71	1937–78	painting, printmaking
†David Reed	10/69–10/70	1946	painting
†Milton Resnick (d)	5/70–3/71	1917–2004	painting
†Pat Passlof	5/70–3/71	1928	painting
†Richard Mock (d)	8/70–8/71	1944	mixed media, printmaking
†Kenneth Kilstrom (d)	12/70–9/71	1922–95	painting
†Francie Rich	1/71–7/71	1947	printmaking, ceramics
Howard Storm	1/71–1/72	1946	painting
Theodore Golubic (d)	6/71–8/72	1928–2005	sculpture
Richard Schindler	8/71–8/72	1942	painting
†Frank Ettenberg	9/71–2/72	1945	painting
Hank Jensen (d)	1/72–1/73	1930–99	sculpture
Wayne Kimball	1/72–8/72	1943	printmaking
Richard Bowman (d)	3/72–6/72	1918–2001	painting
†Luis Jiménez (d)	3/72–3/73	1945–2006	sculpture, printmaking

Name	Residency date(s)	Birth/death date	Medium
Richard Faller	6/72–12/73	1945	photography
†Susan Cooper	9/72–3/73	1947	painting, sculpture
Mark Epstein	9/72–3/73	1944	painting
Sheila Sullivan	1/73–7/73	1939	painting
†Wesley Rusnell	3/73–3/74	1934	painting
Michelle Sewards	3/73–3/74	1944	printmaking
Stephen Lorber	6/73–6/74	1943	painting
Jillian Denby	6/73–6/74	1944	painting
Gerald Bergstein	7/73–2/74	1947*	painting
Marilyn Winsryg	3/74–9/74	1941	painting
Johnnie Winona Ross	8/74–8/75 9/95–8/96	1949	painting
Robert Russell	9/74–3/75	1939	painting
Lee Johnson	3/75–9/75	1935	painting
†Lorna Ritz	5/75–11/75	1948*	painting
†Ben Goo	6/75–4/76 8/03–8/04	1922	sculpture
†Richard Shaffer	8/75–8/76	1947	painting
†Beverly Magennis	9/75–10/76	1942	sculpture, ceramics
Sue Hettmansperger	11/75–11/76 12/89–8/90	1954*	painting
†Rebecca Davis	4/76–10/76	1953	sculpture
Sharyn Finnegan	8/76–2/77	1946	painting
Bradley Petersen	10/76–10/77	1947	painting
†Wook-Kyung Choi (d)	10/76–8/77	1946–85	painting
†Michael Aakhus	11/76–8/77	1952	printmaking, painting
Peter Bilan	1/77–1/78	1946	sculpture
Mary Ahern	9/77–8/78	1952	printmaking
†Elmer Schooley	9/77–9/78	1916	painting
†Gussie DuJardin (d)	9/77–9/78	1918	painting
Robert Neffson	10/77–10/78	1949	painting
Andrea Grassi	11/77–11/78	1938	sculpture
†Jean Promutico	2/78–2/79 9/90–9/91	1936	painting
Frank McCulloch	8/78–8/79	1930	painting
Robin Shores	9/78–9/79	1944	sculpture

Name	Residency date(s)	Birth/death date	Medium
Lynda Long	10/78–10/79	1955	painting
†Janell Wicht	10/78–10/79	1950	painting
Jason Knapp	3/79–3/80	1951	sculpture
Michael Foran	7/79–8/80	1951	painting
†Rudy Pozzatti	8/79–8/80	1925	printmaking
Greg Kitterle	10/79–10/80	1954	painting
Betsy Cain	1/80–1/81	1949	painting
†Robert Jessup	3/80–3/81	1952	painting
Rosie Bernardi	9/80–9/81	1953	printmaking
†Diane Marsh	9/80–9/81 1/02–12/02	1955	painting
Del Christiansen	10/80–10/81 10/89–4/90	1946	sculpture
†Richard Thompson	1/81–7/81	1945	painting
Pedro Lujan	3/81–3/82	1943	sculpture
Aaron Karp	7/81–7/82	1947	painting
Susan Bremner	9/81–9/82 9/88–4/89	1950	printmaking
Irene Pijoan (d)	10/81–10/82	1952–2005	sculpture
†David Hollowell	12/81–12/82	1951	painting
Susana Jacobsen	6/82–6/83	1951	painting
Ed Vega	7/82–7/83	1938	sculpture
†Martie Zelt	9/82–9/83 7/89–8/90	1933	mixed media
Bruce Rod	11/82–11/83	1947	sculpture
†Jerry Williams	1/83–12/83 1/93–12/93	1943	sculpture, mixed media
Dan Rice	8/83–8/84	1951	painting
Mark Packer	7/83–5/84	1957	sculpture, mixed media
†Astrid Furnival	11/83–11/84		fiber
†John Furnival	11/83–11/84		mixed media
Adele Henderson	5/84–5/85	1955	painting
Rita DeWitt	8/84–8/85	1948	mixed media
Wayne Enstice	9/84–9/85	1943	mixed media
Jim Finnegan	10/84–4/85 10/93–9/94	1944	painting

Name	Residency date(s)	Birth/death date	Medium
Jane Abrams	7/85–7/86	1941	printmaking, painting
Dan Socha	5/85–12/85	1943	painting, printmaking
	5/91–8/91		
†Stuart Arends	10/83–10/84	1950	mixed media, painting, sculpture
	2/87–8/93		program director
†Robert Tynes	12/84–12/85	1953	painting
	5/91–7/91		
Elen Feinberg	8/85–8/86	1955	painting
	5/91–8/91		
Alison Saar	9/85–2/86	1956	sculpture
†Ted Kuykendall	12/85–6/87	1953	photography
†L-15 (Bernard Schatz)	1/86–5/87	1931	sculpture
†Joe Edward Grant	3/86–3/87	1940	mixed media
†Stephen Fleming	7/86–7/87	1950	painting, ceramics
	10/91–9/92		
	1993–present		codirector with Nancy Johns Fleming
†Eddie Dominguez	8/86–8/87	1957	sculpture, ceramics, mixed media
	1/02–12/02		
†Robert Colescott	1/87–8/87	1925	painting
Joshua Rose	5/87–5/88	1957*	painting
Lisa Allen	7/87–7/88	1955	painting
	10/90–4/91		
†Stewart MacFarlane	9/87–6/88	1953	painting
	9/90–9/91		
†Daisy Craddock	1/88–12/88	1949	painting
†Biff Elrod	1/88–1/89	1946	painting
†Susan Marie Dopp	6/88–6/89	1951	painting
Judy Richardson	7/88–7/89	1956	sculpture
Celia Chetham	7/88–3/89	1964	mixed media
Ray Waldrep	12/89–12/90		painting, mixed media
Mala Breuer	4/90–9/90	1927	painting
John Whittaker	8/90–8/91		photography
Bob Swan	9/90–9/91		painting
Nancy Johns Fleming	12/91–present	1965	mixed media
	1993–present		codirector with Stephen Fleming
Peter Zokosky	1/91–4/91	1957	painting
†Robbie Barber	5/91–5/92	1966	sculpture

Name	Residency date(s)	Birth/death date	Medium
John Jacobsmeyer	8/91–5/92	1964	painting
Adam Curtis	9/91–9/92		sculpture
†Karen Aqua	11/91–5/92 3/95–8/95	1954	animation
†Phillis Ideal	5/92–5/93	1942	painting
Carl Bronson	1/93–1/94	1960	painting, sculpture
Deborah Aschheim	6/93–6/94	1965	sculpture
†Marcy Edelstein	9/93–9/94	1951	printmaking, painting
†Walter Jackson	9/93–9/94	1942*	sculpture
Julia Couzens	12/93–12/94	1948	painting, sculpture
Coleen Sterritt	3/94–8/94	1953	painting
Stephen and Nancy Johns Fleming	8/94–present		program directors
Robert ParkeHarrison	7/94–7/95	1968	photography, mixed media
Brian Myers	10/94–10/95	1940	painting
Max Cole	11/94–11/95	1937	painting
Matt Barinholtz	3/95–3/96	1973	ceramics, mixed media
John Sparagana	9/95–8/96	1958	painting
Charles Breth	1/96–7/96	1949	painting, drawing
†Dore Gardner	1/96–8/96	1948*	photography
†Sue Wink	8/96–7/97	1957	sculpture, ceramics
Laurel Farrin	9/96–9/97		painting, mixed media
†Yoshiko Kanai	9/96–9/97	1963	sculpture, mixed media
†Scott Greene	9/96–9/97	1958	painting
Deborah Brackenbury	12/96–8/97	1959	sculpture, mixed media
Al Souza	9/97–8/98	1944	mixed media
†Jerry Bleem	10/97–7/98	1954	mixed media, sculpture
†Jane South	12/97–12/98	1965	sculpture, painting
†Steve Levin	12/97–12/98	1955*	painting
Anne Harris	1/98–8/98	1961	painting
†Cristina González	9/98–9/99	1971	painting
†James McGarrell	12/98–4/99 1/00–4/00	1929	painting, printmaking, ceramics
†Mary Josephson	1/99–1/00	1965*	painting
†Maria Rucker	2/99–2/00	1961	sculpture
Katie Kahn	9/99–8/00	1953	painting, drawing

Name	Residency date(s)	Birth/death date	Medium
†Eric Snell	6/99–8/99 10/99–8/00	1953	installation, drawing
Walter Cotten	3/00–2/01		painting, photography
Alexandra Wiesenfeld	5/00–12/00	1967	painting
Linda Mieko Allen	8/00–2/01	1961*	painting
†Jeannette Louie	9/00–12/00	1964	installation
Claire Beaulieu	1/01–7/01	1961*	painting, mixed media
Jenny Hankwitz	4/01–10/01	1962*	painting
†Magdalena Z'Graggen	4/01–11/01		painting
Kumi Yamashita	4/01–3/02	1968	sculpture, mixed media
†Edie Tsong	4/01–3/02	1979*	drawing, mixed media
Kelly Newcomer	8/01–7/02	1974*	painting
†Rosemarie Fiore	2/02–12/02	1973*	drawing, mixed media
Michael Ferris Jr.	7/02–7/03	1970*	sculpture, painting
John Dooley	8/02–8/03	1958*	sculpture, mixed media
Eric Sall	8/02–8/03	1978*	painting
Rachel Hayes	8/02–8/03	1978*	fiber
Jo Ann Jones	7/03–5/04		painting
Ju-Yeon Kim	8/03–7/04	1974*	painting
Ann Piper	9/03–6/04	1972*	painting
Aaron Brown	9/03–6/04		painting
Michael Beitz	11/03–11/04	1978*	sculpture
Kasper Kovitz	6/04–6/05	1968	painting, mixed media
Clayton Merrell	8/04–8/05	1972*	painting
Corrie Witt	9/04–9/05		photography
Christopher Kurtz	9/04–9/05		sculpture
Christy Georg	1/05–1/06	1976*	sculpture, mixed media
Mollie Oblinger	7/05–present	1977*	painting, mixed media
Joey Fauerso	9/05–present	1977*	painting, animation
Theresa Pfarr	9/05–present	1977*	painting
Alison Carey	11/05–present		photography, mixed media
Hajime Mizutami	3/06–6/06		sculpture

Notes

1. The Navajos have a verb specifically to describe an isolated storm whose motion can be tracked: *Yóó' 'ahóółtą*, "The rainstorm moved away out of sight."

2. Rudy Pozzatti's daughter Illica made a name for herself in Roswell, distinguishing herself on the boys' basketball team at the local high school during the 1979–80 season.

3. The vinegarroon or whip scorpion, *Mastigoproctus giganteus*, is not venomous nor is it a true scorpion. It is nonetheless huge (more than two inches long) and it emits a strong vinegar-scented spray. It has frightened many generations of Roswell artists.

4. *Barrio* is the Spanish word for neighborhood; for Hispanics, the word has very strong overtones, meaning "home turf." For Anglos, it can be a threatening concept.

5. Since 1970, Tamarind has been part of the Department of Fine Arts at the University of New Mexico, Albuquerque.

6. Named for the chairman of the infamous House Un-American Activities Committee, which hounded many academics in the 1950s, accusing them of being Communist sympathizers.

7. Geoffrey Dorfman, cited in *Milton Resnick: 1917–2004*, New York City (2004) [privately published as a memorial to Resnick], 51.

8. Press release for David Reed's show at the Roswell Museum, September 1970.

9. Cited by Laura Coyle, *Double Entendre: David Reed*, Corcoran Biennial, Washington, D.C., 2000.

10. It has been estimated that Resnick and Passlof consumed approximately thirty thousand dollars worth of materials during their stay.

11. Author of *Out of the Picture: Milton Resnick and the New York School* (New York: Midmarch Arts Press, 2002).

12. Artaud was a major avant-garde French poet of the twentieth century. *Maudit* means "rejected by God and/or by society."

13. Jonathan Williams, *A Palpable Elysium* (Boston: David Godine, 2003), 76.

14. David Reed, "Memories of Rome," *New Observations 68*, June 1989, 20–23.

15. The others would have been Dick Mock, Ken and Joy Kilstrom, Howard Storm, and perhaps Ted Golubic with his family and possibly Milton Resnick and Pat Passlof.

16. Author's note: the word compound also refers to a cohesive substance, holding things together.

17. Michael J. Riley Ph.D., Roswell Museum brochure for the 1998 Invitational Exhibition.

18. From the Public Service Announcement of her show at the Roswell Museum and Art Center, 6/18/77.

19. Michael Aakhus, in his application to the residency program, 6/20/76.

20. Also known as polystyrene; a clear plastic foam formed into sheets.

21. Annie Osburn, "Elmer Schooley" in *Southwest Art*, October 1991, 77.

22. Artist's statement, published by Littlejohn/Sternau Gallery, New York, NY, 10/4/94.

23. Roswell Museum Bulletin, vol. 29, no. 2 & 3, Summer 1981.

24. Irene, a brilliant and gifted sculptor, died of breast cancer in 2005.

25. Wesley Rusnell, *Memory and the Garden: the Art of Martie Zelt*, RMAC brochure, 3/20/98.

26. As reported by Gailanne Dill in the *Roswell Daily Record*, 3/6/98.

27. Jerry Williams' application statement, 1982.

28. Interview with Joanna Littlejohns, 1/05.

29. Quote from Robert's statement in the Roswell Museum brochure for his show, September 20–October 14, 1970.

30. Ruby is on display in the Anderson Museum, wearing one of Astrid Furnival's magical sweaters.

31. Cited from the Beverley Anderson video, *A Gift of Time*, 1987, Ladder Films, Santa Fe, NM.

32. Wesley Rusnell, Roswell Museum brochure for Joe's show there, 2/8/87.

33. Fernand Léger, French painter, 1881–1955.

34. *New York Times* review, Fri., 4/24/98.

35. Roswell Museum and Art Center Bulletin, 6/25/87.

36. Veronique Helmridge-Marsillian in the brochure for Stewart's show at Charles Nodrum Gallery, Melbourne, Australia, 1994.

37. Ken Johnson, *New York Times* review of Daisy's show 10/19/01.

38. Eileen Myles, Review in *Art in America,* 3/88, 156–57.

39. Robbie's statement accompanying his application, June 1990.

40. Jan Runnqvist, Gallery Bonnier, Genève, Switzerland. Brochure for Jerry's show, 1989.

41. Quoted from the artist's statement.

42. "Explorations: 10 Portfolios," *Aperture* Magazine. Cited in artist's biography in the brochure for her show at the Roswell Museum, 3/8/96.

43. Bleem, Jerry, "Vermont Studio Center and Roswell Artist in Residence Program," in *Artists and Writers [:] Retreats, Residencies, and Respites for the Creative Mind*, Robin Middleton, et al. (Eds.), Blue Heron Publishing: Portland, OR (2000).

44. Jane South, statement accompanying her application, January 1997.

45. About this painting, Ann McGarrell writes:

> Sister, lead me to the buried dolls.
> Shadows fall red as pomegranate seeds.
> We wait inside the day, a haze of gold.
> *Memoria.*
> Sister, stay near me.
> You were the first to know,
> The first to say trees and soft beasts
> Would speak and set me free.
> The sky's in bloom. I wake.

46. Adapted from Sally Midgette Anderson's interview with Jim McGarrell, *RAiR Newsletter*, vol. 1, no. 1, Spring 2004.)

47. Mary Josephson, Artist's statement accompanying her application, March 1998.

48. Statement in the brochure of Eric's show at the Roswell Museum, 8/2000.

49. Written by Joyce Tucker in her review in the *Roswell Daily Record* Vision section, 9/01.

50. Artist's statement on the application for the grant, March 2000.

Index